CURATING
THE
AMERICAN
PAST

CURATING
THE
AMERICAN
PAST

A MEMOIR OF
A QUARTER CENTURY AT THE
SMITHSONIAN NATIONAL MUSEUM
OF AMERICAN HISTORY

PETE DANIEL

THE UNIVERSITY OF ARKANSAS PRESS
FAYETTEVILLE | 2022

ISBN: 978-1-68226-197-2
eISBN: 978-1-61075-764-5

26 25 24 23 22 5 4 3 2 1

Manufactured in the United States of America
Designed by April Leidig

∞ The paper used in this publication meets the minimum
requirements of the American National Standard for Permanence
of Paper for Printed Library Materials z39.48-1984.

Library of Congress Cataloging-in-Publication Data
Names: Daniel, Pete, author.
Title: Curating the American past: a memoir of a quarter century at the
Smithsonian National Museum of American History / Pete Daniel.
Other titles: Memoir of a quarter century at the Smithsonian
National Museum of American History
Description: Fayetteville: The University of Arkansas Press, 2022. | Includes
bibliographical references and index. | Summary: "In Curating the American
Past, Pete Daniel takes readers behind the "Staff Only" door at the Smithsonian's
National Museum of American History to reveal how curators collect objects,
plan exhibits, navigate public-sector politics, and bring alive the events,
characters, and concepts that define our shared history"—Provided by publisher.
Identifiers: LCCN 2021023503 (print) | LCCN 2021023504 (ebook) |
ISBN 9781682261972 (Paperback) | ISBN 9781610757645 (eBook)
Subjects: LCSH: Daniel, Pete. | National Museum of American History (U.S.)—
Officials and employees—Biography. | National Museum of American History
(U.S.)—History. | Museum curators—Washington (D.C.)—Biography.
Classification: LCC E169.1 .D27 2022 (print) | LCC E169.1 (ebook) |
DDC 069.092 [B]—dc23
LC record available at https://lccn.loc.gov/2021023503
LC ebook record available at https://lccn.loc.gov/2021023504

For Family

CONTENTS

ACKNOWLEDGMENTS

Grace Palladino and David DeVorkin read early drafts of the manuscript, and after his reading, Arthur Molella clarified the issue in *Science in American Life* when he replaced David Allison as head curator. In addition to her other suggestions, Pam Henson reminded me of the misogyny that prevailed in the museum and the Institution, and Ray Smock supplied his patented criticisms of my work. Larry Jones read an early draft and assured me that my references to machinery and our projects were correct. An anonymous reader for the press made excellent suggestions on focusing the story. Barbara Fields read the final draft for the press and suggested wise word changes, clarifications, and, most important, the memoir title. Over the years I have no doubt bored friends with recitations of my museum work; they were generous with suggestions. The manuscript went through countless iterations, moldering on the shelf for years, taken down for further work, and at last completed.

Many of the photographs were originally in color but, with an eye on expense, were converted to black-and-white. Sally Stein's photograph of Billy Lee Riley, for example, lost the blue and red lights above his upraised hand while Sherry Schaefer's Hart-Parr No. 3 photo does not reveal the startling red color of the restored tractor. Jeff Tinsley's awesome poster photograph of the John Deere D tractor lost the green of the tractor and the red of the barn. Kim Nielson's warm images of the cotton gin gearing chilled, while Eric Long's photo of an Amish man cutting oats is no longer golden. I owe these and other photographers a sincere thanks for their contributions to the book.

David Scott Cunningham, editor in chief at the University of Arkansas Press, shepherded the manuscript through revisions, and Jenny Vos, project editor, has enforced a rigid publication schedule.

As I read through my correspondence files as the memoir progressed, I again realized how crucial my work with museum fellows became, and I have stayed in touch with many of them. Our relationships have often lasted years,

as I offered advice, read their dissertation drafts, wrote letters of recommen-
dation, and followed their careers and family life. They not only brought the
academy to me and kept me appraised of current scholarship but also dis-
cussed challenging concepts with humor and insight. As I mentioned in the
text, I have four shelves of their books, and new volumes arrive periodically.

CURATING THE AMERICAN PAST

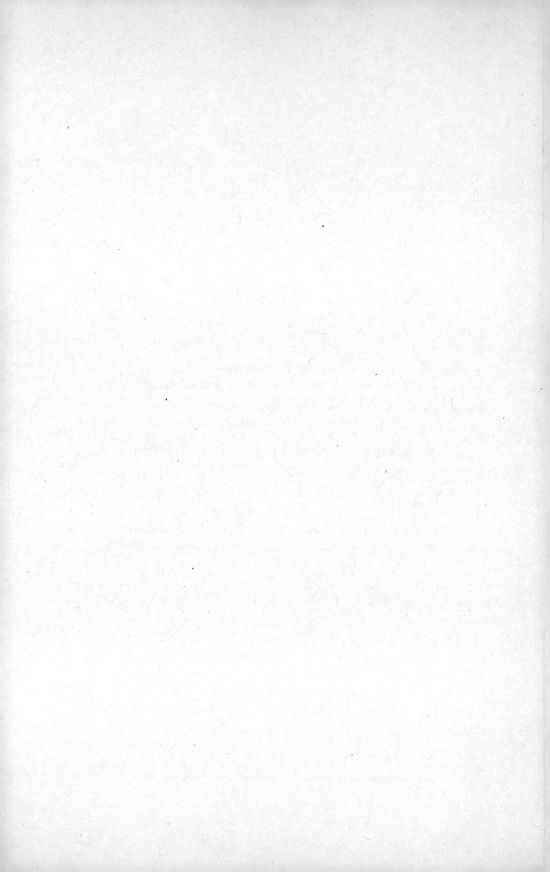

Introduction

More bitterly could I expostulate,
Save that, for reverence to some alive,
I give a sparing limit to my tongue.
—SHAKESPEARE, *Richard the Third*

I first visited the Smithsonian Institution in 1956 with my Spring Hope High School (North Carolina) junior class and witnessed dinosaurs and gems in the preservative-scented National Museum of Natural History, prowled among trains and machines at Arts and Industries, and intensely watched wildlife at the National Zoo. Several of us climbed and descended the steps of the Washington Monument. The city infected my imagination, but it never occurred to me then that someday I might work at the Smithsonian, or that I would criticize feckless leaders and wealthy donors. To my small-town mind, it would take more steps than those up the Washington Monument to gain a position at such a renowned institution.

At Wake Forest College, I majored in history, which in the 1950s was often taught as a chronological parade of actors and facts, and textbooks assumed almost biblical inerrancy. Professor David L. Smiley challenged that canon and opened my eyes to complexity, especially his critical analysis of then-accepted southern history, with its embrace of white supremacy. He employed a magnificent sneer as he tore apart southern mythology and offered a far more nuanced and exciting history of the South. By questioning the accepted historical narrative, he helped me shed my naive skin and begin asking questions of books and ideas. Attacking was far more exciting than defending.

I was elected president of the freshman class due in large part to the encouragement and support of friends I had met at a religious retreat before classes began, and I eventually became vice president of the student body. I was one of a few legislators who voted in favor of integrating the school. Donald Schoonmaker, who later taught my daughter Laura, preceded me

as vice president and presided over the student legislature where I under-studied his mastery of parliamentary procedure, insistence on civility, and decisiveness.

It was only when I was a senior at Wake that graduate school emerged as an option, primarily because the inaugural MA history program at Wake needed warm bodies. Fortunately, I was admitted before taking the Graduate Record Exam; I was not keen on standardized tests, and my score did not indicate success in graduate school. My MA thesis focused on New Deal agriculture, and I published an article in the *North Carolina Historical Review*. Surprisingly, I had become a historian.

Bonnie Jean Sullivan and I were married in June 1961, and our daughter Lisa was born in May 1962 as I was finishing the MA. At the time, we were living in the Wake Forest trailer park surrounded by friendly and interesting non-affluent student families. I entered the training program to be a foreman at R. J. Reynolds Tobacco Company and learned to operate cutting, making, and packing machines and gained experience managing a production floor with a hundred employees and temperamental machines. Despite the challenges of manufacturing cigarettes, I was discontent and was hired by the University of North Carolina Wilmington, which was then evolving from a junior college and needed warm bodies. Three years teaching there convinced me that I needed to get a PhD to continue a college teaching career. In 1966, I entered the University of Maryland's history program, where I spent four of the best years of my life; I was reacquainted with Washington and thrived doing research at the National Archives and the Library of Congress. Our younger daughter, Laura, was born in July 1968 in the midst of antiwar demonstrations.

Louis R. Harlan also arrived at Maryland in 1966, and the next year he began the Booker T. Washington Papers project and selected me to work with him as his graduate assistant. Two years later, I became assistant editor of the project, and by the time I completed my PhD in 1970 we had two volumes ready for the press (which were eventually published in 1972). My good friend Raymond Smock took over as assistant editor, became coeditor, and stayed with the Washington project until its completion. We marched for civil rights and against the war in Vietnam, and on at least one march Lisa came along.

In the spring of 1970, I won the Louis Pelzer Memorial Award, given by the *Journal of American History* for the best paper submitted by a graduate student, and also had an article accepted by the *Journal of Southern History*. After defending my dissertation in the spring of 1970, I spent the summer

Marching against the Vietnam War, 1968. *Left to right:* Jim Lane, Lisa Daniel,
Ray Smock, David Goldfield, Louis and Sadie Harlan. *Author photo.*

teaching in the University of Maryland's program in Berlin, Germany. In the
fall, I went to the Johns Hopkins University on a National Endowment for the
Humanities (NEH) postdoctoral fellowship where I revised my dissertation,
which was published in 1972 as *The Shadow of Slavery: Peonage in the South,
1901–1969.* Bonnie and I separated in the summer of 1970, and in the fall of
1972 I moved to the University of Tennessee, Knoxville, for seven lean years,
with one year off for good behavior at the University of Massachusetts Boston.
As often as possible, I drove the five hundred miles between Knoxville and
Columbia, Maryland, to visit Lisa and Laura. This was not the best time of my
life, and I still refer to it as exile.

During those years, Ray Smock and I wrote *A Talent for Detail: The Photo-
graphs of Miss Frances Benjamin Johnston* (1974), and in 1977 I completed *Deep'n
as It Come: The 1927 Mississippi River Flood.* In 1978, I won an NEH fellowship

At the races, Road Atlanta, 1973.
Myron Wiklund Photo.

for research and study, took leave from the University of Tennessee, moved to Washington, and haunted the Library of Congress and National Archives. As the fellowship was ending, I met US senator Robert Morgan, a fellow North Carolinian, who hired me to organize his papers and interview people important in his career; later he assigned me to write speeches and handle some legislative issues. I had taken leave from Tennessee but was nevertheless promoted to full professor and within months resigned the position. Senator Morgan lost his Senate seat in the Reagan landslide in the 1980 election, and I lost my job, no doubt setting a record for the most rapid descent from full professor to unemployed. After several months, the National Museum of American History (NMAH) hired me to work on an exhibit on the one-hundredth anniversary of Franklin D. Roosevelt's birth, and from there I moved in the fall of 1981 to the Woodrow Wilson International Center for Scholars then located in the Smithsonian Castle and in October 1982 was hired by NMAH to replace a curator who was going on leave for a year.

For years my day started with a bike ride along East Capitol Street, through the Capitol grounds, and downhill to the Mall, peddling past the National Gallery and National Museum of Natural History and on to the history

museum. I walked through the machinery and electricity halls, inhaling musky museum smells, and then coffee aroma lured me downstairs to the staff cafeteria. Museum work—collecting, exhibits, research, and writing— was exhilarating, as was biking to and from work through monumental Washington.

As a rookie curator, I knew practically nothing about the museum's former or even present leaders or the peculiarities of my colleagues. I brought to the museum a naive belief that it soared above political skirmishes and lived up to its sterling reputation as a temple of learning. Thanks to Robert C. Post's *Who Owns America's Past? The Smithsonian and the Problem of History* (2013), I belatedly learned of feuds, dubious agendas, corporate meddling, and other mischief that occurred before I arrived in 1982 and gained a broader per- spective concerning issues that happened during my tenure. I would have benefited from knowing how deeply immersed the museum was with the his- tory of technology epitomized by hosting its journal, *Technology and Culture*, edited by Robert C. Post. I owed my loyalties not to the Society for the History of Technology (SHOT) or to museum organizations but to traditional his- tory associations, in particular the Southern Historical Association and the Organization of American Historians.

For twenty-seven years, I was an 8:45–5:15 bureaucrat, as well as an out- spoken advocate for curatorial prerogatives, a harsh critic of Smithsonian and history-museum leadership, and president of four historical organizations. I witnessed enormous changes that reshaped curatorial work, especially the conception, funding, and scripting of exhibits, as well as misguided leader- ship in the Smithsonian Castle, the history museum, and other Smithsonian components. While some curators and staff challenged worrisome decisions, many decided silently to trust Smithsonian leadership as if nothing untoward could taint the institution.

The history museum held Tuesday colloquiums, and often Smithsonian fellows spoke on their research progress. By 1984 it had become customary to adjourn to a bar to continue discussion. This tradition continues to this day and has over the years included scholars from the German Historical Institute, local colleges and universities, and Smithsonian museums. These discussions were an extension of intellectual life for me, because museum fellows were acquainted with the latest scholarship.

My first twenty years at the museum were frantic with collecting, exhib- its, writing books, and exciting projects. Over time my museum enthusiasm

twisted into frustration as a new generation of visionless Smithsonian secretaries, museum directors, intrusive donors, and compliant curators dictated celebratory exhibits that minimized or ignored important scholarship. Some of my most valued colleagues retired or moved on, unreplaced, leaving the museum both dreadfully understaffed and under-brained. Into the void seeped administrators obsessed with process, forms, reports, meetings, training, and stifling red tape. As Congressional funding for exhibits dried up in the 1980s, donors assumed increasing power and became more aggressive in demanding larger credit panels and, more damaging, in usurping curatorial responsibility by dictating exhibit content and radically altering the exhibit landscape. Museum renovation after the turn of the century closed the history museum for a year and a half, and by then virtual systems had largely replaced human contact. It was not just vacant curatorial and specialist slots, an ineffectual development office, and a worrisome administrative staff that drained vitality, but also process-obsessed and visionless leadership unacquainted with excellence or history. It was frustration that seeded this memoir, for the National Museum of American History should have done better.

What was happening at NMAH was replicated to some extent nationally. As I attended history conventions and spoke with public historians and university professors, they often mentioned top-heavy administrations, burdensome teaching loads, fewer tenure slots, low pay, and a tendency of administrators to adopt corporate management ideas. Museum staffers throughout the country complained that donors had become increasingly aggressive in dictating exhibit topics, and as a result the public was served a bland diet of great American triumphs and denied the red meat of adversity, protest, diversity, and struggle. In addition, popular culture, including music, radio, film, and TV, became a new canon of discourse, stoked by the digital revolution that supplied perpetual and often addictive entertainment. Cell phones released a flood of dammed-up words, and, freed from landlines, conversations proliferated across the landscape. Increasingly, the virtual replaced the authentic, and clever digital manipulation challenged museums that featured real objects. Wealthy donors often bullied museum directors and curators to script a virtual historical past featuring an ever-happy America divorced from the complex struggles that built the country.

What is behind the forbidding "staff only" door, and what do museum curators do? These questions intrigued me both in 1981, working on the Roosevelt exhibit, and in the fall of 1982 as I assumed curatorial duties. I

hope not only to demystify museum work but also to analyze the transformation that I witnessed. The Smithsonian is often regarded as a hallowed, even noble, institution whose curators possess exemplary expertise, even wisdom, as they increase and diffuse knowledge. Indeed, there are talented employees at all levels who collect, store, move, and exhibit objects, conduct significant research, publish important articles and books, carry out extraordinary projects, care for animals at the National Zoo, and guard and maintain the institution. My responsibilities at the National Museum of American History offered unique opportunities to converse with staff and to exchange ideas on national and international stages.

I hoped to create an exhibit on southern rural life based on my scholarship and with that in mind bent my collecting toward the rural South. Ideally, a curator did research and wrote, collected significant objects, created exhibit ideas based on research and collections, and put it all together in an exhibit. In my career, all of these elements never came together, but on the other hand exhibit research sometimes led me in novel directions, especially my work on the exhibit *Science in American Life*.

The Smithsonian Institution suffered immensely under the secretarial reigns first of I. Michael Heyman, who abandoned what he labeled controversial exhibits, and then of Lawrence Small, who undermined its scholarly tradition, permitted donors to intrude on the domain of curators and scholars, and shuttered outstanding programs. Wealthy donors marched into this curatorial and leadership vacuum with inflated demands that included credit for their financial support, naming demands, and their own dreadfully misinformed exhibit ideas. Why wealthy people assume they understand our history better than historians is a grave mystery. Even as scholars offered challenging new interpretations, the American history museum's exhibits often suggested a repository of historical clichés. In a larger sense, the museum's direction merged with other efforts to present US history as unflawed and above criticism.

When I unexpectedly began a university career and then became a museum curator, I brought high expectations, making it difficult for me to forgive administrators who lacked nerve and allowed great opportunities to slip by, and directors and curators who listened to funders rather than historians and who, rather than increasing and diffusing knowledge, held it in bondage. While my first two decades at the museum were filled with collecting, exhibits, exciting projects, and writing history, in my last decade I witnessed

insensate leadership both in the Castle and in the history museum. Fortunately, during those years I was deeply involved in leading history organizations.

That the Smithsonian Institution sometimes settled for less than the best, or worse, tolerated mediocre leadership and ideas, upset me enormously. In an almost biblical sense, I feel we must use our talents to the fullest. As the great Formula 1 champion Ayrton Senna put it, "You either do well, or, forget it." Nerve and focus were often lacking among Smithsonian leaders, and the lure of funding shattered their integrity. Still, I felt extremely fortunate to be a Smithsonian curator and attempted to do it exceptionally well.

My memory is fallible, but fortunately I am an inveterate letter and email correspondent and have kept incoming and outgoing letters since graduate school and also recorded my thoughts in notebooks. I often shared my observations about museum work, especially when annoyed or delighted. As with most private correspondence, mine sometimes strayed from King James English and lapsed into profanity and libelous characterizations. The Smithsonian Congress of Scholars, composed of representatives from all museums, circulated stories from national newspapers, magazines, and journals relevant to scholarly issues. At the Smithsonian Institution Archives, I looked through my colleague Paul Forman's papers and also read Pam Henson's interviews with Smithsonian Secretary I. Michael Heyman. Over the years, Pam, director of the Institutional History Division, has generously shared with me her profound insights into Smithsonian history. Her mentoring of Smithsonian fellows is legendary. I was not privy to director decisions, secretary mandates, or Board of Regents meetings and trust that in time sources will emerge to more fully illuminate leadership folly.

This is neither a personal story nor a history of the National Museum of American History but rather an account of my curatorial work. When I explained to my family over dinner several years ago that this memoir would never be a best seller because it contained no sex or violence, my fifteen-year-old granddaughter, Stella, asked, "No intellectual violence?"

1

Historian/Curator

There was a kind of general assumption around the shop that
laboring men and women were all more or less evil, surely
misguided, and not quite American, maybe not quite human.
—THOMAS PYNCHON, *Against the Day*

I n the summer of 1981, I eagerly took a summer research position at
the National Museum of American History (NMAH), a bridge between
losing my aide position with US Senator Robert Morgan (defeated in
the Reagan landslide) and a fellowship at the Woodrow Wilson International
Center for Scholars. Working on *FDR: The Intimate Presidency* was a sharp
but not unwelcome break both from academia and the Hill. As has happened
often in my life, the unlikely opportunity came about when I attended a recep-
tion at NMAH and learned that the museum was preparing the exhibit. A few
days later, I met with Director Roger Kennedy and Arthur Molella, recently
moved from the Smithsonian's Joseph Henry Papers to head the exhibit team,
and was hired. Art and I got along well in part because of our mutual editing
backgrounds and also our agreeing on the scope of the exhibit. Since I had
done substantial research both at the Library of Congress and the National
Archives, my museum research focused on relevant 1930s photographs and
later film and audio of FDR's fireside chats, Huey Long's sensational "Share
Our Wealth" speeches, and Father Charles Coughlin's shrill and accusatory
rants. Often, at our exhibit team meetings, dynamic designer Ben Lawless
exploded with ideas and humor such as always mispronouncing *Molella*.

Museum work was invigorating, and the bold ideas, striking objects, and
imaginative design promised an exhibit that would reach far more people than
my college lectures or my books. Fortunately, I had stumbled into the museum
at a moment of substantial creativity when, not without some friction, history

of science and technology curators mixed with a growing cadre of social and cultural historians. I had assumed that nearly all curators were academically trained scholars but learned that until the 1950s they were a more diverse group, some with corporate or practical backgrounds.

In September 1981, I left the FDR team and went across the Mall to the Woodrow Wilson International Center for Scholars, then located in the Smithsonian Castle. The Wilson Center hosted a diverse group of intellectuals and popular writers, some from newspapers and magazines, a few novelists, and an international group of history scholars who mixed at colloquiums, lunch, and sherry hour. By the time I left the Wilson Center in late summer of 1982, I had nearly completed the manuscript for *Breaking the Land: The Transformation of Cotton, Tobacco, and Rice Cultures since 1880*.

Barney Finn, head of the Department of Science and Technology, mentioned to me that curator Terry Sharrer would replace Robert Rydell, a professor at Montana State University, who had won a Smithsonian fellowship to study world's fairs. Terry and Robert basically traded places, and Barney recommended that I apply for Terry's vacant position for the year, and after weathering the vexing hiring process I was selected. Given the slim academic job offerings, I considered myself extremely fortunate.

Before the museum job began, I headed south to the University of Louisiana at Lafayette for additional research on the prairie rice culture, one section of my book. After a productive week in Lafayette, I shifted to my pending curatorial role and visited the Arkansas County Agricultural Museum in Stuttgart and talked with curator Helen Boyd. After I mentioned that my book project included rice, she telephoned ninety-year-old J. M. Spicer, who had written a book about his career as a rice grower, and he came in for an interview.[1] Like many farmers, Spicer had an infallible memory of weather, commodity prices, technology, and hired help. As I was leaving, Helen suggested I visit a crew harvesting rice nearby, and I took the opportunity to chat and take photographs, two of which appeared in *Breaking the Land*. Even before officially starting at NMAH, I discovered a welcome compatibility between history and curatorial work.[2]

I was in my mid-forties when I arrived at the history museum in October 1982 and had spent nearly a decade in academia before working on the Hill. I was assigned to the Division of Extractive Industries, headed by John Schlebecker, a prominent historian of agriculture; but I did not fit into the clubby group that had included Terry Sharrer and started the morning with

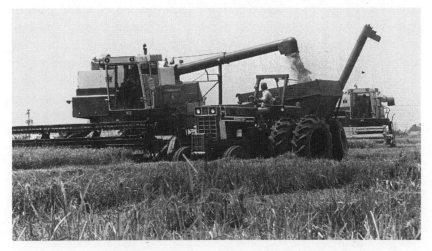

Marvin Scroggins and crew combining rice,
Stuttgart, Arkansas, August 31, 1982. *Author photo.*

extensive chats. One of my first missions was finding a serviceable typewriter, for unlike many curators at that time I did all my own typing. Prospecting along the hallways, I tried and discarded one machine without a "correct" key, another with a wandering element ball, and several others of varying desuetude, before adopting a less than pristine machine. The museum had recently installed a Wang computer system, and curators who used the few terminals assumed an air of superiority. I had been introduced to word processing at the Wilson Center the year before and was sold not on its sophistication (computer technology was primitive at that time) but in being able to revise drafts without typing over the entire manuscript. I spent many evenings after work sitting at a Wang terminal, editing my book manuscript.

Although I had worked in the museum during the summer of 1981, I was unprepared for its medieval infrastructure and preindustrial work habits. Both the Castle, which housed legendary Smithsonian secretary S. Dillon Ripley and his central administration, and American History, with Director Roger Kennedy, seemed remote, opaque, even mysterious, certainly unapproachable. I had not been privy to controversies concerning former directors, infighting among curators, and disputes over exhibits, but I did look askance at a few haughty and unproductive curators who arrived late, performed poorly, and

rarely contributed to scholarship. New ideas and enthusiasm, I sadly learned, threatened curatorial lethargy. Still, I was blinded by the Smithsonian's prestige and felt loathe to criticize my colleagues, at least at first. Barney Finn assigned me projects, and gradually I began to learn how the museum operated.

Soon after I arrived at the museum, the Agricultural History Society began a search for a new home for its journal, *Agricultural History*. In addition to hosting *Isis*, the journal of the History of Science Society, edited by Robert Multhauf, and the *Smithsonian Journal of History*, the museum became home both to *American Quarterly*, the journal of the American Studies Association, edited by Gary Kulik, and *Technology and Culture*, the Society for the History of Technology's journal, edited by Robert Post. While Barney was always interested in increasing the museum's scholarly profile and was supportive of a bid to bring *Agricultural History* to the museum, John Schlebecker mumbled noncommittally when I talked with him and then discussed the journal's home with the Agricultural History Society's old boy network, which did not support bringing it to the museum. John probably suspected (correctly) that I wanted to edit the journal in order to remain on the museum payroll, and, of course, my scholarship did not fit into the old boy canon.

After sharing a smoky office with museum specialist Bob Walther for a month (the ceiling above his desk was yellow), I was assigned John Hoffman's former office; he had died the summer before. Largely unappreciated in the division, Hoffman was an expert on mining, petroleum, and iron and steel manufacturing, and was notably successful in bringing to the museum a large collection of mining lamps, tools, and documentation from mining companies.

Specialist Francis Gadson had worked closely with Hoffman, and he helped me claim the cluttered office. I was going through one of Hoffman's desk drawers as Francis cleared shelves nearby and discovered what I thought was a dummy blasting cap. Francis examined it and, in one of his rare definitive statements, calmly said, "That's not a dummy." I called the hazardous materials office. Francis was a repository of information about collections and institutional history, and he spoke favorably of John Hoffman, who, like Francis, was excluded from the inner sanctum of the division.

Letters of inquiry arrived frequently at the museum, just as constituent mail had at the Senate, and correspondents expected Smithsonian curators to give definitive answers to their inquiries. In those pre-Google days, most people simply wanted information, and supplying it was a crucial part of our

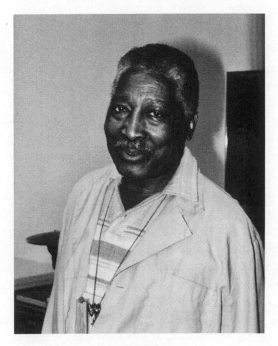

Francis Gadson.
Author photo.

job. I recall that the musical history division kept a form letter sent to hopeful Stradivarius violin claimants listing identifying marks. Having learned annotation at the Booker T. Washington Papers and mastered responsive replies to constituent mail in Senator Robert Morgan's office, I took pride in my replies, which often required tracking down obscure information.

In January 1983, Barney Finn stepped down as department head, and Arthur Molella, who had headed the FDR exhibit and strongly supported my work, took over. We had oblique discussions about my staying on when Terry Sharrer returned, but I figured that if a slot opened it would go to someone with an Ivy League degree or who possessed museum studies credentials. Despite my enchantment with museum work, I was not convinced I wanted to spend the remainder of my productive years in a museum. It was a bureaucracy, after all, and one had practically to insult some people to get them to think outside their conservative comfort zone. Each Christmas holiday season, for example, the museum displayed elaborately decorated trees. In a

conversation with a curator about the role of the military-industrial complex, I recalled a recent cost-overrun document made public that showed a bolt manufactured at $0.02 and sold in hardware stores for $0.05 when bought by the Pentagon cost $1,200. I suggested we collect bolts and other hardware mentioned in the report and put them on a Christmas tree with an appropriate label. The curator forced an insincere smile as he shook his head.

I paused at the staff cafeteria before working hours for coffee and to chat and conduct business. The space was buzzing with energy and spirited conversations. At the time, Jim Wallace supervised an excellent Smithsonian photography unit housed in the museum basement, and I would work with several photographers on projects in the coming years but first got to know them over morning coffee. Before email corrupted face-to-face conversations, a morning cup of coffee in the staff cafeteria allowed for making appointments, setting priorities, and discussing promising projects. I usually exited through the cabinet shop, where the smell of wood triggered memories of my father's millwork shop. My after-school job in high school had been shoveling the sawdust and shavings onto a truck (which I learned to drive at age fourteen) and cleaning up the wood blocks around power saws. I learned to organize the work to save steps and duplication, a skill that has served me well. Over coffee I could ask naive questions about exhibits, collecting, and other issues, which was useful given that I had no official orientation. It would surprise me, for example, that museum collections had sometimes followed curators who migrated from corporations and that exhibits might reflect Smithsonian/corporate cooperation.[3] I assumed that exhibits would rest on scholarship.

It did not occur to me at the time that I was ensconced in predominantly male-dominated environments—in the Division of Extractive Industries, in the staff cafeteria, and throughout the museum and the Smithsonian. I later learned of the discriminatory treatment of women curators and museum specialists. There were outstanding women curators, but directors' favor fell on men. Male prerogatives would endure, but rumblings from the women's movement were already growing louder, and I later discovered that some women in the Smithsonian had already united to oppose discriminatory treatment. Many of the women who received Smithsonian fellowships were part of the wave that would aggressively challenge misogyny.

Gradually I learned of the unfitness of some of my male colleagues. One spent his days mooning over a temporary secretary. A curator from another

Walker Percy, C. Vann Woodward, and Eudora Welty.
Smithsonian Institution.

division recounted a luncheon outside the museum where two other curators had drinks before, during, and after the meal before groggily returning to the museum. I resented that some curators and specialists treated Francis Gadson with dismissive paternalism. He had a profound understanding of the division's holdings and history, and he eagerly helped me adjust to museum work; he was a wonderful mentor.

Doubleday publishers sponsored an excellent museum lecture series, and in May 1983 Walker Percy, Eudora Welty, and C. Vann Woodward spoke, a who's who representing southern literature and history. I had read all of their books. They talked about Yankees as they plugged Doubleday's Library of America: Percy on Herman Melville, Welty on Nathaniel Hawthorne, and Woodward on Francis Parkman. It was an excellent program, and the food afterward was delicious, although my appetite slightly soured when the orchestra played "Old Black Joe" as we went downstairs for food. I briefly chatted with Woodward, who had reviewed my book *The Shadow of Slavery.*

With the clock ticking on this temporary job, I applied for a position at the Library of Congress's Prints and Photographs Division, and it turned out that my friend Ray Smock and I both were applying for the position of

Historian of the US House of Representatives. Then, in August the museum hired me as a curator specializing in agriculture. Meanwhile, Ray Smock became historian of the US House of Representatives. Already another of my graduate school friends, Donald Ritchie, was associate US Senate historian, and Samuel Walker was a historian at the Nuclear Regulatory Commission. Despite our achievements, the University of Maryland's history department never capitalized on preparing students for the Washington job market and regarded our public history positions as second-rate.

The museum position opened opportunities quite unlike university teaching and also exposed me to elite biases. In the spring of 1983, curator Gary Kulik, Carla Borden (who worked in the Castle on special projects), and I traveled to North Carolina for a planning session for the British-American Folk Festival and met with George Holt in the North Carolina Department of Natural and Cultural Resources. I found scant support for anything connected to agriculture, so I mentioned that both Brits and Americans were obsessed with automobile racing and suggested a forum featuring Formula 1 and NASCAR drivers. I had been to stock-car races in high school during the sport's wild years in the mid-1950s and, of course, drag raced on back roads but had lost interest in college. In the summer of 1970, though, while teaching at the University of Maryland abroad program in Berlin, I attended a Formula 1 race at Hockenheim. The power, sound, and technology fascinated me, and I began following Formula 1 and renewed my interest in NASCAR.[4]

I envisioned a program featuring Rob Walker, the erudite *Road and Track* Formula 1 columnist, co-moderating a session with a stock-car counterpart as both Formula 1 and NASCAR drivers discussed their careers. Naturally, there would be representative race cars on display. Stock-car drivers from the early days were still active, but getting the likes of world champions Jackie Stewart or Graham Hill offered a challenge. I contacted Junior Johnson, who had granted me an interview in 1978 at the Southern 500 at Darlington and whom I helped with an Energy Department gasohol grant application through Senator Robert Morgan's office.

I wrote cold to Rob Walker in England, who not only covered Formula 1 for *Road and Track* but was also a profound student of racing and had once owned a Formula 1 team. I explained that I was a Smithsonian curator and was working with the North Carolina Department of Natural and Cultural Resources and asked for suggestions. The program, I insisted, would be good publicity for both Formula 1 and NASCAR. Several Formula 1 drivers, includ-

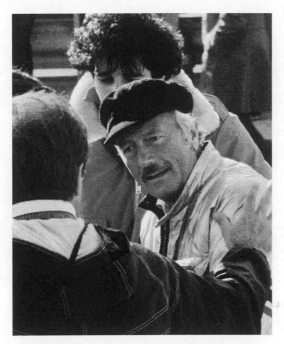

Colin Chapman, US Grand Prix, Watkins Glen, NY.
Author photo.

ing Jim Clark and Jackie Ickx, had previously competed in stock-car races in the South; Clark, driving a Lotus, won the Indianapolis 500 in 1965, and Graham Hill won the next year in a Lola. George and I had high hopes for pulling this off until Rob Walker sent me the sobering news that Formula 1 drivers were not a generous lot and that it would take substantial, read more than we had, compensation to lure them over.[5]

After the failed British-American folk festival project, I conceived an exhibit on ground effect, the application of aerodynamics to race cars. In the spring of 1985, I traveled to the UK, having written ahead to Rob Walker and also to Michael Kimberley at Lotus Cars to set up meetings.[6] I interviewed Tony Rudd about how Lotus founder Colin Chapman developed ground effect. To go faster, race-car bodies need to be sleek and aerodynamic, he explained, but to corner they require downforce. Nearly all race cars at the time had wings that gave downforce on cornering but also created drag and robbed straightaway speed.

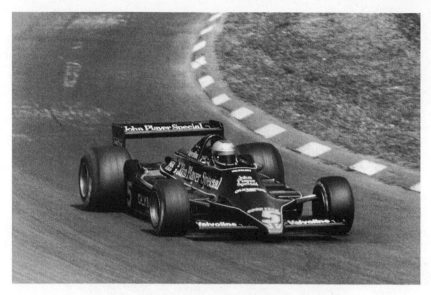

Mario Andretti at Watkins Glen, 1978.
Author photo.

Chapman theorized ground effect in a twenty-seven-page concept docu-
ment, and he assigned Tony Rudd and Peter Wright to head the development
team with other top engineers. By controlling airflow over and especially
under the car, Chapman predicted, they could reduce drag and increase
downforce simultaneously. Rudd explained that the team generated 2.2 miles
of computer tapes and fifty-four rig tests, and spent four hundred hours in the
wind tunnel. When the prototype rolled out, Chapman abruptly left Rudd
behind at the office as the team track-tested the race car, and then told him
that his calculations were wrong—before explaining that the car was even
faster than predicted. Lotus Racing introduced its ground effect Formula 1
car in 1977, and Mario Andretti won the World Championship in the Lotus 79
in 1978.

There were wing cars in the US, as well as innovative prototypes. In 1970,
Jim Hall introduced the revolutionary Chaparral 2J, nicknamed the "sucker
car" because its twin fans created a vacuum that sucked the car to the track.
It was banned for not meeting the Can-Am series regulations. A decade later,
Hall's Chaparral 2K won the Indianapolis 500. I contacted Jim Hall, who
agreed to lend his 2J; the Indianapolis Museum would lend the 2K, and Lotus

would lend the 79. These race cars were iconic—and beautiful—and the aero-
dynamic ideas, basically turning flight upside down to keep cars on track,
were significant, not to mention educational. The technology of race cars
offered an opportunity to educate museum visitors about engines, transmis-
sions, suspensions, aerodynamics, and the obsession that pushed designers
and engineers—and drivers—to go faster.[7] My exhibit idea did not meet with
the head designer's approval.

Meanwhile I was keeping an eye on Richard Petty as he neared his two-
hundredth NASCAR victory. By May 1984, he had 199, and I worked on a
plan for the Smithsonian to acquire the car that would win number 200.
Richard Petty conveniently won the Daytona Firecracker July 4 race even as
President Ronald Reagan looked on. Bill Withuhn, a curator in the division
of transportation and far better than me at hobnobbing, handled the collect-
ing work.[8]

This important acquisition required appropriate recognition, and the
museum planned an evening reception and dinner. Petty won in a Pontiac,
and the Smithsonian public relations staff stressed to General Motors that
it could not advertise any relationship between Pontiac and the Institution.
Pontiac's ad agency blithely raced ahead with an ad that read in bold let-
ters, "America's Newest Museum Piece," and underneath, "They're putting
Richard Petty's STP Pontiac in the Smithsonian." The Office of the General
Counsel found the ad objectionable, perhaps legally actionable. The ad was
a cautionary warning that corporations would push aggressively for recogni-
tion regardless of Smithsonian policy. As a result, the reception and dinner
were canceled, and instead there was a luncheon with the Petty family, car
owner Mike Curb, and top officials of NASCAR. Richard's father, Lee, an
ever-disgruntled former NASCAR champion, seemed peeved that it was not
his race car that the Smithsonian planned to display. Richard's son Kyle, who
at the time was beginning his racing career, claimed that someday he would
win a lot of races and get his car in the museum. His dad quipped, "Hell, they
might take your car if you win one race."[9]

In February 1988, I agreed to interview Junior Johnson for the *Notable
North Carolinians* project run by the Southern Oral History Project at the
University of North Carolina. Jacquelyn Dowd Hall headed the program in
addition to teaching and mentoring numerous graduate students. Johnson
at the time owned a race team, so we decided to meet at the race in Dover,
Delaware. The only time he had free was during the Grand National race

Saturday afternoon, so we sat in the cab of the team's eighteen-wheel hauler with my tape recorder on the dash. The sound of race cars rose and faded as they circled the track.

Johnson was deliberative sometimes to the point of reticence, but when I asked him about Tom Wolfe's essay in *Esquire*, "The Last American Hero Is Junior Johnson. Yes!," he became expansive. Wolfe, he recalled, showed up in Wilkes County, North Carolina, took a seat at the local bar, overdressed in a spiffy suit and drawing puzzled, if not scornful, glances from the racing crowd and other locals. When Johnson arrived, the bartender nodded toward the guy in the suit. After chatting a few minutes, Wolfe asked for an interview, but Johnson told him, no, he should instead interview the people who knew him. He would clarify things if necessary. Wolfe impressed Johnson by spending months talking with people in Wilkes County and in the racing fraternity. Johnson remembered Wolfe with fondness and admiration. My dream had been to host a program with Johnson and Wolfe discussing this moment in American letters.

Junior Johnson became one of the most successful drivers and owners in NASCAR history. He combined fearless aggression with subtle strategy, and no driver wanted to see Johnson in his rearview mirror in the late stages of a race. Over his driving career, he won fifty races; he retired in 1966, and then managed his own team. His drivers won 139 races and six NASCAR championships. He would often stand with one foot on the pit wall and calculate how to get his car ahead, mentally shifting the deck as cars pitted, wrecked, or suffered mechanical problems, all the while encouraging or goading his drivers to go faster.

I was coming to recognize that my focus on stock-car drivers and fans indicated growing awareness of working-class culture, a concept that matured as later I interviewed musicians and dozens of stock-car drivers, mechanics, and NASCAR executives. Almost without exception, the stock-car community was working class, as were many rhythm and blues, rock 'n' roll, and soul performers. More polished people wrinkled their noses at stock-car racing, but drivers and fans did not give a damn. They judged drivers by their skill. It was Junior Johnson's nerve, and knowing when to use it, and Ayrton Senna's impatience with anything but excellence that linked these drivers in a pursuit of speed and excellence. With the exception of acquiring the Petty car, automobile racing failed to interest museum administrators, at least

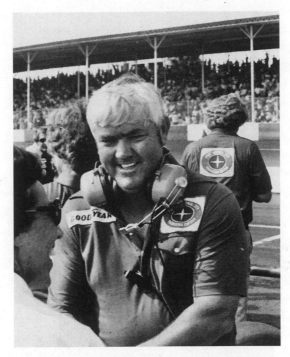

Junior Johnson after Cale Yarborough's 1978 victory
at the Southern 500 at Darlington. *Author photo.*

in part because it featured working-class southerners, a bitter flavor to elite
Smithsonian tastes.

Collecting rural objects became my first priority, since I specialized in
agriculture and rural life, and I often combined collecting trips with research
and lectures. In October 1983, I set out on a research and speaking tour and
at the state archives in Atlanta found in the Vanishing Georgia Photographic
Collection images for *Breaking the Land*. The staff there knew me as a his-
torian and was curious what I might collect as a museum curator. Some of
my fellow curators, I told them, did not concede intelligent life south of the
Potomac River, so I was intent on correcting their views by collecting south-
ern objects that testified to a dynamic rural culture. The staff recalled that
years earlier a historian had located a cotton gin in Monroe County, but the
file listed no proper address or road name, just the vicinity.

On my way south, I detoured through Monroe County, hoping to find the gin shed, and, braving barking dogs, knocked on doors and asked people if they knew of an old gin. No one did, not even the sheriff and his deputies. I continued west to New Orleans to give a talk at Tulane University and visited with my good friend Sylvia Frey, who put me in touch with two of her uncles, Ernest Frey and Rouseb Soileau, both rice farmers who lived in Eunice, Louisiana. They shared their extraordinary understanding of the rice culture.

Then I drove north to Oxford, Mississippi, for the prestigious Chancellor's Symposium at the University of Mississippi. I had sent Professor Paul Conkin a copy of my paper, "The New Deal, Southern Agriculture and Economic Change." At the University of Maryland, I had studied with Conkin, a profound intellectual historian, and had followed his career as he moved to the University of Wisconsin and then to Vanderbilt University. He did not own kid gloves, so I expected sharp and deserved criticism. To my surprise, at the first evening session, he commented on historian Frank Freidel's assessment of the New Deal and mentioned my paper favorably. Later, as we discussed the New Deal, he explained that my analysis resonated with the experiences of his tobacco-farming family in the Tennessee hills. I have never had a conversation with Paul Conkin in which he did not teach me something.

After the symposium ended on October 14, I drove north toward I-40 and, when I crossed the Mississippi-Tennessee border near Grand Junction, saw a mechanical cotton harvester at work in a field and U-turned. A man was sitting in a pickup beside the field, and I engaged him about the crop and asked if I could take some photographs. His brother drove up, and we talked for a while before I headed north. I used one of the photographs in *Breaking the Land*. On this tour I clocked about 1,700 miles. More important, I had continued to combine curatorial work and historical research.

Several months after my visit to the Georgia Archives, the staff tracked down the Monroe County cotton gin. With this information, I contacted the owner and asked if I might see the gin on my way to Charleston for the Southern Historical Association's convention. I left Washington around midnight and arrived at the farm about seven in the morning and met the owner. I took photographs of the gearing, scrambled up to the second floor to photograph the forty-saw gin stand, and talked with the owner about documentation and price. As soon as I saw the exacting craftsmanship of the huge wooden gears and how well-preserved all the elements were, I knew I wanted to collect the gears and gin stand.

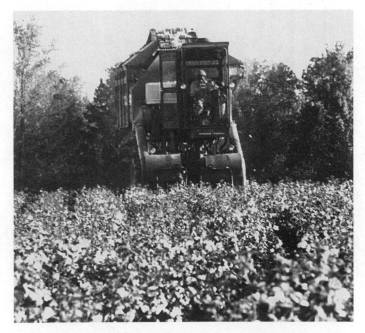

Robert Anderson harvesting cotton near Grand Junction,
Tennessee, October 14, 1983. *Author photo.*

In September 1984, specialist Larry Jones, photographer Kim Nielson, and I crammed into a Ryder truck and set off for Monroe County. The gin shed, originally owned by Augustus Smith, was built in the 1840s and was dominated by a large, unobstructed inside space that allowed mules to turn the bull wheel and engage the gears. We estimated that segments of the wooden gears were at least a century old. The gin stand probably dated from the 1880s.

Larry gazed intently at the pegged-together wooden blocks that composed the bull wheel, as well as a puzzle of intersecting wooden shafts that attached the bull gear to a large wooden shaft, and concluded, "I think it will come apart like this." Larry grew up on a Shenandoah County, Virginia, dairy farm until his father was killed in a hunting accident in 1954, when he moved to Woodstock, Virginia. He had worked in the Space Program, as a mechanic, as a truck driver, and had owned and operated a trucking company. In 1974 he had read a news story featuring Smithsonian secretary S. Dillon Ripley and mentioning some of his projects, prompting Larry to compose a résumé

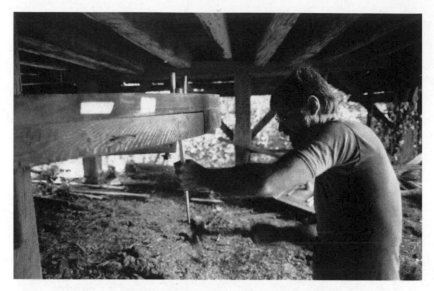

Author driving out pegs in bull wheel assembly.
Kim Nielson. Smithsonian Institution.

and hand-deliver it to the Smithsonian. Hired to a temporary position to work
on the centennial exhibit, *1876*, he later made his way to the conservation
division at NMAH and became an invaluable museum specialist. As Kim
began photographing the gears, gin stand, and shed, we planned our strat-
egy as we helped Kim set up for his photographs. After spending the night
in nearby Forsyth, the next morning we began driving out the wooden pegs
that held the bull gear together and coaxing out the intersecting wooden
shafts, and it came apart just the way Larry predicted. We discovered notches
in some blocks, indicating that at one time the bull wheel had wooden gear
teeth before being retrofitted with cast iron. A team of two graduate students
from Georgia Tech made measured drawings of the structure that epitomized
nineteenth-century gin-house architecture.

The gin stand, that is, the actual forty-saw cotton gin that contained the
saws that pulled the lint from the seeds, was on the second floor. That end of
the gin shed was open to the weather, so we were fortunate to collect the gin
stand before weather ruined it.

We aligned the gin stand with the drive wheel protruding through the floor,
and I imagined mules engaging the gears and a belt turning the gin. Larry

(*Left*) Drive wheel aligned with the gin stand, located upstairs. *Kim Nielson. Smithsonian Institution.*

(*Below*) Bull wheel, pinion gear, and drive wheel. *Kim Nielson. Smithsonian Institution.*

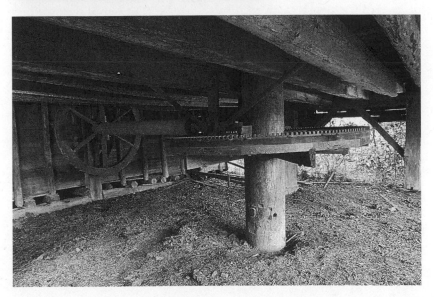

quickly figured out how to get the several-hundred-pound gin stand down into the truck. He stepped into the woods with a chain saw and returned with two poles, and we carefully skidded the gin stand down into the truck bed. When not documenting our work, Kim lent us a hand. Given the stories that Larry and Kim spun about other collecting trips, I gathered that we were fortunate in how well we got along.

As we were working through the hot afternoon, a delegation from the Monroe County Historical Society arrived. They could not disguise their unhappiness that the gin was leaving the county—although no one there had previously paid it any mind—and they seemed inordinately interested in what we paid for the gin, which we kept to ourselves. We were hot and sweaty and had just hefted a 400-pound gear into the truck and, nearly finished load-ing, took the occasion to pop beers, making sure to offer the delegation a pint. They shrank in horror, soon left, and we could sense their indignation: Smithsonian employees not only sweating like vulgar workmen and drinking like rednecks but also stealing one of their treasures.

We learned that after the Augustus Smith farm stopped ginning cotton around 1910 the shed was used as a cow barn, and thus we worked on a sur-face of calcified cow patties that fortunately offered only a faint scent of their origin. Descendants of the original owners and some neighbors had historical information, including some pages from a ledger listing repairs and purchases dating to the mid-nineteenth century, and we later did census research that documented the Smith farm. The next day, we drove back to Washington, glancing over our shoulders at the approach of hurricane Diane.

I have always looked back on this expedition as textbook collecting, for we brought back not only the gin stand and gears but also a photographic record of the site and of our work, documentary records, and measured drawings. With the gin stand, gearing, records, and census material, we had the ingre-dients for a spectacular exhibit that featured the life of a yeoman farmer and covered the crucial years from 1840 to the turn of the twentieth century. Back at the museum, Larry restored the gin stand, saving what he could and fabricating the rest. We never ginned cotton with it, but there is no doubt but that it would have performed like new. It went on display in the *Field to Factory* exhibit.

A few years later, another cotton gin came our way, an eighty-saw Lummus gin stand that dated to the turn of the twentieth century and would need extensive restoration work before being exhibited. I explained to the col-

lections committee that this eighty-saw, steam-powered gin represented an important technological step beyond the forty-saw, mule-powered Smith gin and would strengthen our rural technology collection. Larry Jones went down to Macon, Georgia, with photographer Dick Hofmeister and supervised the transfer to F. H. Lummus and Sons for restoration. We displayed the restored Lummus gin and some gears from the Smith gin in the Agriculture Hall as part of a small section on the cotton culture. Larry organized this project, basically performing both curatorial and specialist duties.

Continually, I tried to weave southern agriculture into the museum's major reinstallation plan. Technological exhibits, I argued, had seldom featured workers (certainly not rural workers) but focused on invention and captains of industry. The cotton culture epitomized incremental developments in ginning, the transition from slave to free labor, then to sharecropping, and ultimately the mid-twentieth-century transformation wrought by mechanical cotton pickers and chemicals. Some historians and most agribusiness corporations considered this transformation inevitable, but by focusing on workers and communities, I suggested, museum visitors would understand mechanization's substantial human impact as thousands of rural people were forced off the land. To counter the technological triumph story, I suggested that the exhibit include a component on successful Amish farmers who carefully selected technology that did not violate their beliefs.

Since there was no interest in a major renovation of the Agriculture Hall, I busied myself with incrementally improving the old exhibit. It became apparent over the years that museum leaders and potential donors harbored an aversion to any exhibit on rural life that was not celebratory of mechanization and chemicals and were especially disdainful of southern farmers. Dealing with poor Black and white people, women, and Hispanic or American Indian farmers undermined the mythological success story that portrayed the triumph of machines and chemicals. It was not the kind of story that attracted funding or interest from museum leaders.

I was coming to realize that farmers, race-car drivers, African Americans, indeed, all working-class folks personified what elite administrators considered a backward culture unpalatable to elite Smithsonian tastes. Given the continuing transformation of rural life, the increasing popularity of stock-car racing, the civil rights movement, and important scholarly contributions to working-class history, ignoring these topics in favor of celebratory exhibits put the museum on an unfortunate trajectory.

2

Boundaries

But it is one thing to write as a poet and another to write as a historian:
the poet can recount or sing about things not as they were, but as they should have
been, and the historian must write about them not as they should have been,
but as they were, without adding or subtracting anything from the truth.
—MIGUEL DE CERVANTES, *Don Quixote*

My first years at NMAH were filled with exciting museum work, getting to know my colleagues, discussing imaginative exhibition ideas, increasing the division's collections, advising fellows, and at night and on weekends writing history, but I also witnessed disturbing conflicts over exhibit content and funding. I would realize only later that the Smithsonian was on the cusp of radical changes partly brought on by reduced federal support of exhibits that necessitated corporate funding and also, at least in my opinion, administrators and curators all too willing to go along with funder desires. In a larger sense, Smithsonian leaders who accommodated to funder demands often violated museum standards. That Smithsonian leaders and curators would bend history for any reason shocked and upset me and brought back unpleasant memories. I had no patience for those who embraced a fable of national innocence.

Gradually I learned more about director Roger Kennedy: Yale undergraduate, law degree from the University of Minnesota, and banking experience before serving as vice president for finance at the Ford Foundation. He arrived at the Smithsonian in 1979 as director at a museum known primarily for its emphasis on science and technology. Kennedy possessed enormous energy that ultimately pushed the museum into a broader mission, acknowledged in 1980 when it became the National Museum of American History. While

Kennedy listened to ideas from curators, he kept an ear cocked for unusual notions from outside the museum.[1]

Kennedy brought in David F. Noble, who had emerged as an outstanding historian of technology. *America by Design: Science, Technology, and the Rise of Corporate Capitalism* (1977) won deserved praise from scholars, and Noble's critique of corporate control of science and technology raised significant questions that shaped debates for years. *Forces of Production: A Social History of Industrial Automation* (1984) analyzed the history of machine tool automation and how management withdrew machine tool programming from union members. David was contentious, to me one of his most endearing qualities. It was my good fortune that both David Noble and Paul Forman, the world-renowned historian of physics, were just doors down the hall from my office. I remember Paul standing thoughtfully at his desk and marveled at the disconcerting questions he posed at Tuesday colloquiums.

David shared with several other curators a desire to inform the museum's exhibits with current historical scholarship and to challenge visitors with fresh interpretations that transcended conventional wisdom. As Congressional funding diminished and exhibits came to rely upon private funding, David brilliantly analyzed the threat of donor intrusion and its impact both on curators and on exhibit content. In a prescient, even prophetic, memorandum of May 6, 1983, David appealed to Kennedy to set aside Congressional or discretionary funds for exhibits that would not attract private funding. Fundraising efforts focused on the wealthy, he explained, and "those more fortunate citizens and more amply endowed organizations come thereby to have an undue influence over the way the Museum carries out its educational and other missions." Such influence was "rarely heavy-handed," he observed. "Instead, curators tend subtly, and oftentimes unconsciously, to tailor their efforts and proposals in such a way as to attract and sustain funding—whether this is actually requested by prospective donors or not." Sidling up to donors was not unique in Smithsonian history, but David foresaw a time when money could exert malign control over the museum's agenda. In time I saw his prophesy come to pass, as curators seized on dubious exhibit ideas simply because there was funding or shaded scripts to avoid controversy. David began shaping an exhibit, *Automation Madness*, a departure from celebratory consensus history and one that would lead visitors toward a more complex understanding of US history.[2]

David was a thorn in Roger Kennedy's side and at nearly every staff meet-
ing had some observation, comment, or question that tormented the direc-
tor. Still, David gained support from Kennedy and the head of exhibits and
energetically moved ahead on *Automation Madness*, set to open June 1984.
But David and the head of exhibits clashed over funding and scheduling;
ultimately Kennedy strangled the exhibit.

Automation Madness was an important and innovative exhibit idea in the
history of technology, one that drew heavily on David's scholarship, exactly
what curators aspired to. His memos were brilliant, accusatory, self-righteous,
and analytical but did not sway Kennedy, who may simply have judged *Auto-
mation Madness* too controversial and a threat to corporate sponsors or even
to the Smithsonian's Congressional funding.[3] Sponsors and politicians, alas,
demanded a heroic view of history. In September 1984, David resigned from
his museum position, just before Roger Kennedy would have fired him. David
had gone to Smithsonian secretary Robert McCormick Adams and com-
plained bitterly about Kennedy's lack of nerve in mounting challenging exhib-
its and about what he considered Kennedy's condescension toward women.

Paul Forman also had a running dispute with Kennedy, who belittled his
work, refused to approve a deserved promotion, and demeaned him at every
opportunity. It disturbed me that the director detested two of the museum's
most brilliant curators while having hired, in my opinion, some less than
sterling curators and also backed exhibits of dubious merit. The museum's
curators association, chaired by Barney Finn, sent a stiff note to Kennedy
expressing "its dismay that a valued colleague should be faced with the stark
alternatives of resignation or prompt removal from his position" and asking
Kennedy to withdraw his draconian order, but the crisis had gone too far for
compromise. With David's departure, the museum lost a promising curator
and also missed the opportunity to mount a significant exhibit on technology.
Later, funding issues would fly at the museum from all directions, and intru-
sion by donors and what came to be known as "stakeholder input" plagued
NMAH and other museums.[4] David Noble's stubborn insistence on curating
a challenging exhibit and then going down with it showed not only his mettle
but also the power of Kennedy to sack an exhibit.

In addition to defending David, the museum's curators association dis-
cussed and took stands on national and international issues. In the summer
of 1985, for example, there was a groundswell of opposition to South Africa's

apartheid policies that included marches and arrests in Washington. In July 1985, the association passed a resolution requesting the Smithsonian Board of Regents to divest the remainder of its South African stock, arguing that holding it "is in direct conflict with its own ideals and deeply compromises both the Institution's integrity and its public reputation." A few weeks later, my office phone rang late one afternoon, and the Castle's Dean Anderson was on the line, outraged at our resolution. He charged that the museum's curators would forever be regarded as ignorant and prone to go off half-cocked. I bit my tongue and listened politely to his critique, and when he finished, I forcefully told him that I had grown up with the civil rights movement and did not allow racism, in this case apartheid, to go unremarked or unchallenged and that I was proud of the resolution and hoped it had some impact on the regents. I also suggested that when Barney Finn and Barbara Clark Smith returned from holiday, he talk with them, for they had led the initiative. At their next meeting the regents failed to divest the tainted stock.[5]

My curatorial job description included research, writing, and publishing, along with collecting, exhibits, and other duties. Amid the chaos of David's firing and the South African issue, I continued writing book reviews, commenting on fellowship proposals, advising fellows, giving papers, and writing letters of recommendation. I belonged to the Southern Historical Association, the Organization of American Historians, the American Historical Association, the Agricultural History Society, and the Society for History in the Federal Government, and most of my professional contacts were in those communities rather than in museum organizations. At annual conferences, I heard scholarly papers, shared ideas, perused book exhibits, and renewed friendships. A convention never failed to energize me.

At last in February 1984, I sent the University of Illinois Press my overweight and ill-organized manuscript that would become *Breaking the Land*, and readers thoughtfully suggested diets and purges to trim it down and, most importantly, included sage advice on reorganization. By mid-July 1984, I had revised and reorganized the manuscript, cut over a hundred pages, and mailed it off before my annual holiday trip to Nags Head. Letting go the manuscript lightened my workload, but I missed it, for until it was finally completed it throbbed in my mind.

While drafting the book, I corresponded regularly with a number of historians, including Jack Temple Kirby, as we both were writing about the twentieth century rural South. We exchanged chapters and suggestions and

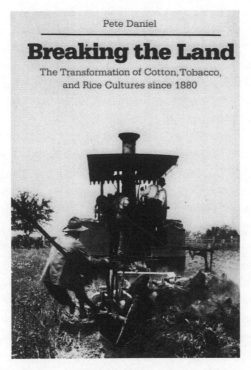

Breaking the Land cover.

critically reviewed relevant historical literature. Over the years, Jack and I corresponded, drank bourbon, argued, and enjoyed each other's company.

Breaking the Land was supposed to appear in 1984, but in addition to tardy production there was a bindery mishap. On page 305, the footnote language changed to Spanish under the title *The Conquest of Michoacan*, and, of course, on the same page of that book the footnotes were in English and about agriculture. I stressed to press director Richard Wentworth, an old friend who I had worked with both on the Booker T. Washington Papers and on *The Shadow of Slavery*, my disappointment that it would miss the year's history conferences. I also demanded to have one of the misbound books, which I have kept.

The press suggested a cover photograph, but I insisted on one that I furnished that showed a tractor breaking the land, while horses, idled by the machine, stood tied to a fence in the background. You could almost smell the

freshly turned earth. Mechanization and the decimation of farmers was a major factor in the transformation of the rural South, and the last photograph in the book showed the rear of Marvin Scroggins's rice combine; there were no people in the frame. *Breaking the Land* won both the Southern Historical Association's Charles S. Sydnor Award for a distinguished book on the history of the South and the American Historical Association's Herbert Feis Award for the best book by a nonacademic historian.

Already I was drafting what would become *Standing at the Crossroads: Southern Life in the Twentieth Century* for Hill & Wang and often communicated with publisher Arthur Wang and with Eric Foner, editor of the press's American Century series. In the late summer of 1985, I was nearing completion of the book, but the title was being difficult. I worked well with Arthur Wang, a brilliant editor, but we fell out over the title and the cover. I was fond of Robert Johnson's albums and was taken with "Standing at the Crossroads," particularly since my book was about decisions that pushed the South in one direction or another, not dissimilar to a midnight bargain with the devil at a desolate crossroads. Arthur was not convinced, and we had a quite frank telephone discussion. Finally he said, "Dammit, it's your book; you can call it anything you like. If you want to call it 'Screwing at the Crossroads,' that's all right." The first cover showed workers attending crates, with a city skyline ridiculously juxtaposed in the background; none of it looked southern, and I disliked it immensely. The next version lost the cityscape but kept the workers and crates, so Californiaish that I hung my head. Arthur would not budge, so *Standing at the Crossroads* came out in the spring of 1986 with that image and a yellow-tinged cover. Over the years I have had many run-ins with presses—shoddy reproductions, book titles, cover art, and bindery mishaps, among others.

In early February 1985, Louis Harlan sent me the final volume of the Booker T. Washington Papers. "Though a slimmer cumulative index volume is still in the process," he wrote, "Ray Smock joins me in a collective sigh of relief at the end of our editorial labors begun in 1967." After I left the project as assistant editor in 1970, I had continued to serve on the board of editorial advisors until the end, so I felt pride holding volume 12. Louis and Ray were an excellent team and certainly presided over one of the most efficiently run major editorial projects.[6]

Shortly after I arrived at the museum, Barney Finn had assigned me to the fellowship selection committee, and over the years I served numerous

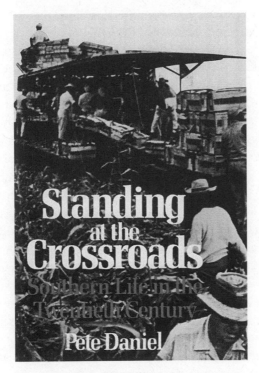

Standing at the Crossroads cover

times and relished the assignment. Smithsonian secretary S. Dillon Ripley had inaugurated the fellowship program, and over the years it has supported thousands of scholars. Since I shunned museum politics, focused on my work, and did not court favor from supervisors, advising fellows and sharing their intellectual excitement added a challenging intellectual bonus to my duties, and reading hundreds of applications each year kept me abreast of recent scholarship. It was exciting to make fellowship selections and then anticipate their arrival months later. The highly competitive program brought to the museum exceptional and diverse scholars, and I mentored a substantial number who studied rural life, southern history, music, and photography.

The first group that arrived after I started at the museum set the tone for twenty-seven years. At that time, the dozen or so fellows were scattered over the museum, but most shared a large open space on the third floor with hand-me-down desks, tattered chairs, faulty typewriters, and no privacy.

Bob Korstad, a predoctoral fellow from the University of North Carolina, burst into my office one day, red-faced and outraged that two workmen had entered their area and, talking in loud voices, had begun to measure the space. It was not the first time that staff, workers, and passersby had disturbed fellows there; in addition, the public announcement system for abandoned children and other museum-wide notices blared into the area. Disgruntled fellows filled two and a half pages with complaints of everything from noise to faulty typewriters. I wrote a testy memo to the deputy director demanding that fellows be treated as serious scholars and deplored the practice of packing them into this third-floor bullpen with no consideration for the serious historical work going on.[7] Bob started a campaign, "Scholars Not Scum," to dramatize fellows' treatment. His prizewinning book, *Civil Rights Unionism: Tobacco Workers and the Struggle for Democracy in the Mid-Twentieth Century South*, appeared in 2003.

Bruce Hunt brought his laconic far-west humor to the museum along with an interest in all things Elvis Presley. He left behind an evaluation of his tenure, and it was eloquent, analytical, and offered constructive suggestions. He faulted museum leadership for ignoring fellows' role in the wider intellectual community and stressed the importance of quiet office space. Later, a dedicated space for fellows eased discontent, although museum renovation eventually shuffled fellows to the basement. Bruce's book, *The Maxwellians*, came out in 1991, followed by *Pursuing Power and Light: Technology and Physics from James Watt to Albert Einstein* in 2010. Despite Bruce's suggestion, rarely did NMAH directors meet with fellows or make any attempt to engage them in discussions. Sadly, many curators also ignored fellows, even those they were advising.[8]

Sally Stein, for example, came to my office reporting that the curator of photography had denied her access to photographs needed for her research. I phoned the curator to inform him of Sally's report to me. He began mumbling nonsense before I curtly cut him off and with some heat insisted that either Sally gain access immediately or I would accompany her to his office for a more intimate chat. The photography curator's lethargy and obstinacy actually worked in my favor, offering opportunities for me to curate photography exhibits and advise fellows who were studying photographic history.

I eagerly promoted the fellows program at history conventions and other gatherings, and I encouraged my academic friends to send their best graduate students to the museum. Each year brought in a new crop, a stream of schol-

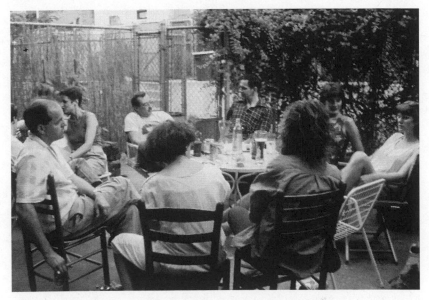

Fellows and friends in Author's backyard, about 1985.
Author photo.

ars who were among the most intellectually active people in the museum
and who provided a continuing graduate seminar for me. They were self-
motivated, industrious, and fun, and I often read their chapter drafts, dis-
cussed their work with them, sometimes served on their dissertation com-
mittees, wrote recommendations, and followed their careers as they moved
on. We frequently lunched together in the staff cafeteria and gathered after
Tuesday colloquiums at Kelly's Irish Times. Because of my academic interests,
I had far more in common with fellows than with most curators.

New fellows who arrived at the Irish Times were initiated with a good-
natured interrogation: What are you writing on? Where? Who is your advisor?
What sources are you using? Because of the diversity of fellows, there were
wide-ranging questions about relevant books, sources, and ideas. Some nights
we discussed politics, others sports, and still others the merits or demerits of
advisors. I benefited enormously from learning about recent scholarship and
ideas percolating through academia.

The intellectual and social life at the museum intensified in the fall of
1985, when fellows Stephanie McCurry and Grace Palladino brought to the

museum not only scholarship but also enthusiasm and humor. I had met Stephanie at the Southern Historical Convention the year before in Louisville and encouraged her to apply for a fellowship. Grace used documentary material that John Hoffman collected for her study of coal miners. They shared the office vacated by retired John Schlebecker; their space divided by bookcases. Grace arrived first each day and began work, and when Stephanie came in the office would explode into talk and laughter and then grow quiet. Both were writing what would become prizewinning books: Stephanie, *Masters of Small Worlds: Yeoman Households, Gender Relations, and the Political Culture of the Antebellum South Carolina Low Country*; and Grace, *Another Civil War: Labor, Capital, and the State in the Anthracite Regions of Pennsylvania, 1840–1868*. Like Bruce Hunt, Stephanie wrote an evaluation of her fellowship tenure and complained that, among other things, fellows lacked computer access. This was long before laptops became affordable to most graduate students.

The museum's fellowship program was highly regarded for music scholarship, and fellows utilized museum collections, Smithsonian Folklife sources, and the resources of the Library of Congress. After I had retired, I introduced Charles Hughes for his museum colloquium on the music triangle of Nashville, Muscle Shoals, and Memphis and to provide context read from an *American Quarterly* review of books by two former fellows, Karl Hagstrom Miller's 2010 *Segregating Sound: Inventing Folk and Pop Music in the Age of Jim Crow* and David Suisman's 2009 *Selling Sounds: The Commercial Revolution in American Music*, and mentioned former fellow Ronald M. Radano's *New Musical Figurations: Anthony Braxton's Cultural Critique* (1993). I accurately predicted success for Charles's 2015 book, *Country Soul: Making Music and Making Race in the American South*, advertised side by side with former fellow David Gilbert's *The Product of Our Souls: Ragtime, Race, and the Birth of the Manhattan Musical Marketplace* (2015). The list continues with John W. Troutman, *Indian Blues: American Indians and the Politics of Music, 1879–1934* (2009), and *Kika Kila: How the Hawaiian Steel Guitar Changed the Sound of Modern Music* (2016) and Mark Allan Jackson, *Prophet Singer: The Voice and Vision of Woody Guthrie* (2007). John Troutman later became a curator in the museum's division of music. I had hardly any role in advising these music scholars, but I listened to and encouraged them and realized that the museum played a major role in encouraging important music scholarship. Charles Hughes and David Gilbert wrote and recorded a song about my exile in Knoxville and performed it at a Broken Heart Ball, my annual Valentine party.

As if "Scholars Not Scum" were not bad enough, on October 10, 2002, the Castle, that is, Smithsonian secretary Lawrence Small, sent out a disturbing memo threatening the fellowship program for 2003, insisting that the economic downturn after 9/11, fewer tourists, and less purchases in the shops forced curtailment of the program. During the 1980s, the fellowship program was funded at $1.8 million and in its peak year received 520 applications. In 2003, the program was not funded, a decision that eliminated a substantial slice of the Institution's intellectual power, and, to my mind, represented a frontal attack on scholarship. In 2004, there were only some 300 applications and a budget of $750,000, but the program gradually regained strength. Given my close relationship with fellows, it was especially galling to witness an invaluable program nearly zeroed out because it had no visible contribution to the bottom line. Lawrence Small had no idea of how to measure scholarship, so he eliminated it.[9]

As I sat on Smithsonian-wide committees, I met curators and scholars from other museums, and our conversations sometimes turned to photography. The book that Ray Smock and I did on Frances Benjamin Johnston and my 1927 flood book, *Deep'n as It Come*, plus my research both in the Library of Congress and the National Archives, furnished a foundation to converse with scholars who were educated to photography and American Studies. At the American Art Museum and the Portrait Gallery, I sometimes joined curators Virginia Mecklenburg and Merry Foresta and at times talked with Maren Stange, a fellow at the National Gallery, and with Mary Panzer, who was working on several Smithsonian projects and would later become the curator of photography at the Portrait Gallery. Our conversations often broached the well-known Farm Security Administration (FSA) collection at the Library of Congress, for Maren and Sally Stein had done extensive research in the collection. I recalled how US Department of Agriculture (USDA) photographs from the Depression Era portrayed idyllic rural life, a stark contrast with FSA images of hard luck and trouble. Government agencies often employed photographs as advertisements to trumpet accomplishments and burnish their image or to show problems that would justify additional funding. We were curious what photographs from other agencies might reveal, so Sally took on the National Youth Administration, Maren both the FSA and the Works Progress Administration (WPA), Merry the WPA Federal Art Project, and I analyzed USDA images. We proposed an exhibit and a book of essays heavy with photographs, and I became the quarterback and coordinated photograph

Official Images cover.

acquisition from the Library of Congress and the National Archives, worked with designer Jana Justin, and hectored my three colleagues for their essays. In 1987, these strong-minded friends and I produced an exhibit and a significant book of essays, *Official Images: New Deal Photography*.[10]

Jana Justin designed an exhibit space with red walls and enlarged black-and-white images organized around each agency. The exhibit and book were well received, not least because they included insights from American studies scholarship, photographic history, and art criticism, and because we explored government photography as agency propaganda. We were mortified at the poor quality of the book's photograph reproductions, and when a second printing was imminent, I wrote to Sally that I had warned the press "not to fuck up again." She later wrote, "I am sufficiently naive to believe that they share our concern and will make an effort to produce a well-printed book." The second printing was, in Sally's estimation, "a great improvement." This

was not the first time I had suffered from poor reproduction, for in *A Talent for Detail: The Photographs of Miss Frances Benjamin Johnston* (1974), which Ray Smock and I wrote, the published images had a nauseating green tint that the press approved.[11]

In 1988, the 150th anniversary of photography was fast approaching, but the museum had nothing scheduled. At a Smithsonian-wide planning meeting, the notoriously inept curator of photography complained that he had a book review coming due and would not have time to contribute anything. I looked at him with disgust, thinking, That's the kind of project I do of a weekend. On the other hand, it gave me license to make suggestions, and I quickly wrote to the head of exhibits that I wanted to do photography exhibits on the works of David Plowden, Debbie Caffery, and Smithsonian photographers who had accompanied Lu Ann Jones on her oral-history interviews. Since I was already in negotiations with Smithsonian Institution Press about a book of Debbie's work, I recommended an exhibit and book signing. The David Plowden and Debbie Caffery exhibits worked out, but the works of Smithsonian photographers sadly did not.[12]

My interest in Debbie Caffery's photography began in 1985, when I went to Marie Martin's Georgetown gallery for an exhibit opening featuring three Louisiana photographers. Several of Debbie's photographs taken during sugarcane-grinding season were haunting, in particular those taken at dawn or dusk and dominated by shadows and a chill of mystery. I proposed to collect some of her photographs of work during grinding season, and the collections committee approved six photographs, which I installed in the Agriculture Hall.

In October 1990, Debbie's *Carry Me Home* photography exhibit opened at the museum, and the book appeared with essays by Anne Tucker and me. When the designer at Smithsonian Press insisted on a cover photograph of a Black woman's hands on a bucket, both Debbie and I objected and demanded *Papa*, an eerie image of a man backlit at dawn in a burning cane field. In my essay, I had mentioned passages by George Washington Cable, a nineteenth-century Louisiana writer, and other southern authors suggesting the haunting and mysterious light in cane country. I protested that the press wanted the hands on the bucket image because it suggested familiar FSA imagery, but, I insisted, only Debbie Caffery could have created *Papa*. My argument was successful. When the Agriculture Hall closed two decades later, Debbie's photographs were transferred to the Division of Photography. By then Debbie had

Carry me Home cover, featuring Debbie Caffery's
photograph *Papa*.

shown in dozens of galleries, important museums collected her work, and she
was internationally recognized.

Several years later in mid-February 1993, John Wetenhall, a former fel-
low at the Smithsonian Art Museum and at the time curator of painting and
sculpture at the Birmingham Museum of Art, invited Debbie Caffery, Birney
Imes, and me for a panel on photography. Birney's book *Juke Joint* and photo-
graphs of rural life in the South had won substantial praise. He and Debbie
presented a gallery talk to docents and members of the photography guild's
board, we attended a reception, and then we had a panel discussion. I offered
my appraisal of their work and their focus on working-class southerners.
Afterward, we went to one of John's favorite pubs. Debbie was fooling with a
new camera when a man sitting nearby offered advice, and she handed him
the camera. He had no idea, of course, of Debbie's stature in photography or

that she had a general idea of how cameras work. She went along with his demonstration as we smiled and looked on.[13]

I had taught Birney when he was an undergraduate at the University of Tennessee. When in 1975 I was doing research, interviewing people, and copying photographs in the area flooded in 1927 by the Mississippi River, I visited Birney in Columbus, Mississippi, and he developed my film so I could check the negatives for focus and exposure.

My scholarship on agriculture prompted my colleague Terry Sharrer to invite me to a meeting in February 1984 with Maryland Agricultural Experiment Station executives at the Cosmos Club, a venue I avoided because of its elitism and failure to admit women. The Maryland group proposed an exhibit to celebrate the upcoming one hundredth anniversary of the Hatch Act that established federal agricultural experiment stations. Every state has at least one experiment station that conducts research aimed at helping farmers, mostly affluent farmers. After 1887, experiment stations expanded both in scope and budget and became adjuncts to agribusiness. The men from Maryland's station spoke enthusiastically of great achievements in agricultural science and technology and hinted at Congressional financial support. They ignored my questions about research benefiting wealthy farmers and instead wooed Terry, who was keen on a celebratory exhibit.[14] I thought of David Noble's warning about curators being lured into dubious projects.

With Roger Kennedy's blessing, the celebratory exhibit idea bypassed the exhibits committee and sidestepped other museum protocol, and in September 1984, experiment station directors throughout the country learned that a major Smithsonian exhibit was in the offing. The six-month exhibit plan, meanwhile, had evolved into "a permanent exhibit showing the contribution that science makes to agriculture and through agriculture to American well-being."[15] The exhibit would showcase the new and controversial field of genetic engineering and would be called The Search for Life. While I scoffed both at the presumptuous title and the boast that genetic engineering would perfect the world, Terry became enraptured, a convert and true believer. Experiment stations anted $25,000, and the Kellogg Foundation donated $1 million, allegedly to explore new exhibit concepts. Other scheduled exhibits were pushed aside to ensure The Search for Life would open in the summer of 1987.[16]

Roger Kennedy demanded that I join the exhibit team and when I refused confronted me in a tense meeting where I explained that I detested genetic

engineering based on what I had read, that I had done no scholarly research on it, and that in good conscience I could not join the project. Recalling David Noble's fate, I knew I was risking at most my job and at least future support as a curator. Kennedy could have fired me for insubordination. Still, I was angry knowing that he wanted to enlist not my knowledge about genetic engineering but my standing as a historian, for I had recently won two major history book prizes and completed *Standing at the Crossroads*. I refused to lend my name to this exhibit and somehow walked out of the meeting with both my job and my integrity intact.

In November 1987, *The Search for Life* opened and then quickly closed. In December it opened again. The innovative design could not contain blaring videos, the sound of which ended up bleeding together into a cacophonous warble, and its celebratory but confusing science was largely lost on visitors. It closed again, and, as I recall, was banished to Cold Spring Harbor Laboratory. The exhibit's exorbitant promises were not balanced by ethical questions about altering life, possible environmental dangers, commercial use of genetically engineered products, or patenting new life-forms.[17] Genetic engineering suggested that nature was not good enough, but I knew better.

While *The Search for Life* epitomized a flawed commemorative project, *A More Perfect Union* had opened on October 1, 1987, and was arguably the museum's best exhibit ever. The idea, as I recall, came from a conversation that Roger Kennedy had about the 442nd Regiment, which was composed of Japanese Americans who fought valiantly in Europe during World War II, while, of course, their families were interned behind barbed wire. Tom Crouch had recently come to the museum from the National Air and Space Museum, and as the exhibit's head curator traveled to the West Coast to collect objects and to interview former internees. Both Tom and Roger received death threats from ultra patriots who evidently did not want this chapter of US history to be exhibited. *A More Perfect Union* celebrated the two hundredth anniversary of the US Constitution and was a cautionary warning about a moment when it failed. Visitors approached a wall-size reproduction of the Constitution and at the entrance a TV monitor featuring reporter John Chancellor warned that this was not a celebratory exhibit. Many museum visitors learned for the first time that during World War II US citizens were rounded up and put in guarded camps. They saw a guard tower, a reconstructed room from a camp, many objects such as trunks and valuables, a section on the 442nd and its impressive war record, and poignant video inter-

views. Near the exhibit exit, video interviews with several people discussed internment. At the end of Senator Daniel Inouye's interview, he was asked if concentration camps could ever happen again in the US. He paused, reflected, and said, "Not to Japanese." His chilling and ambivalent reply accentuated the imperfect Constitution, vulnerable to human interpretation. The exhibit garnered high praise, and the public appreciated being exposed to an almost invisible chapter of history.

Concerned that exhibit ideas and funding increasingly came from outside, the Smithsonian conducted an internal study that analyzed donor pressure for exhibit credit such as logos and signage and for association with the Smithsonian brand. Curators suggested a statement that reflected the century-old Smithsonian policy of giving credit for support without offering an advertising opportunity. Had the Smithsonian protected its reputation and its integrity, it could easily have attracted donors to imaginative exhibits, but instead it increasingly allowed donor intrusion both in pushing exhibit ideas and in ad-like credit, prerogatives that sponsors never gave up.[18]

Congressional funding had never come without oversight, but museum directors seeking funding had usually approached the Hill with mature exhibit ideas generated by curators. Furthermore, Congress did not seek to profit from exhibits but only to make sure they did not appear un-American or embarrassing. Most corporate donors, on the other hand, sought not only to guide curators into celebratory themes but also to influence content. What corporation would have sponsored *A More Perfect Union*, an exhibit about internment? David Noble's warnings about pliant curators and subtle corporate meddling seemed ever more prescient.

3

An Exemplary Division

Mostly you just do what you're good at, even if the people
you're doing it for are no good themselves.
—PHILIP KERR, *Prussian Blue*

O n February 19, 1985, Art Molella appointed me head of the Division of Extractive Industries to replace the recently retired John Schlebecker. The division included curator Terry Sharrer, museum specialists Nanci Edwards and Francis Gadson, and secretary Marjorie Berry, plus storage room 5028, part of basement room CB 064, and thousands of objects offsite at the Silver Hill storage facility. It didn't take long for me to ask for a name change, and, after discussions with the division staff, we settled on the Division of Agriculture and Natural Resources, and we became one of the most active and arguably the most ambitious division in the museum.[1]

By this time, Terry Sharrer was following his interest in genetic engineering and courting the medical history division. Seriously overqualified for her secretarial position, Margie, in addition to her other duties, labeled and dry-mounted the division's vast collection of agricultural photographs. Nanci Edwards's energy and competence put our collections in good order, while Francis Gadson continued his specialist work in storage room 5028 and employed his institutional memory to good effect. Lu Ann Jones was launching her Oral History of Southern Agriculture, and I had no idea then that I would work with Lu Ann for years on her oral history project, advise her as a predoctoral fellow, and follow her career from university teaching to the National Park Service.[2] The cover of her book *Mama Learned Us to Work: Farm Women in the New South* (2002) featured Smithsonian photographer Eric Long's image of Mrs. Lurline Stokes Murray, a South Carolina farmwoman, in her farmyard amid her flock of chickens. Lu Ann's book explored the hopes,

dreams, and immense resourcefulness of southern rural men and women in the first half of the twentieth century. Larry Jones, restless and underutilized in the division of conservation, moved to our division, where he focused on collecting farm machinery. In addition, numerous interns buzzed around the offices, working on exhibits and other projects. I usually introduced interns to the Library of Congress and the National Archives, and they quickly became adept at research.

Collecting continued to be a high priority, and Larry scouted the land for likely acquisitions. In early June 1988, Larry, photographer Eric Long, and I traveled to Illinois to transport a Rumely Oil Pull 20-40 tractor to Ronnie Miller's farm sixty miles away for restoration. The machine had sat idle for years, and Larry and his volunteer crew tried in vain to crank it, provoking only coughs and wheezes, so they muscled it onto a flatbed. Ronnie owned an Advance Rumely threshing machine that, surprisingly, years earlier had been belted to the same Rumely Oil Pull tractor we were collecting, and he donated the thresher to the museum.

In the summer of 1991, the restored Rumely Oil Pull tractor and the Advance Rumely threshing machine arrived in Washington and performed at the Folk Festival on the Mall. Larry coordinated delivery of the machines and also contacted an Amish farmer in southern Maryland who generously furnished oats that he cut with a binder in return for our threshing them. Photographer Eric Long captured images of the farmer at work and carefully avoided showing his face, for Amish prefer not to call attention to themselves. John Paulson from Smithsonian Productions shot video of the operation, and our staff and interns pitched in to help shock the oats.

Threshing on the Mall was a big hit, and weatherman Willard Scott appeared and enthusiastically cheered our threshing effort as he gave his report. Festival visitors asked questions of the farmers operating the threshing machine and eagerly waited for us to crank the Oil Pull. J. Sanford Rikoon, who had written *Threshing in the Midwest, 1820–1940: A Study of Traditional Culture and Technological Change*, talked with visitors about how threshing rings operated. Needless to say, this demonstration was extremely important in increasing and diffusing knowledge, as the Smithsonian motto urged. It also combined collecting, documentation, restoration, logistics, obtaining oats, and coordinating the arrival of machines, oats, and farmers who operated the machinery. Larry handled all of these elements with his usual competence and good humor.

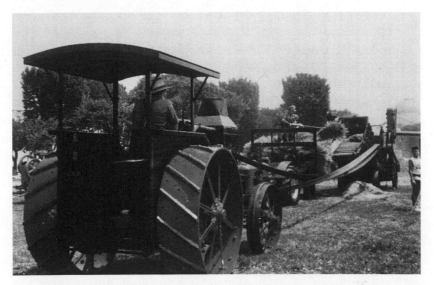

Rumely Oil Pull 20-40 tractor belted to the Advance Rumely thresher, National Mall, 1991. *Smithsonian Institution.*

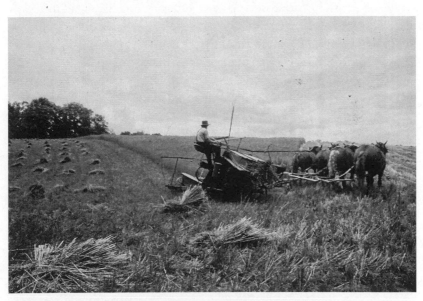

Amish farmer cutting oats, southern Maryland, 1991. *Eric Long. Smithsonian Institution.*

On another research and collecting trip in June 1989, I visited the Hopson Plantation, near Clarksdale, Mississippi, in search of documentation on the International Harvester mechanical cotton picker developed there during World War II. Hank Garrett, an heir to the plantation, gave me a tour and discussed its history. James Butler, who ran the Hopson Antique Mall, found a weigh-up scale and a picking sack inscribed with the picker's name, Annie Casey. Evidently no documentation survived at the Hopson Plantation of the International Harvester project.

In early April 1986, Robert Vogel, an energetic and versatile curator who specialized in machinery, asked me to accompany him to Puerto Rico to look at some rural Conservation Trust properties. On the way to the coffee plantation near Ponce, Robert saw smoke billowing from a sugar mill and insisted we take a tour, and we followed the process from grinding cane to the bagged sugar at the other end. At the coffee plantation, there were two mills, one with an overshot wheel and the other with a turbine, an unusual arrangement. After two days of meetings, we visited Esperanza, a sugar plantation near the coast. A huge steam engine had been taken apart for study and restoration, and Robert Vogel vigorously analyzed the innards.

While the visit to Puerto Rico was extraordinary, interacting with employees in other Smithsonian museums continued to provoke exciting conversations and projects. In October 1988, Lois Fink at the Smithsonian American Art Museum invited Larry Jones and me to analyze paintings for "agricultural and mechanical" content. When a slide of a painting by a realist artist was put on the screen, Larry darkly commented, "There's a lot wrong with this one." The pulley was on the wrong side of the tractor, the tractor was too small to drive the thresher, and thresher parts were misplaced. Larry observed in another painting that the wrong type horses were hitched to a hay wagon, trotters rather than draft horses. The art staff was intrigued by these and other examples of artistic license and fascinated with Larry's incisive analysis.

Lu Ann Jones, meanwhile, managed her Oral History of Southern Agriculture project and roamed the South interviewing farmers and then returning to debrief, transcribe interviews, and plan a new tour. Smithsonian photographers sometimes accompanied Lu Ann, amassing a body of images that complemented her interviews. In autumn 1991, she completed her Oral History of Southern Agriculture, having interviewed some two hundred southern farm men and women, and all of these life history interviews were transcribed. The interviews and thousands of contextual images by Smithsonian

Lu Ann Jones interviewing Charlie Bailey, 1987.
Laurie Minor Penland. Smithsonian Institution.

photographers embody one of the most significant documentary projects of the decade. Lu Ann earned a notable reputation at the museum, not only for conducting the interviews but also for her speed and accuracy at transcribing them. She also collaborated with textile curator Sunnai Park on an exhibit featuring feed sack clothing. After completing the project, Lu Ann departed to pursue a PhD at the University of North Carolina.

During my workdays, I spent as much time with Larry Jones, other specialists, photographers, and the Skull Crew as I did with curators. The Skull Crew, a half dozen African Americans, most Vietnam veterans, rigged large museum objects and also hefted file cabinets, bookcases, and office furniture as staff was moved here and there, an occasion that became far too common. These men were highly respected not only for their skill and hard work but also for their demeanor and good humor. They worked out of basement offices and each holiday season hosted a major party with food, music, and beer. The Division of Agriculture and Natural Resources also hosted a party at our end of the fifth floor hall with beer (and hard liquor and sometimes moonshine in my office) and food. In those years the staff had vitality and enjoyed the

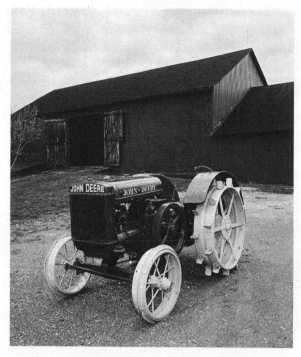

Poster photograph of the John Deere D tractor.
Original in color. Jeff Tinsley. Smithsonian Institution.

events that brought everyone together. Over the years as the core Skull Crew retired, the museum became spiritually poorer.

Larry conceived the brilliant idea of photographing some tractors in our collection and selling posters to raise money for special division projects. In the spring of 1986, the Skull Crew moved the John Deere D tractor from the Agriculture Hall, loaded it on a truck, and the Skull Crew's Steve Jones traveled with Larry, photographer Jeff Tinsley, and me to Bill and Jeannie Tucker's farm near Davidsonville, Maryland. Jeff decided to place the tractor downhill from an impressive red barn and pose the barn as background, but our truck got stuck in mud before we could unload the tractor. Jeannie Tucker cranked her tractor and pulled the truck out of the muck. Jeff then decided to pose the tractor nearer the barn, and, as photographers are wont to do, fretted for an hour or so setting up. It was a cloudy but bright day that turned out perfect for the photograph. Later we photographed the Waterloo Boy tractor.

The production of the Deere poster got tangled in museum red tape and poor decisions by the designer, and although we delivered a transparency to the department of public programs in April, it was August before the poster was completed and October before advertising brochures were available. Only then did we discover that the public programs division would take two-thirds of the poster revenue despite having done relatively nothing and done it slowly. I wrote a memo to Roger Kennedy complaining that our one-third fraction was punitive and would discourage divisions from engaging in creative projects. This decision dampened our enthusiasm for more posters, but both the John Deere D and Waterloo Boy posters sold well in the shops and through mail order.[3]

With funds from poster sales, in late September 1988 we organized a research and collecting trip to Danville, Virginia, for staff and interns to witness a tobacco auction, tour a tobacco museum, and visit a former tobacco farm. At the farm, we collected some feed bags and household objects, financial records, and clothing from an abandoned sharecropper house. It was a time warp seeing calendars on the wall from several decades earlier, photographs, letters, two old TVs, three radios, clothing hanging in the bedroom, pots, pans, a cook stove, and other elements of rural living. It was a peek at a rapidly vanishing world. We returned to Washington with a wealth of objects. Had our tractor poster project continued, the division could have sponsored more such trips.

In April 1991, curatorial affairs head Lonnie Bunch, curator Carlene Stevens, and I visited the offices of the *New Yorker* to collect objects before the magazine moved across the street from offices it had occupied since 1931. We met vice president Ginger Jesperson and managing editor Martha Kaplan at the Algonquin Hotel, and it was not lost on us that this was where the *New Yorker* staff had hung out in its early years. I was a devoted reader of the magazine and was thrilled to meet Roger Angell (though not as much as Lonnie Bunch, who engaged Angell in baseball lore), amused at the disorder in Brendan Gill's office, and tickled at the prospect of acquiring the day bed in Calvin Trillin's office. The offices, I wrote to former museum fellow Bruce Hunt, were "old, battered, [and had] poor wiring, wrecked old royal uprights, ledgers out of Scrooge and Bob Cratchit, day beds in offices, books and manuscripts piled to the ceiling, and general disarray, in a word, the antithesis of the slick, aloof magazine that issues forth from the premises." The offices hummed with activity, especially the make-up room awash in paper cuttings

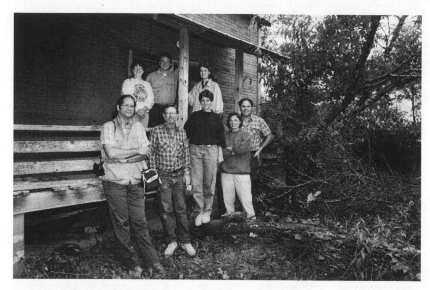

In front of the sharecropper house, near Danville, Virginia. *Back row:* unidentified intern, Louis Hutchins, Margaret McKinnon. *Front row:* Eric Long, Author, Nanci Edwards, Lu Ann Jones, Larry Jones. *Eric Long. Smithsonian Institution.*

as the staff composed pages. The magazine was in the process of moving to computerized composing, and some staff sat at terminals with coaches teaching them the new system.

Martha was gracious in showing us the *New Yorker* operation, and when we entered her office, I noticed on the windowsill an Elvis Presley radio, just like the one Bruce Hunt owned and had displayed to fellows. I asked Martha if I could look at the radio, and then asked if she knew Elvis's secret. She gave me a quizzical frown. Then I rolled up a pant leg showing black cloth and, as Bruce had joked, told her that Elvis was black from the waist down. Martha did not know whether to laugh or scream, but she laughed. Lonnie Bunch explained to the magazine staff how the objects we were collecting might be used, and I warned, correctly as it turned out, that paltry funding—not to mention lack of vision and fecklessness—might prevent an exhibit. The objects we collected from the *New Yorker* remain in offsite storage. Several weeks later, the Talk of the Town column quoted Lonnie that I was "the most literate man in the museum." I never argued with Lonnie's inflated evaluation.[4]

I drove to Orlando in 1993 for the Southern Historical Convention and then up to Dixie, Georgia, to follow up on correspondence with Nancy Stipe that had involved collecting a cotton basket. Several of her postcards featured intriguing photographs, taken, we learned, by her deceased husband, John Wesley Stipe, who left behind not only six children but also an old freezer full of photographs and newspaper clippings. Nancy said that no one had looked at the photographs since they were put away after her husband died. She and her children registered intense emotion as we looked at the prints, negatives, contact sheets, newspaper articles featuring his photographs, and material from his World War II military assignment as a photographer. I successfully recommended to the collections committee that we accession this significant material.

In June 1997, years after the John Wesley Stipe collection arrived at the museum, I requested $5,000 from the collections committee for supplies to continue processing the material. Committee members visited our fifth-floor storage room to examine Nancy Stipe's annotations and assess the ongoing digital inventory. Only she knew the people in the photographs, her husband's assignments, and the context of his work, and she had sent us remarkably detailed descriptions. I had patiently answered the committee's often inane questions about the collection, queries that I knew would never have arisen had John Wesley Stipe been from New York rather than Dixie, Georgia. On June 18, the head of the committee told me it could not fund work for "processing" but only for acquisition, ignoring that it had earlier funded $5,000 for processing. I was outraged and showed it, and the head of the committee blanched and started recommending other funds to draw on as I fumed and stalked away. Skipper StipeMaas, one of Nancy's daughters, worked closely with me on the project, and I called Skipper, for Nancy Stipe had no telephone or automobile at this time.

In addition to museum work, I remained tightly connected to the academic history community and wrote recommendations for fellows, reviewed manuscripts for journals and book manuscripts for presses, gave numerous lectures across the country, and corresponded with scholars about southern history. In 1987 I was elected to the Organization of American Historians' executive board, and the first meeting was tense and contentious. It would not be the last time I sat through harrowing OAH board meetings.

In July 1990, I gave a talk to the Arkansas Humanities Council, and afterward adjourned to a bar with a group including Barbara Taylor, who worked in the

Nancy Stipe.
Author photo.

University of Arkansas's human relations office. She asked if Oxford University Press intended a second printing of my 1977 book, *Deep'n as it Come: The 1927 Mississippi River Flood*, and indicated that the University of Arkansas Press was interested. Oxford demurred, so the University of Arkansas Press brought out a handsome paperback edition of *Deep'n*.[5] Sales increase, I'm told, every time the river rises or a hurricane causes mischief along the Gulf or threatens New Orleans. I joke that climate change might make me a millionaire.

In addition to the flood book being republished by the University of Arkansas Press, the University of Illinois brought out a new edition of *The Shadow of Slavery*, originally published in 1972. I wrote an updated introduction and included the most recent Supreme Court case plus a startling case from Nash County, North Carolina, where I grew up. Much later I worked

with Randy Boehm at University Publications of America on a microfilm edition of peonage files located at the National Archives that I had used in the book. Randy did a remarkable search through the Justice Department peonage files, wrote a finding aid, and I wrote an introductory statement.

Curators routinely subjected themselves to peer review, and the Professional Accomplishment Evaluation Committee (PAEC) evaluated curators and reported its results to the director. While I had many productive colleagues, some curators presented lists of insignificant achievements, an elaborate form of vita inflation. I headed PAEC for several years and was hard-assed on such nonsense, and with the committee's guidance I wrote frank letters to the director assessing curatorial work or the lack thereof. I doubt it made any difference.

When I informed Roger Kennedy that I was resigning from the PAEC committee because of all my other commitments, in so many words Roger told me that historical organizations were full of busybodies and were unimportant. I responded that, after all, this was a history museum and should engage with historians and their organizations to learn of significant scholarship that might fuel imaginative exhibits. I was disappointed that Roger questioned both the utility of historians as well as the PAEC's importance.

No matter what Roger Kennedy thought of historians and their organizations, I took an active role at the OAH convention held in Washington in the spring of 1990, spending a day and a half in executive board meetings, then interviewing candidates for OAH executive secretary, and participating on the program. I commented on a three-paper session dealing with a peonage case in Sunnyside, Arkansas, across the Mississippi River from Greenville, Mississippi. Ernesto R. Milani traced the immigrants' path from Italy to the United States, revealing how labor agents used debt to coerce them. Randy Boehm described the investigative work of Mary Grace Quackenbos, a New York attorney who was the first woman assistant US attorney and who pursued peonage with alacrity in Florida, Mississippi, and New York.

Bertram Wyatt-Brown, a senior scholar who had done remarkable work on southern honor and the Percy family, described former US senator LeRoy Percy's role in the case. Percy had shamelessly attempted to distract Quackenbos from her investigation by offering his carriage and putting forth his practiced southern charm. It didn't work. She brought charges against his Sunnyside partner. In my commentary, I questioned Wyatt-Brown's defense of what I considered Percy's indefensible actions, and I believe that he never forgave my biting remarks. The session survived the convention because Jeannie Whayne, a

former museum fellow and editor of the *Arkansas Historical Quarterly*, published the papers and my comment in the journal and later expanded the essays into a book, *Shadows over Sunnyside: An Arkansas Plantation in Transition, 1830–1945*, including a brilliant contextualizing essay by Willard Gatewood.

At the OAH convention in April 1994, I presented "Rhythms of the Land," my presidential address for the Agricultural History Society, incorporating interviews with musicians we had conducted for the slowly developing *Rock 'n' Soul* exhibit. As president, I was hoping to attract new members to the society, and several friends helped me smuggle beer and bourbon up to my room (no way we could afford hotel prices for alcohol or a banquet room), and the society held its first outlaw cocktail party. The society diversified and grew and now holds impressive annual conferences, attracts international scholars, and continues to publish a superb journal.

In September 1993, the Mississippi State History Museum in Jackson, facing a protest that its exhibit on cotton gins did not contain enough material on the contribution of slaves, invited me to give the featured lecture. US Secretary of Agriculture Mike Espy, a Mississippian and the scheduled speaker, canceled at the last minute. The talk went well, but downstairs at the exhibit a small group protested before TV news cameras. Museum director Donna Dye had warned me of a possible protest, and as much as said that when Espy canceled she asked me to talk because the Smithsonian connection lent the museum some cover from criticism. Well, maybe.[6]

In early November 1993, I left on a trip that included the Southern Historical Association convention and collecting. Just south of Chattanooga, my attention snapped left to a car turning directly into me. I nearly stood my car on its head as the errant car swept by my front bumper and crossed three lanes, barely making an exit ramp and bringing a large smile to the hefty woman driver. I safely drove on to Starkville to do research at Mississippi State University.

As I searched the Hodding Carter Papers, an undergraduate student sat down across from me, opened a folder, and started mumbling. I was annoyed until I realized that he was reading something about an atomic explosion in Mississippi. Since I was deep into the *Science in American Life* exhibit, part of which included nuclear testing, I humbly asked the student if I could see the folder when he finished. Sure enough, there were two underground tests in Mississippi, the first on October 22, 1964, shortly after Freedom Summer, and the second on December 3, 1966. The purpose of the blasts was to deter-

mine whether an explosion set off in a large underground chamber might go undetected. The first test shook the ground all the way to Hattiesburg, some twenty miles away, damaged some of the nearby homes, and left a large cavity two thousand feet down in the Tatum salt dome. The chamber remained hot and radioactive for months before it could be opened for samples and evaluation. Radiation lingered around the site for years, although the Atomic Energy Commission proclaimed it benign. *Science in American Life* would not only teach me about environmental issues but also provide a primer on official denials.

On May 4, 1991, I returned to Wake Forest University for David Smiley's retirement dinner and to pay respects to the man who ignited my interest in history and liberated me from southern mythology. In my remarks, I mentioned his unique teaching style, his sage advice on writing historical essays, and his book *Lion of Whitehall: The Life of Cassius M. Clay* (1962). Smiley, as he was fondly called by students, grew up in Clarksdale, Mississippi, was a World War II veteran, and had studied at the University of Wisconsin under William B. Hesseltine. In addition to his other eccentricities, he picked up stray paper around campus, reprimanded students who walked across the grass lawn (forbidden at the time), and outraged Old and New South partisans, stampeding their herds of sacred cows. His lectures bristled with wit, puns, trivia, word games, and interpretations that drove skeptics to the library. Cultivating fallow brains, such as mine, was his specialty. I was extremely fortunate to take his courses and discover the delight of challenging conventional wisdom.

I struck up a conversation with the man seated next to me and mentioned to him an incident in chapel during our undergraduate years. In those days, Wake required chapel attendance twice a week, one religious, one secular. The speaker at this particular religious chapel was a veteran of the foreign mission fields, distinguished and venerable. Over the chapel stage is a domed ceiling covering the pulpit, choir loft, and seats for dignitaries. As the speaker began his message, an extremely large white bra fell from one of the overhead lights and dangled by a thread directly over his head. There was a gasp from students, shock and dread from dignitaries as they glanced up, and then an explosion of laughter from the student body. The speaker was confounded, for he had not looked above to see not an angel but a white bra dancing above his head. He was quickly ushered offstage. As I smiled in remembrance of this moment and commented that it was a perfect crime and that the genius that

staged it was never caught, my dinner companion not only admitted guilt but also explained exactly how he rigged a clock to time the bra's fall.

On December 27, 2004, David Smiley died, and I wrote an obituary in the *Journal of Southern History* and attended a ceremony in his honor at Wake. I considered myself one of his least promising students, yet by 2004 I had written five books and curated a half dozen exhibits. I have often wondered what would have become of me had not I encountered David Smiley.

4

Lectures

But one must not stop telling people the truth; and the
shocking and appalling things one observes must under
no circumstances be suppressed or even doctored.
—THOMAS BERNHARD, *Gathering Evidence*

As if collecting, research, writing, exhibits, and routine work were not enough, speaking invitations arrived from abroad, as my scholarship on the rural South attracted international interest. I had spent three summers in Berlin in the early 1970s, teaching for the University of Maryland's University College, and made friends not only with soldiers and other professors but also with Berliners. Renate Semler, at the time working on her MA at the Free University, became a close and enduring friend. By the 1980s, she was organizing seminars for Amerika Haus Berlin and in 1986 asked me to participate in a weeklong seminar on the US South at Glienicke Castle, across the river from Potsdam. I met with an impressive group of German schoolteachers, and because administrators, teachers, and guest lecturers resided in the castle, we had the opportunity to chat informally, dine together, and discuss issues into the night.[1]

The temperatures in late April hovered in the mid-70s, with soft Berlin clouds puffing by, the perfect setting for discussing history and long walks around the Castle grounds. Nikki Floess, Inge Schulze-Reckzeh, and Max Preisler would become friends and correspondents. Inge later wrote an eyewitness description of the celebration as the Berlin Wall opened. Max, who later left teaching to produce radio features, occasionally visited the US as he gathered material for his programs on American culture, especially music. Years later he brought me a piece of the Berlin Wall.

A familiar pose at the seminar.
Photographer unknown.

During the seminar, Chernobyl exploded on April 26, and Berlin was downwind. The radioactive cloud would follow me from Berlin to Munich and on to Monaco. In Munich I visited former museum fellow Hartmut Keil, and we drove around the Bavarian countryside where, because of fallout, no cattle grazed outside, nor were fresh vegetables offered in markets. Since the Soviets furnished practically no information, the rest of Europe was left to calculate danger.

My trip's finale was the Formula 1 race in Monaco, an event I had fantasized about since 1970, when I saw my first Formula 1 race at Hockenheim, Germany. I found a room in Nice and trained over to Monaco for time trials. My seat for qualifying was across from the harbor where I looked down on the track and to boats docked trackside, and the harbor filled with yachts.

On race day, I sat in the grandstand at the exit of Lowes Tunnel, where the cars exploded from the tunnel, braked, and turned left then right before speeding around the harbor.

After the race, I wandered by the Lowes Hotel and examined an amazing collection of exotic cars; then I aimlessly strolled through casino square

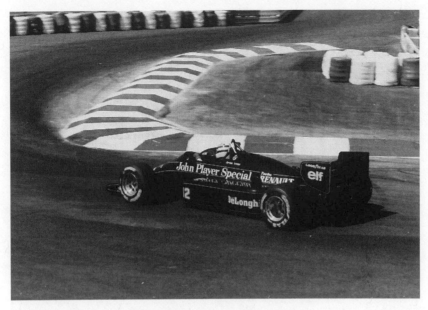

Ayrton Senna at Lowes Tunnel exit.
Author photo.

and headed downhill along what had earlier been the racetrack. My eye was
drawn to a crowd of people watching a man mooning while balancing on a
rolling set of shrink-wrapped tires earlier used as track buffers.

As I walked into the crowd, someone handed me a beer. I had happened
onto Rosie's Bar, a haven for English speakers, primarily Brits and residents of
the former British Empire. Inside, the walls were filled with everything from
Elvis Presley license plates to less precious objects. I barely made the last train
to Nice that night, and the next day I flew home.

As I worked on the *Science in American Life* exhibit, I was warily look-
ing ahead to the prestigious Commonwealth Fund Lecture at University
College London scheduled for February 1992. I had been invited the year
before by historians Melvyn Stokes and Rick Halpern, and realized, of course,
that warmed-over material from former publications would not be accept-
able, but after *Breaking the Land* and *Standing at the Crossroads*, the well
was dry. What might I develop that would stand up to previous lectures by
C. Vann Woodward, Kenneth M. Stampp, John Hope Franklin, and Eugene
Genovese? Anthony Badger, who had recently been elected to the Paul Mellon

Outside Rosie's Bar.
Author photo.

Professorship of American History at Cambridge University, informed me
that post–Commonwealth Fund lecture tradition compelled me also to offer
a lecture at Cambridge. I had no idea what I might say in either place.

As I cast about for a topic, a friend returned some loaned notes from
Breaking the Land research, including a 170-page 1934 USDA legal study com-
piled by department liberals who were later fired. I reread the document,
which was thick with legalese and references to court cases. The study con-
cluded that sharecroppers had gained substantial legal rights from landlords
to control a share of the crop and thus should receive a portion of federal
agricultural adjustment payments. Some landlords had been stiffing share-
croppers and pocketing all federal payments, while others transformed
sharecroppers into wage laborers who had no claim on federal payments.
Significantly, landlords were using federal payments to mechanize and fur-
ther reduce their reliance on labor. Intrigued by the implications of the study,
I rushed to the Library of Congress Law Library and began reading cases,
state codes, and law review articles that suggested a major reinterpretation
of federal agricultural policy, in particular the enormous power New Deal

agricultural policies vested in county committees, invariably composed of wealthier white farmers. I spent most nights and weekends on this project and completed a draft that I circulated to lawyers and historians and got the final draft to London by January 20.[2]

My speaking tour had been expanded to include York, Durham, Newcastle, and Swansea. The Commonwealth Fund Lecture program involved a half dozen scholars discussing race and class in the US South. My lecture came after two papers and 5:30 tea on February 21 and took place in the Gustave Tuck Lecture Theatre, which featured tiers of wall-to-wall oak desks with church-pew-like benches. The lecture, "The Collapse of an Agrarian Society in the American South, 1930–1970," was well received, and after a formal reception we adjourned for dinner and then to a pub. The next morning two commentators critiqued my talk, and after I responded the audience had at me for three hours as I parried questions, some profound, some not. That afternoon other scholars presented their papers, and after tea I eagerly escaped to Cambridge. Two years later the essay, now titled "The Legal Basis of Agrarian Capitalism: The South since 1933," commentaries, and other talks appeared in *Race and Class in the American South since 1890*, edited by Stokes and Halpern.

I immediately fell in love with Cambridge. Tony Badger situated me in the senior guest room, and I ate at high table. Tony and I had published on the flue-cured tobacco culture and had corresponded for years, but I only met him in person on this trip. I had begun serious work on the 1950s, and my talks on this tour were titled, "Beyond Sharecropping: The South's Search for Identity in the 1950s." One evening Tony invited the novelist Richard Powers, a MacArthur Fellow who had recently published *The Goldbug Variations*, to join us for dinner, provoking me to read that book and his subsequent works as they appeared.

From Cambridge I moved on to York, Durham, Newcastle, and Swansea. It was a delightful, if exhausting, tour through a slice of UK academia. Brian Ward hosted me in Newcastle, and my lecture was held upstairs in Trent House Soul Bar. Students drew a pint and chatted a bit before I was introduced, then I gave the lecture, and students drew another pint before discussion. The pub seemed more conducive to scholarly discourse than many university classrooms. After my last lecture in Swansea, I was exhausted but managed to see Ariel Dorfman's *Death and the Maiden* in London before departing.

Five years later in November 1997, my friend and former PhD student Nan Woodruff and I traveled to Cambridge University to visit Sylvia Frey, the prestigious Pitt Professor and the first woman to hold that position. Nan and I were scheduled for lectures, and I offered ideas from the in-progress fifties book and got excellent feedback. I was also drafted to talk to a graduate seminar at King's College about museums and politics. I discussed how we fought for the scholarly integrity of *Science in American Life* and contrasted our work with Secretary I. Michael Heyman's undermining the proposed *Enola Gay* exhibit and his chilling announcement to abandon controversial exhibits. Then we adjourned to a red room for wine, and, as haughty dons glared down from their portraits, I engaged several professors on the merits of Don DeLillo's recent *Underworld* (which I was lugging around) and Thomas Pynchon's *Mason & Dixon*. It was an engaging conversation so lacking among museum colleagues back home.

Nan, Sylvia, and I attended a concert in the chapel of St. John's College, and the St. Catharine's Choir and orchestra performed Beethoven, Bach, and Mozart. We hosted a Thanksgiving feast for our UK friends, and I had brought bourbon from the US to fuel the pagan enterprise. From the luxurious Pitt House, we often took morning walks across pastures to a bakery several miles away, later went to shops in town, and occasionally to a pub. Nan discovered Monsoon, a hip clothing establishment, and won over the clerks with her southern accent and eccentricity. I bought a few Christmas presents for my daughters and sat down and read. At one point, Nan emerged from a dressing room trailing a clerk with an armful of clothes. As she passed, she nodded toward me and said to the clerk, "There's my rich husband. He'll buy me anything I want."[3]

In April 1992, Wang Siming wrote from China evidently thinking that because I was president of the Agricultural History Society, I was a very important, even powerful, historian. He invited me to Nanjing to meet with the faculty of the Nanjing Agricultural University and then give a lecture at a conference in Beijing.[4] After some rather sticky red tape, the trip to China materialized, and on November 28 Siming greeted me at the Shanghai airport. The next morning we walked around before boarding the train for Nanjing, and in a square near the station, merchants filled blankets with medicinal animal parts, including bear claws. Everywhere I looked, there were contrasts between the old and the new. Bicycles streamed along the streets even as a few Mercedeses and BMWs sped by, and donkeys, motorized

Sylvia and Nan in Nan's backyard
at State College. *Author photo.*

inventions that defied labeling, and bicycles piled eight feet high with goods shared the road. There was enormous energy.

Siming was a graduate student in the Institute of Agricultural History at the Nanjing Agricultural University, and I was a guest there for several days. On my first day, the history faculty hosted a luncheon banquet, and Siming translated the spirited conversation around the table. The food came out, and as the lazy Susan revolved I politely ate some of everything, but to my surprise more dishes appeared, then even more. By the time I left the table, my appreciation for such delicacies as tongue, eel, and jellyfish had led to discomfort, so, like a bloated lion, I took a nap. Siming and I rode a smoky bus downtown, and he escorted me on a tour of monuments and lectured me on history. I was taken aback by the number of bicycles, the hectic pace of commerce, and by the number of people who smoked. That evening we ate at

a downtown restaurant, and, after Siming sang a few karaoke tunes, he had a whispered conversation with the hostess. I followed him upstairs to what had formerly been the quarters of a prostitute, a very elaborate set of rooms that, I surmised, not everyone got to see.

Siming and I took an unheated train to Beijing and shared a compartment with a young man and woman. With Siming translating, we had a lively conversation. They were surprised at my frankness about US foreign policy and my willingness to hear their criticisms. In Beijing I spoke at a conference on China's rural development. Most foreigners, including those who worked for agribusiness concerns, stressed the wonders of machines and chemicals. At the time, Chinese agricultural leaders were debating whether to plunge further into modern agriculture and displace millions more farmers or continue traditional farming. I used the US South as a cautionary tale of what happens when people are forced to leave the land when agribusiness arrives. The Americans seemed upset that instead of embracing capital-intensive cultivation I had offered a cautionary tale of its consequences.

Siming and I stayed in a downtown hotel, one that was playing Christmas carols in the elevator, and he escorted me to museums, the Ming tombs, the Forbidden City (where an audio program narrated by Roger Moore explained the buildings' functions and history), the Great Wall, and to the Tongxian Zhangjiawan integrated farm-industry area outside Beijing. There we visited a small factory, surveyed large fields of growing grain, and visited a proud couple in a new garden apartment complex. My cautionary tale seemed a bit late.

During my visit to a farming district, the hosts organized a noon banquet, and local officials filled a dozen tables. The head of the district offered a toast to better relations between China and the United States. I lifted the small glass of what smelled like moonshine, took a sip, and was greeted with a chorus. "Gombay." Siming turned to me with the translation: "Bottoms up." Then there was another toast, and several more before I offered one. After a while I asked the location of the restroom, and as I stood several men also answered the call of nature and followed me. On the ride back to Beijing, Siming revealed that the men accompanying me had expected me to puke my guts out. I smiled and replied that I had trained all my life and would not let the US down.

I felt honored to be the guest of Chinese agricultural policy makers and escorted by Siming and other people steeped in agricultural history. One of

Toasting to better relations between China and the US. Siming is at the left.
Photographer unknown, Author's camera.

the highlights of the trip came at a Peking duck dinner with high-ranking agri-
cultural officials. A handsome man with noble bearing carefully instructed
me on the proper way to eat Peking duck.

I left Beijing with a nasty cold and cough and made my way back through
Tokyo and Chicago and on to Washington. Leaving Chicago's O'Hare on a
blindingly clear winter night, I stared at the blinking city, the dark lake, and
what seemed endless cords of light reaching south into the distance. "Coming
home was no picnic," I wrote to a friend. "Seeing the sun set both in Tokyo
and in Chicago really unwound my clock. I was so psyched that on the flight
I watched two films, did not sleep, was awake thirty hours, could not even
sleep but a few hours once home, and was a zombie for a week, waking up in
the middle of the night and getting up a few hours."[5]

In February 1993, Smithsonian Associates asked me give lectures on south-
ern history aboard the *Delta Queen* as it steamed from Pittsburgh to New
Orleans. This was my fourth trip aboard the *Delta Queen*, and being on the
river in 1993 seemed an ideal way to spend a week and a half in mid-May.
Historian Peggy Radford also gave lectures. Mine included southern music,

the Ohio River as the boundary between slavery and freedom, Sunnyside Plantation (based on the OAH session and book), the 1927 Mississippi River flood (from *Deep'n as it Come*), the transformation of southern agriculture (from *Breaking the Land*), and the civil rights movement.

The passengers aboard the *Delta Queen* were mostly older white Smithsonian Associates who were no doubt conversant with *Smithsonian Magazine* and its upbeat noncontroversial articles. Some were mired in celebratory US history, while others expected challenging lectures. After my first lecture, which included a discussion about the land north of the Ohio River that was won/taken from the American Indians, a large gentleman from Indiana confronted me, and I could tell at once that he was accustomed to lording over people. He boasted that he had forebears among those white settlers and that they were above reproach in their dealings with Indians. I was puzzled at what had set him off, for I had tuned the lectures for a nonacademic audience and certainly did not mean to stir controversy. Then the gentleman deplored the Smithsonian for getting into political correctness and snorted a few accusatory words about communism and socialism. I listened politely, but when he mentioned political correctness and communism, my redneck temper battled with my professional responsibility to stay cool, for I was outraged at this aggressively ignorant bully demeaning me as if he had studied history. When he paused for a breath, I defiantly looked him in the eye, moved closer, and threateningly said, "No, my lecture was not politically correct; it was historically correct." I stood there inviting more confrontation, but he dropped his eyes and walked away.

The term *politically correct* emerged in the 1980s and 1990s to ridicule historical scholarship that included African Americans, women, Hispanics, and other neglected groups and that contested demeaning terms of disrespect. Critics attacked the insistence on civility and weaponized it to bully liberal and leftist scholars who studied groups of Americans who bore the brunt of name-calling. The term assumed a damning weight that implied a leftist or radical view of history that opponents dismissed without analysis or apology. Many people desired to preserve their vocabulary of contempt, and many still do.

Among the passengers, a Georgia planter advertised that he was a well-traveled big game hunter and tossed the term *nigger* around freely. We had drinks one afternoon, and, of course, we disagreed politely on southern history and on social issues. That night I was sitting near the bar about midnight

with Bodine, a sleight-of-hand performer, and other friends. When we got up to walk outside, the Georgian, very drunk, intercepted me and started berating my lectures and what he interpreted as anti-southern bias. The bartender attempted to intervene, but the Georgian followed me to the bar, where I turned on him and said that we were not accomplishing anything with this conversation, that we each knew where the other stood, and that we could continue this conversation at another time. I really thought he was going to swing at me; he was that out of control.

The next day we went on an excursion to a small Ohio River town, and when we got back to the stage (gangplank), the Georgian murmured something, and I begged his pardon. Then he said, "Peace." He was not the only person who considered me anti-southern. American Indian removal, civil rights, and the transformation to capital-intensive agriculture and the dispossession of millions of farmers obviously did not fit triumphant history. I puzzled over why even minute departures from the celebratory canon caused such anguish, but I refused to parrot conventional wisdom and hoped to educate my shipmates with a more accurate history.

Still, it was a wonderful trip, for watching the river from the *Delta Queen* was special. I spent many hours standing at the stern, watching the paddlewheel churn the water, enjoying its soothing rhythm. We stopped at quaint river towns, a Kentucky horse farm, and in Cajun country ate crayfish and heard a Cajun band. I'm sure Smithsonian Associates put me on the *never invite again* list.

5

Science and Conflict

"And Men of Science," cries Dixon, "may be but the simple
Tools of others, with no more idea of what they are about,
than a Hammer knows of a House."
—THOMAS PYNCHON, *Mason and Dixon*

It was not history that judged, but the historian
who decides where the story ends.
—PRIYA SATIA, *Time's Monster*

T he cautionary examples of *Automation Madness* and David Noble's
firing and of the flawed *Search for Life* exhibit made clear the equal
dangers of alienating the director while advocating a controversial
topic and of evading museum procedures to mount a celebratory exhibit. Was
it possible anymore to produce an exhibit based on sound scholarship, abide
by museum rules, and at the same time please a financial backer? These ques-
tions became more crucial as Congressional funding evaporated and corpo-
rate sponsors insisted both on lavish credit and also on shaping the content of
exhibits. Across the Smithsonian, curators rallied to confront attacks on "revi-
sionism," and on July 31, 1991, five curators spoke at a Smithsonian History
Roundtable, "Beyond Criticism: Historical Revisionism in the Museum."
My talk, "Tell Our Story: Money and the Shaping of Exhibits," warned that
what was at stake was both curatorial integrity and the deterioration of the
Smithsonian's reputation. *Science in American Life* became a battleground of
these crucial issues.

In 1987 I curated *Pesticides on Trial*, one of three exhibit cases titled
"Science, Power, and Conflict." Given my overbooked schedule and steep
learning curve, I asked for a research assistant and surprisingly received fund-
ing to hire Louis Hutchins, whose wife, Nina Silber, was a museum fellow.

Louis was resourceful, brimming with good ideas, an aggressive researcher, and in large part curated *Pesticides on Trial: Miracle Chemicals or Environmental Scourge?*, which ran from May through August 1988. We also crafted an informative brochure to accompany the exhibit with a bibliography of suggested readings. Louis also discovered a cache of records at the National Archives documenting the fire-ant spray campaign of the late 1950s, something I knew nothing about but on which I would later write both an article and a book chapter.

We included photographs of DDT being sprayed in neighborhoods, immigrants being doused with insecticides at the US-Mexico border, pesticide containers, and labels that raised questions about toxicity. Even though the *Washington Post* had recently featured several stories on pesticide toxicity, chemical companies and pesticide defenders vilified our tiny exhibit. One critic wrote a four-page, single-spaced letter complaining of bias and accusing us of aiming to destroy the pesticide industry. The chemical industry's attacks on Rachel Carson's *Silent Spring* suggested we would receive criticism no matter how well we documented chemical toxicity.[1]

Because of this exhibit and Louis's research on pesticides, my scholarly interest expanded to include environmental issues. In 1989, for example, I gave a paper at an Agricultural History Society conference analyzing the USDA's reckless fire-ant spray campaign. The session's four papers divided evenly over whether or not USDA policy was benign and provoked lively debate. A prominent conference funder took belligerent exception to my paper, questioning both my evidence and conclusions. After taking a deep breath and calming down, I replied that my evidence came primarily from the USDA's Agricultural Research Service and from Congressional hearings and was solidly contextualized in secondary historical literature. The paper was published as "A Rogue Bureaucracy: The USDA Fire Ant Campaign of the Late 1950s" in the spring 1990 issue of *Agricultural History*.

The "Science, Power, and Conflict" cases rekindled interest in a science exhibit. The idea went back twenty years to when curator Barney Finn lauded the exhibit potential of the museum's significant science objects. His ideas lay dormant until 1989, when the American Chemical Society (ACS) committed funding for a major science exhibit. The ACS not surprisingly expected the exhibit to focus on heroic science, while curators insisted on including the history of what happened when science left the laboratory and entered society. This tension between scientists and historians prompted the museum to

Lu Ann Jones presenting Author with gifts from her interview
travels as Louis Hutchins looks on. *Smithsonian Institution.*

establish an advisory board composed half of scientists and half of historians
of science to meet regularly with curators and discuss exhibit development.[2]

The exhibit process called for teamwork, and in the spring of 1990, I joined
curators Linda Tucker, Larry Bird, and Patricia Gossel to curate *Science in
American Life*. We teamed with my four interns and head researcher Louis
Hutchins and swarmed the National Archives and Library of Congress look-
ing into the Manhattan Project, Hanford, plastics, pesticides, and nuclear
fallout. Our team was discovering a dark side of Cold War science that ignored
threats to health, and the trail led from the impressive Manhattan Project
through atomic destruction of two Japanese cities, to atomic and hydrogen
bomb tests, to an arms race, and Hanford's secret radiation release and leak-
ing storage tanks.

Our team was far along in script development when David Allison became
head curator and gratuitously presented us with an organizational chart fea-
turing him at the top. Then, he imperiously moved curatorial meetings from
my office to his and, ignoring our ideas and several years' research and plan-
ning, laid out his agenda, which was almost indistinguishable from that of
the ACS. David's authoritative style, mirthless demeanor, tiresome repetition

of scientific heroism, and sucking up to sponsors and administrators did not endear him to our team. David championed an uncritical view of science and not only attempted to undermine our work on social history, but also, we agreed, threatened the exhibit's integrity. By this time, the four of us were a tight team and aggressively protected our work, and we resented the intrusion of an omnipotent administrator.

There were tense team meetings, and I challenged David, sometimes with Art Molella serving as referee, for I was determined that David not erode our work. David was obsequious to those above him in the chain of command, but he was contemptuous to those of us he considered beneath him. Our team did not assume a genuflectory posture, and Linda Tucker and Pat Gossel were especially wrought with David's meddling and found it difficult to work with him. It wore me out, dealing with David, the advisory board, and the ACS.

As I drafted script for the Manhattan Project, the plutonium plant at Hanford, nuclear testing, the happy atom (atomic bubble gum, dreams of atomic cars, ships, and planes, etc.), a fallout shelter, an H-bomb casing hanging from the ceiling, and a section on the impact of Rachel Carson's *Silent Spring*, David wrote a seven-page critique that I judged condescending, judgmental, insulting, and opinionated, a shameless treatise of ACS arguments. I replied with a half page that impolitely told him to fuck off and then circulated his memo widely among curators so they could see for themselves his presumptuous and intrusive nonsense. Realizing that he could not bend the team to his desire, David met with Art Molella and suggested that if Art could not live with the tension that he should take over. We all breathed a sigh of relief as Art reluctantly took over as head curator and endured criticism from ACS leaders and other vocal critics that would have tried a saint's patience.[3]

The education component of the exhibit became another battlefront. Both our team and the ACS expected the exhibit to inspire interest in science, so it was important that interactive and hands-on stations introduce visitors, especially young people, to important and exciting scientific principles. The head of educational programs and her team visited Europe and substantial swaths of the United States searching for ideas on how to present science and concluded that some of the interactive innovations they saw were "neat." There was a lot of smoke from the educational team, but its ideas seldom kindled. Increasingly, I felt I was mired in a grim soap opera. At one meeting when the education leader had vacantly rambled on and on, I challenged everything she had said as irrelevant, if not inane. It had come to the point that, at every

meeting with the advisory board or the educational team, we were under fire for our ideas and script.

In September 1991, a group of physicists—not surprisingly the same group that the education leader had consulted—sent a letter requesting that we should balance our section on World War II by minimizing the Manhattan Project. This was a puzzling request given physicists' role in conceptualizing and building atomic bombs, but no doubt they wanted to end the exhibit narrative before the bombs dropped. The education head declared that the World War II and postwar section I curated was "too negative," two words I despise. The Manhattan Project, plutonium production at Hanford, the destruction of Nagasaki, nuclear testing, fallout, and pesticide residues epitomized a stream of history that incorporated heroic science and technology, as well as troubling political, environmental, and health issues. The focus on Enrico Fermi and a replica of the University of Chicago racquet court where the first pile went critical and the construction of Hanford and its plutonium production showed heroic science and engineering. The narrative did not end when enough plutonium was manufactured to make a bomb, for this project launched the atomic age. It is, after all, common knowledge that the United States dropped two atomic bombs on Japan, that afterward it staged tests both in the Pacific and in the US, and that there was an ensuing arms race with the Soviets. But we encountered criticism from the ACS, the advisory committee, and scientists for including that history.

Scientists were too willing to keep on their lab coats and ignore the impact of their work outside the laboratory. Fortunately, directors Roger Kennedy and later Spencer Crew defended us and preserved curatorial control of content. In a meeting with the advisory board, one of the scientists was distressed that we were including a fallout shelter that Smithsonian staff had recently dug up in Fort Wayne, Indiana. What did it have to do with science, he asked? I explained that it had a great deal to do with the implications of science: once the US and Soviets began a weapons race, people lived in the shadow of the bomb, and the fallout shelter was a telling example of how some people dealt with the threat of nuclear war.[4]

Part of my focus centered on radioactive fallout and pesticide residues, two invisible toxins that Rachel Carson so eloquently discussed in *Silent Spring*. We also had what I smilingly referred to as the "Carson Shrine," an alcove featuring a video of Carson discussing nature and the use of pesticides countered by Dr. Robert White-Stevens, a Strangelovian character who at the time was

Interior of the fallout shelter.
Author photo.

assistant director of agricultural research at American Cyanamid. Carson's *Silent Spring* and several of her other books were on display. We borrowed two pelican eggs from the National Museum of Natural History, one solid and healthy and the other collapsed, as the pelican's DDT intake weakened the egg.

Louis Hutchins returned from the National Archives one day excitedly telling me he had met Edmund Russell, a graduate student who was working on a history of DDT. When I met him shortly afterward, Ed explained his research agenda, and I realized that he would make an enormous contribution to the history of science and suggested he apply for a Smithsonian fellowship. He was successful and even as he continued his research and writing shared with us his understanding of toxic chemicals.

In advisory board meetings, scientists and historians closely questioned our ideas and script drafts and made invaluable suggestions, but the tension was often palpable. At a meeting in June 1991 at the ACS headquarters in downtown Washington, our team was beat up on all day. In an afternoon

session as I discussed the effect science exerted on society, the ACS chairman took vehement exception to my remarks on DDT and rudely suggested that our team lacked expertise. Our script on DDT, however, was informed by Ed Russell's pathbreaking research, and I confidently countered that DDT's development, success, and problems were accurately explained in the script and then hotly suggested that he read the script. He was taken aback and huffed with displeasure. The meeting was demoralizing, for I felt we could never heal the ideological disagreements, and because I had confronted the ACS president on a science question, I expected that he would pull the financial plug. Powerful ACS members were accustomed to having their way, and they considered curators insignificant and uninformed pests that they could swat away. Then, in September, Louis Hutchins left the team for a job in Boston and joined his wife, Nina Silber, who was teaching at Boston University. In September 1991, Sarah Heald joined the project.[5]

I had made contact with Paul Zimmer, an editor at the University of Iowa Press and a poet who as a young man was an atomic veteran, a dubious term awarded to soldiers who were in foxholes (too) near nuclear tests. Paul wrote a page-and-a-half description of his experience in a trench, including seeing the bones in his arm when the bomb exploded, the shock wave roaring over his foxhole, and then marching toward ground zero with the mushroom cloud filled with lightning and nightmarish colors rising above and blasted wildlife scattered across the landscape. He furnished a photograph of himself cockily posing with a mushroom cloud in the background on a day he was not in a foxhole. In addition to Zimmer's account and photograph, we also included a *Life* magazine photograph of kids in a school near the Nevada test site ducking in the schoolyard as a mushroom cloud rose fifteen miles beyond the schoolhouse. We learned that the Las Vegas casinos would become quiet early in the morning on test days as gamblers walked out to see the sky light up and a mushroom cloud rise in the distance.

Downwind from the test site, the mushroom clouds drifted over Utah, and substantial radioactive fallout descended on the area around Saint George. I included an Atomic Energy Commission (AEC) film featuring the town in a loop of 1950s shows, advertisements, and newsreels. The film began with a radio announcement advising residents there would be no danger from fallout from that day's test, although it warned them to stay inside until the all-clear. In fact, there were grave health threats as the descending cloud released radioactive fallout over the town and nearby countryside. The country's

nuclear manufacturing and assembling apparatus denied that escaping radio-active residues were harmful, but scholarship and memoirs trace a sad trail of illnesses.

I visited Hanford with fellow curator Paul Forman, esteemed curator of physics, and we received a warm welcome from the staff, who assured us that all of the (leaking) underground storage tanks and resting reactors were benign. A man who had operated one of the reactors during the war escorted us through the second reactor put in service, where we faced a huge and complex wall of pipes that circulated water to cool uranium as it matured into plutonium.

Whether at Hanford, Rocky Flats, Savannah River, or the Nevada, Mississippi, or Pacific test sites, downwind fallout and leaking radiation were the rule. My team was appalled at the recklessness of the nuclear enterprise, and the scientists on our advisory board were alarmed that we would include such material in the exhibit. This aversion to anything but a celebratory narrative would appear continually as the museum relied increasingly on corporate funding. The scientists on the advisory board became more and more contentious as we hammered out the final script. In December 1993 under ACS pressure, Art found it necessary to shorten the script of my section. We could only mention a fraction of the issues surrounding nuclear testing, but the topic could be avoided only at the cost of historical accuracy.

Meanwhile, researcher Sarah Heald departed, and Art assigned Smita Dutta to the project; she quickly got up to speed and became a confidant who brought fresh ideas and abundant energy. She went to Texas and secured a section of the never-to-be completed Superconducting Super Collider and then traveled to New Mexico to interview people who lived in the Albuquerque suburb Princess Jeanne; she also collected objects and interviewed residents, gathering information that documented the exhibit's suburban home. Before he departed, Louis Hutchins had done extensive research on the image of the perfect, weed-free lawn, and we agreed that the magazine ads resembled Astroturf, so that's what we used for the yard. To maintain such a pristine lawn that framed a suburban home, pesticides and herbicides were deemed imperative, not to mention mowers. In addition to a cabinet with DDT and other pesticides (and an educational video cartoon about pesticide use), we featured what was alleged to be the first Snapping Turtle lawnmower off the assembly line. The cutaway house allowed us to explain the ubiquitous use of plastic in homes and furnishings.

Perhaps the most surprising exhibit case examined B. F. Skinner's pigeon-guided missile project during World War II. He conditioned pigeons to peck at a photograph of a target so that in combat when the missile approached the target in real time their pecking at the target would control the fins keeping the missile aimed properly. We relied on a scholarly article on Skinner's project to ensure our label's accuracy, and our case contained the missile's nose cone.

We replicated the racquet court beneath the Chicago stadium where the first radioactive pile went critical with Enrico Fermi and other scientists standing on a balcony above the pile as an assistant pulled out the control rods initiating the reaction. Shortly before the exhibit opened a scientist who had worked with Fermi visited for a chat with curators. I accompanied him to the nearly completed exhibit so he could check the accuracy of our replication of the pile and view the video reenactment that Enrico Fermi and his staff performed some time later, including a segment on the construction of the pile. He smiled with excitement when he spotted himself placing graphite blocks on the pile. The video also explained through animation what went on inside the pile when it went critical as Fermi stood on the balcony with his slide rule. The successful test confirmed that plutonium could be produced industrially and that it could fuel a bomb. Fermi made calculations with his three-inch slide rule while a colleague used a twenty-four-inch slide rule, leading to the colleague's conclusion that one's brilliance was in inverse proportion to the length of one's slide rule.

We included some of the nagging historical questions about the decision to drop the bomb, postwar testing, fallout, downwind health problems, and radiation contamination at the primary production facilities. The lavishly restored control panel from the reactor that Paul and I viewed at Hanford assumed iconic status.

These segments epitomized heroic Big Science. We also featured photographs and video of Hanford construction, including work on the underground storage tanks for radioactive waste, and, of course, the T-shirts and jackets with the high school logo "Bombers." Art Molella had located a hydrogen bomb casing in New Mexico that we hung from the ceiling with its shadow playing on the floor, the shadow of the bomb for real.

As museum visitors turned from the Hanford section, they faced a wall-size photograph of the mushroom cloud rising above Nagasaki and smaller photographs of ground-level destruction. On the opposite wall were letters

Detail of the Hanford reactor control panel.
Author photo.

from prominent scientists arguing against using the bomb on human targets
and then a small section on nuclear testing.

Smita had contacted the attorney who represented the Bikini islanders
who were removed from their atoll to make way for Pacific nuclear tests.
She learned that divers were active in the Bikini lagoon and suspected that
we might obtain an object from one of the ships sunk in the 1946 Crossroads
test. I spoke with the divers on a radio hookup, and we obtained two objects:
the first disintegrated when exposed to air; the second, a radar dish from
the aircraft carrier USS *Saratoga*, made it into the exhibit. The Bikini Atoll
became uninhabitable. Our section on nuclear testing explored some of the
health issues arising from exposure during the tests.

After returning from a trip to China in December 1993, I tightened my
safety belt for the race to the April 26 opening of *Science in American Life*. Our
opening almost overlapped with the dispute boiling in early April over the
proposed *Enola Gay* exhibit at the National Air and Space Museum (NASM).

I thoroughly enjoyed the opening on April 26, a lavish black-tie party, and an after-party flowing with champagne. Too early the next morning the phone rang, and Art Molella asked if I had seen the *Washington Post* review. It was bad, he warned. Pointing to what he labeled political correctness, reporter Henry Allen objected to the exhibit introduction and display of a half dozen life-size cutouts of scientists (a man, woman, African American, white, Asian, and Jew), discussing their scientific work on video, and he scorned the scene of a science class at Hampton Institute at the turn of the twentieth century, seemingly put out that it was not at Harvard or Yale. He found too much emphasis on the environment, too much on pesticide toxicity, and took much of his spite out on Rachel Carson. Allen insinuated that we defrocked noble scientists and, instead of keeping them on a pedestal, snidely indulged in political correctness to demean them. "Upon my second reading last night," I wrote to former museum fellow Randy Finley, "I realized that this reviewer personified pure Iron-John WASPism, insecure among diversity, longing for the golden age of male domination, and only interested in undressing all his WASP prejudices before the reading public."[6]

For me it was over, but it was not for Art Molella, as criticism continued from the science community and from ACS. To reiterate, this exhibit had profited enormously from the advisory board of historians of science and scientists as well as formidable review by the ACS, but we maintained curatorial control of content and presentation, demonstrating that it was possible to tackle complex and even controversial topics. *Science in American Life* was a blueprint for balancing curatorial control and scholarly integrity while working with a powerful and involved donor.

Smithsonian secretary I. Michael Heyman turned on *Science in American Life* and used every opportunity to demean our curatorial team and the exhibit. "Well, I remember how sore I was when I went over to see *Science in American Life* when the American Physical Society sort of went mad, and including their Nobelists," he recalled in his oral history interview with historian Pam Henson in April 2001. Although he described the exhibit as "one-sided" and portrayed the curators as hopelessly naive and negative, he had never discussed the exhibit with us and ignored contributions of the advisory committee.[7] In September 1995, Heyman issued strict guidelines to curb curators from engaging in controversial exhibits, offering NASM's cancelled exhibit on the end of World War II as a cautionary tale. He insisted that the

Air and Space museum should serve as "a temple in which we show our very positive response to the brilliance and courage of Americans with regards to aviation and space." A *Washington Times* article observed approvingly that Smithsonian leaders "have returned the Smithsonian to the good graces of Republican kingpins."[8]

From my vantage as a curator of the science exhibit, Heyman's statements were outrageous, ludicrous, and tailored to please conservative critics. Since the 1850s, the Smithsonian had sometimes provoked controversy but for the most part had mounted conservative and attractive exhibits. Historical scholarship, like science and every other discipline, produced new insights and interpretations, and I was proud of how my historical writing had revised our understanding of the past. Since I had come of age as a historian during the civil rights movement and had worked with and associated with leftist historians, I applauded scholarship that challenged a celebratory view of the past. It seemed to me that Heyman and other critics opposed sharing history narratives about African Americans, women, American Indians, Hispanics, and working people because they might eclipse traditional history narratives. Attending to toxic pesticides, nuclear fallout, leaking Hanford storage tanks, and radiation experiments challenged the notion of white masculine invincibility. By prohibiting curators from mounting exhibits informed by creative and imaginative recent scholarship, Heyman threatened the very purpose of the Smithsonian, the increase and diffusion of knowledge, insisting on conventional wisdom packaged attractively, without challenging the celebratory narrative.

Bowing to pressure from the American Physical Society (APS), Heyman organized a dinner with physicists and all-day meetings that included curators. Our team faced six APS members, four of them on the APS Board and four former presidents. Their critique started with distaste for the title and expanded to the entire exhibit, although they did not identify errors of fact, leftist arguments, or examples of political correctness. Some liked the exhibit, and most were impressed with the level of research and complexity that went into the project.

In the few minutes I had to justify my part of the exhibit, I praised the interns and researchers who scoured the Library of Congress and the National Archives, explained my current research on the 1950s and '60s (some inspired by the *Science* exhibit), and chronicled the exacting research required to construct an accurate Chicago pile. I concluded with a story from novelist Harry

Crews' memoir, *A Childhood*, that challenged the perfect models in the Sears catalog who did not resemble most people he knew who "had something missing, a finger cut off, a toe split, an ear half-chewed away, an eye clouded with blindness from a glancing fence staple." Crews and his playmate devised stories that inserted flaws and portrayed catalog models involved in feuds and violence. Just as Harry Crews knew there was more to models than their bland presentation, I argued that, had we ignored the larger context of the times and not followed science into society, we would have produced the museum counterpart of the Sears catalog. I concluded by expressing pride in the exhibit and how it stirred people's curiosity.[9]

The group lunched in the staff dining room on the fifth floor, and I sat beside and chatted with Burton Richter, not only president of the APS but also director of the Stanford University Linear Accelerator and, I later learned, one among several Nobel laureates in the group of the six APS members. The physicists had come to accept us as serious scholars, not the radicals that Heyman suggested. The formal meeting and the luncheon conversations demonstrated that intelligent people usually have civil discussions and reach, if not consensus, at least a respect for one another's opinions.

Heyman's antagonism to the exhibit and self-assurance that his judgment was irrefutable showed most clearly when he read visitor comments. "The folks in *Science in American Life* were so proud when they did those questions on the computer at the end, they were getting very positive statements about science," he told Pam Henson, "and I said, 'Here you've got a whole show that's debunking science, and you're pleased.'" He sneered that museum visitors must not have been paying attention. In fact, Heyman was not paying attention, either to the scientific content of the exhibit or to the public that saw it as thoughtful, even inspiring. *Science in American Life* was doing exactly what we had hoped, and for encouraging interest in science we were condemned.[10] Celebratory exhibits make visitors feel good; challenging exhibits encourage people to think and head to the bookstore curious to learn more. Until I read Pam Henson's interviews with Heyman, I could not imagine the *Science* exhibit being undone to suit stakeholders, but that is exactly what Heyman desired.

In August 1995, the ACS demanded of Director Spencer Crew a list of changes, including the deletion of the Superconducting Super Collider and taming the labels that explained pesticide dangers. It suggested a change that read, "[chemicals] increased crop production for the prevention of starvation

of millions of people," a tired claim trotted out to ennoble their mischief; it never failed to rile me. The *Silent Spring* label added the sentence, "Agricultural chemists responded to Rachel Carson's findings by developing new generations of herbicides and pesticides, such as biodegradable insect-specific pesticides." The immediate response from scientists, of course, was an aggressive attack on Carson's scholarship.[11]

Over a decade later when my book, *Toxic Drift*, appeared, by the way a book that was inspired by my work on *Science in American Life*, a man who had been a director of the American Chemical Society when it decided to fund the *SAL* exhibit sent me a memorable letter. He recalled that when the exhibit opened ACS members were shocked at the exhibit's treatment of toxic pesticides and upset that the Smithsonian refused to yield. He had recently studied *Toxic Drift*, he continued, and understood why we refused to change the script. Most ACS leaders, he explained, were either academics or industrial scientists who did fundamental research convinced that their work was benign and had only positive results. "Now that I have read your book," he concluded, "I appreciate now how industrial leaders took laboratory results thought by researchers to have only benign consequences and sacrificed the health of the environment to corporate greed, with government collusion."[12]

6

Denying History

Every government in every country and every state has
an interest in keeping society unenlightened, for if society
were once enlightened it would very soon destroy them.
—THOMAS BERNHARD, *Gathering Evidence*

History is not woven by innocent hands.
—THOMAS PYNCHON, *Gravity's Rainbow*

I t was unfortunate, I think, that Spencer Crew's tenure as museum direc-
tor coincided with a blizzard of controversies: *The West as America* at the
American Art Museum, the *Science in American Life* exhibit at NMAH,
and the *Enola Gay* debacle at Air and Space. In addition, Smithsonian secre-
tary I. Michael Heyman showered contempt on most museum directors and
curators and expected exhibits to soothe corporate donors and Congressmen
rather than educate museum visitors. For the most part, Spencer defended
Science in American Life but had no weapons sufficient to combat Heyman's
jocular bullying and denigration. Spencer hid behind bureaucratic process
rather than support exhibits that might agitate Heyman, who gleefully
boasted that he was "more intrusive" in NMAH's exhibits.[1] Under Heyman
and later Lawrence Small, the Smithsonian pulled back into a conservative
shell that resisted scholarship and bold exhibits.

A Rutgers University PhD, Spencer Crew had curated the very successful
Field to Factory exhibit that opened in 1987, became acting director, and was
elevated to director in January 1994. He had arrived at the museum in 1981
and worked on the FDR exhibit, where I first met him. Then he became a
curator in the Division of Community Life and from 1989 to 1991 chaired the
Division of Social and Cultural History. Curators had high regard for Spencer
and hoped that he would restore whatever real or imagined authority they

had lost and promote imaginative exhibits based on outstanding scholarship. After all, his challenging *Field to Factory* exhibit won universal praise for successfully exploring a complex historical subject.

My wise and engaged colleague Barney Finn, always working to improve the intellectual quality of the museum, sent a memorandum to Spencer providing a concise history of curatorial prerogatives and scholarly expectations. For context, Barney analyzed exhibits that succeeded and those that had not. He praised *Field to Factory*, *A More Perfect Union*, and *From Parlor to Politics*, Edie Mayo's exhibit on the women's movement, for embracing "new scholarship" and upholding intellectual standards.

Barney's memo criticized increasing bureaucratization, and he focused on a flawed initiative to catalog collections that while expensive and unsuccessful added personnel and power to the registrar's office. I had skeptically raised questions about the efficacy of the cataloging project but received the smug reply that I simply did not understand the complex system. Finally, Barney observed that in the 1980s "money rather than scholarship became the controlling element in exhibit development, and the exhibits program became determined by the interests of the Director rather than by any collective opinion of the staff." Barney appended a dozen suggestions to the memo.[2]

Sadly, Spencer immersed himself in bureaucratic minutiae at the expense of scholarly issues and significant exhibits. He seemed consumed, for example, with producing a strategic plan and a mission statement, both endlessly debated in tedious staff meetings that consumed time and energy. As I saw staff walking the halls with their unsmiling faces staring at the floor, I wondered where the former vitality had gone.

Curators had been allowed a research day each week, which some colleagues abused as a day off. With funding cuts, staff reductions, and additional responsibilities, research days disappeared. If there was a sabbatical policy at NMAH, I never learned of it, but several favored curators mysteriously came by time off for research and writing. Few curators presented their ideas at Tuesday colloquiums or shared their work with colleagues, and I suspected that some needed more mentoring than museum fellows who sought me out for discussions and for reading articles, chapters, and dissertation drafts. To be sure, the Smithsonian's shrinking budget and added burdensome tasks eroded curators' time for collecting, research, and publication.

History museum staff kept a keen eye on other museums and how their exhibits fared not only with the Castle but also with the press and Congress.

The West as America, the Smithsonian American Art Museum's 1991 exhibit depicting the landscape and inhabitants of the US West, drew sharp criticism for its so-called revisionism and political correctness. William H. Truettner, who curated the exhibit, dared include the latest historical scholarship in presenting 164 works by 86 artists, and he contextualized how these artists with their magnificent vistas and portrayal of American Indians perpetuated the celebratory narrative of westward expansion rather than the more conflicted and violent historical narrative. Using history to amplify art did not please some powerful politicians and defenders of heroic frontier mythology. Daniel Boorstin, who had been director of NMAH before becoming Librarian of Congress, described the *West* exhibit as "a perverse, historically inaccurate, destructive exhibit. No credit to the Smithsonian." Senator Ted Stevens seized on the exhibit as proof of the Smithsonian's leftist agenda and, along with other politicians, threatened to cut Smithsonian appropriations.[3] In early August 1991, I sat on a Smithsonian Roundtable discussion on revisionism that focused on *The West as America*. After discussing museum funding and donor intrusion, I added that *politically correct* and *revisionism* were loaded terms often employed to discredit scholarly ideas. "The only historians who are not revisionists are either plagiarists or dead," I judged.

At about the same time that *Science in American Life* opened at NMAH in April 1994, the *Enola Gay* crisis exploded across the Mall at the National Air and Space Museum (NASM), and, added to *The West as America* and *Science in American Life*, incited critics who portrayed the Smithsonian as a hotbed of politically correct leftists. Until the Air Force Association condemned an early leaked draft, and then veterans, Congressmen, the American Legion, and the press sensationalized it, curators had produced a working draft of an exhibit on strategic bombing and the end of World War II that at such an early stage of development would have endured additional reviews by military, diplomatic, and cultural historians, vetting by the Castle, and, no doubt, input from veterans' organizations.

It never got beyond the Air Force Association and *Air Force* magazine, which in the spring of 1994 publicized uncontextualized segments of the script alerting Congress and the press and insisting that it was unpatriotic, pro-Japanese, and politically correct, among other faults, never mentioning the lively historical debates that swirled around the end of the Pacific War. For soldiers awaiting orders to invade the Japanese mainland, of course, the atomic bombs ensured that whether pending diplomacy succeeded or failed

there would be no invasion. Unwise efforts to revise the script to suit critics failed. Untangling political, military, and diplomatic issues and explaining the Manhattan Project's creation of atomic bombs could have informed museum visitors that history is extremely complex and constantly undergoing revision as more information becomes available.

A half century after atomic bombs destroyed Hiroshima and Nagasaki, the intensity of public reaction to atomic power had faded, but immediately after the attacks, the public expressed sobering thoughts on weapons that vaporized people and leveled the two cities. A year later, John Hersey's intense account of destruction and survivors ran in the *New Yorker* on August 31, 1946, and later was expanded into the best-selling book *Hiroshima*, and numerous other accounts appeared in the intervening years. NASM curators realized that displaying the B-29 *Enola Gay*, which dropped the atomic bomb on Hiroshima could be controversial, but it was an important object attached to a significant moment in world history. Though the *Enola Gay* could be celebrated as a triumph of technology and its crew praised for doing their duty, what happened below the aircraft on August 6, 1945, seemed best ignored. With amazing dexterity, critics transmogrified the museum draft into a nefarious testament of unpatriotic fervor that dishonored veterans and favored the Japanese enemy. Secretary Heyman folded before criticism from the Air Force Association, the American Legion, and some eighty members of Congress and in January 1995 canceled the proposed exhibit. The Smithsonian Castle under Heyman became at best a symbol of fecklessness and at worst a tool for sanitizing history. As the *Journal of American History* suggested, US patriots praised Soviet, Japanese, and German historians who owned up to blunders and war crimes but were reluctant to raise uncomfortable questions about US history.[4]

Interestingly, ten years earlier in August 1985, forty years after the destruction of Hiroshima and Nagasaki, historian Stanley Goldberg had curated a NMAH exhibit, *Building the Bomb*, that featured bomb casings representing the two atomic weapons dropped on Japan. He hoped to curate a larger exhibit on the beginning of the atomic age, but sadly Goldberg died before the project came to fruition.[5]

As a Smithsonian regent, I. Michael Heyman had lobbied to increase development on a board that was notoriously indolent, and as secretary he redoubled his fundraising agenda. As chancellor of the University of California, Berkeley, he dealt with professors whose scholarly work represented

their point of view, not that of the university. At the Smithsonian, he "was a little put off by the attitude of some curators" who, he claimed, insisted on complete freedom "to do whatever they wanted to paint on the stage, and yet on the other hand, grasped the institutional reputation in order to legitimize what they were doing." He suggested that curators should sign exhibits and take sole responsibility for their message and thus distance their work from the Institution.[6] His focus on controversial exhibits ignored straightforward treatments on electricity, agriculture, machinery, coins, first ladies, and so forth and demonstrated a malign misunderstanding of museum work. Researching and installing exhibits, of course, were key elements of curatorial work. No outrageous exhibit proposal would get by a museum exhibits committee, much less endure review by the director and input by designers, educators, and editors.

Heyman drew his concept of museum exhibits from his legal training, more specifically the courtroom, and gave the example of "people arguing on either side of a case with regard to the same record" and insisted that exhibits have arguments on both sides. History, however, is not litigation. If well done, it is a brief based on extensive and rigorous research and analysis. Historical scholarship inspires debate and fresh interpretations, while also fighting the headwinds of earlier works. Curators would cheat museum visitors if they presented both prosecution and defense arguments at the expense of a clear interpretation based on painstaking scholarship. Heyman shrank from controversial exhibits in part because he did not want to drive away potential funders and anger Congress, but he also had a crabbed and legalistic notion of US history.[7] Indeed, throughout the crisis over *Science* and *Enola Gay* the specter of Congressional punishment loomed over the Smithsonian. Unless it abandoned its political correctness and leftist inclinations, the argument went, funding cuts would punish the institution and teach it a lesson. Sadly, the stately old Smithsonian was portrayed as a hotbed of radicalism primarily because the staff wanted to raise significant historical questions.[8]

One of Heyman's most egregious decisions, with Spencer Crew's blessing, was cutting from the major nineteenth-century exhibit *Land of Promise* the "Trail of Tears," the brutal removal of Cherokee Indians from western North Carolina to Oklahoma and, for good measure, deleting a section on westward expansion. Thousands of Indians died on the forced march to Oklahoma, thus "the trail of tears," but feckless Smithsonian management claimed the sections contained "too much white male bashing." Given the fate of the exiled

Cherokees and shredded treaties with Indian tribes as settlers populated the West, the "bashing" statement invites calculated distortion. *Land of Promise* curators were justifiably irate. Evidently Heyman feared that pulling back the celebratory curtain and honestly dealing with American Indian removal could set off more controversy. Commiserating with Karen Leathem, a friend who worked at the Greater New Orleans Collection, I jokingly wrote, "I always claim that if your exhibits aren't pissing off at least 30 percent of the people who see them, then you aren't doing your job."[9]

Air and Space, Heyman later announced, would put up a "much simpler" exhibit, "permitting the *Enola Gay* and its crew to speak for themselves." I envisioned a talking airplane. On June 28, 1995, NASM opened an exhibit featuring the fuselage of the *Enola Gay*, brief statements by the pilot and crew, information on restoration work, and a conventional account of how atomic bombs ended the war. This sanitized version contained inaccurate, unhistorical, and misleading information, including that the bombs led to "many tens of thousands of deaths," while official statistics reported that two hundred thousand Japanese people died. The claim that the bombs ended the war and made an invasion unnecessary ignored the complex situation that included Russia's entrance into the Pacific War and the diplomatic negotiations then underway. The exhibit parroted the conventional wisdom of American innocence and justifications for using the bombs. I became nauseous as I walked through the exhibit.[10]

Fortunately, the history museum continued some of its traditions. On April Fools' Day, staff members invented preposterous spoofs, highbrow nonsense, straight-faced fabrications, and spouted warped polysyllabic rhetoric. Despite misgivings about leadership and agendas, the staff united around the annual April Fools' program that in 1994 focused on marshmallows. As the day approached for the program, I asked museum fellows at the Irish Times for suggestions, and John Hartigan Jr., an anthropologist, conspired with me to create a glossary of fashionable-sounding jargon that was then coursing through academia. I titled my marshmallow talk "The Moon Pie Millennium and Goo Goo Cluster Transgressions," and some of my museum colleagues were unsure this was a spoof. Rodris Roth, the dean of domestic life curators, presented a tongue-in-cheek slide presentation on the proper way to set a table for marshmallow treats, and her highly formal vocabulary applied to a lowly marshmallow provoked appreciative laughter. The festivities also featured an art contest and some marshmallow dishes, and the press covered the

program with appropriate mock seriousness. Such breaks in museum routine not only provided cheer but also allowed talented staff to show their creative side. Sadly, there were fewer and fewer such moments.

In the spring of 1995, museum curators closely watched Disney's effort to build a history theme park near the Bull Run Civil War battlefield outside Washington, an effort that stirred major controversy. Disney boasted that it could educate the public by bringing history to life, an underhanded slap at the history museum. To illustrate its living history, Disney representatives visited the museum and screened short films. One featured a soundtrack from hell (wailing ooohs from a choir of youngsters) accompanying images of Abraham Lincoln, Martin Luther King Jr., an American Indian, and a Hispanic soaring through the clouds above celebratory nonsense. Eventually, the Disney project died, in no small part because of objections from a band of notable historians as well as public outrage at a mouse dominating the land-scape so near the sacred Bull Run Civil War battlefield and opposition from wealthy denizens of nearby Virginia horse country. When I hear the words "bring history to life," I immediately begin to ask questions about veracity, just as when I hear "tell the story of American agriculture," I smell agribusi-ness manure.

While the April Fools' program and to some extent the Disney gambit pro-voked levity, in a blow to morale director Spencer Crew outlawed alcohol at parties, including the popular museum-wide Christmas party as well as both the Skull Crew party and that of our division. The decision was framed in concern for people drinking too much and dangerously steering or staggering home. These had been parties full of good cheer, and without alcoholic fuel they coasted to a stop. I still recall the first dry museum-wide holiday party with folks sitting soberly around the cafeteria unable even to pretend at hav-ing a good time.

Over the years, dozens of interns worked on division projects, and invari-ably they were treated as staff, given important assignments, and partici-pated in meetings. It would take a chapter to record their contributions, which included collecting, research, transcribing interviews, writing script, and installing exhibits. Annette Day, for example, arrived from the United Kingdom on April 18, 1994, and stayed with us until October 14. She left behind a thirteen-page journal of her activities, which included orientation, research at the Library of Congress and the National Archives, a tour of the Silver Hill storage facility, relevant reading, films, a sexual harassment

Author, Smita Dutta, and Annette Day.
Smithsonian Institution.

awareness class, work on a fund-raising brochure, assisting with opening a photography exhibit, a week in Memphis with Smita Dutta for music research, and heroic work transcribing some dozen of our interviews. Such interns brought intelligence, fun, and energy to the division.

Feeling frustrated and isolated in the museum, I applied for a Regents' Fellowship for a year of released time to continue work on my 1950s book. The 1950s decade was transforming in my mind from a calm and happy time into a decade of enormous energy and strife. At every opportunity I continued research. At the Southern Historical Collection at the University of North Carolina, I read the papers of Wesley Critz George, a professor in the medical school and a leader of the North Carolina Patriots, a 1950s segregationist organization. A number of George's correspondents quoted their African American maids who assured their segregationist employers that they had no interest in integrating schools. I smiled at such white people's gullibility, recalling that when Emancipation came planters were aghast that their "faithful" slaves happily walked away to freedom and never looked back.

Wang Siming, who had invited me to China and interpreted during my stay, successfully applied for a visiting Smithsonian fellowship and arrived in May 1994 and was my houseguest for three months. He was working on his

dissertation at Nanjing Agricultural University. The museum provided him a small office, but Siming preferred to stay home reading books and documents he found in the museum library. Siming was also a stir-fry enthusiast. On one occasion, he was preparing a meal and turned the gas high under the peanut oil, and the wok was smoking fiercely and glowing red when he dropped in the tofu. I had to look away.

I took Siming to a reading of *Ulysses* at the Irish Times, which he enjoyed, but our Tuesday evening meetings there made him nervous as we discussed politics and criticized Congress and the administration. He expected the police to arrest us, and he then would be disgraced. He did enjoy the Rolling Stones "Voodoo Lounge" concert at RFK Stadium on August 1, and I made him a music tape that included several genres suggesting the historical development of southern music. His wife was a musician, he told me, and he loved to sing karaoke, as he had demonstrated in Nanjing. Siming left early in September and made his way back to Nanjing, where he completed his graduate work and has enjoyed a remarkable career.

In early June I went to an agricultural history conference in Little Rock, arriving early and staying late doing research both in Little Rock and in Fayetteville. Siming flew in for the conference. Linda Pine, archivist at the University of Arkansas at Little Rock, offered important suggestions about the collections, and her sharp wit enlivened my research. She told me about Harvey Goodwin, who was born in Little Rock, moved to San Francisco, and performed as a female impersonator, and accompanying photographs revealed him affecting a Greta Garbo persona. The next day, I went through segregationist politician Jim Johnson's papers and was confident that, despite his insistence in an interview that he was a statesman, I was correct in my estimation that he was a racist agitator. Looking at Harvey Goodwin and Jim Johnson back-to-back vividly evoked the South's diversity.

Both in Little Rock and at the University of Arkansas in Fayetteville, I found a wealth of information about the 1957 integration crisis at Central High School, including copies of FBI files and the diary of Elizabeth Huckaby, the assistant principal. A number of white high school students were "troublemakers" but left very little behind to explain their behavior. Eventually, I came to understand that white parents were behind much of the meanness that tore through the school. Children were their agents. Though cursed, hit, and reviled, the Black students were instructed to show no reaction.

Harvey Goodwin performing at a Little Rock, Arkansas,
ordnance plant September 25, 1942. *Courtesy of the
Center for Arkansas History and Culture, UA Little Rock.*

Former museum fellow Jeannie Whayne, a professor at the University of
Arkansas in Fayetteville, suggested that I look at the Wilson Plantation Papers
at the university archives for a list of movies playing at the Wilson theater
to get an idea of smalltown popular culture. One envelope contained a half
dozen photographs of a program held in the Wilson school auditorium. I
puzzled over white men, some in blackface and others cross-dressed in
skimpy beauty contestant clothing.

With the help of friends, especially the historians John Howard and Grace
Hale, I deduced that there had been two performances, one blackface and the
other a cross-dressing beauty contest. If Black men had shared a stage with
white women in the 1950s, as these photographs portrayed, it would have

Stage show, Wilson, Arkansas. *Courtesy of Wilson Plantation Papers, 1949–50,*
Special Collections Division, University of Arkansas Libraries.

provoked a riot. White men, though, could parade around as they pleased, all
in good fun. I found transgressive photographs across the South, surprising
some archivists when I asked to copy suggestive cross-dressing and camp
photographs.

Colin Johnson's book *Just Queer Folks: Gender and Sexuality in Rural America*
(2013) was the culmination of intense research and writing, but most of all
innovative analysis. I served on his dissertation committee at the University
of Michigan and suspected that he had not only read but could cross-analyze
every important book in the library. When I was searching for a title for my
book on pesticides, Colin was among a group of people at a party and asked
me about the title, and I admitted that I hadn't decided. When he asked what
it was about, I replied, "pesticides." He frowned and asked what about pesti-
cides? "They're toxic," I explained, and when he asked what effect they had,
I replied, "They're everywhere, they drift." He smiled and said, "That's your
title, *Toxic Drift*."

Museum fellows Elena Razlogova
and Colin Johnson. *Author photo.*

Colin and David K. Johnson increased my understanding of gay culture
and built my confidence when writing about gays and lesbians in my study of
the 1950s. David's book, *The Lavender Scare: The Cold War Persecution of Gays
and Lesbians in the Federal Government* (2004) analyzed the harassment of
gays and lesbians during the nasty McCarthy years. It was exciting to discuss
with these and other scholars the emerging field of gay, lesbian, bisexual, and
transgender history.

Postdoctoral fellow Laura Edwards and I often discussed her work and
especially her proficiency at using legal sources. We would occasionally dine
out, and one evening the maître d' hesitated to seat us upstairs; when we
insisted, we ended up at a table beside Attorney General Janet Reno and a
friend. Laura is a productive scholar whose works include *Gendered Strife*

and Confusion: The Political Culture of Reconstruction (1997) and *The People and Their Peace: Legal Culture and the Transformation of Inequality in the Post-Revolutionary South* (2009).

Much of my museum work, however, required patience and tact. In January 1996, for example, I met with two gentlemen from agribusiness who proposed an exhibit that would "tell the story of American agriculture." I listened as they lauded machines, chemicals, and increased production, and painted a celebratory picture of how American agriculture was feeding a starving world. They promised "input" from various sectors of the agribusiness community, but, having been to boot camp with our science exhibit funders, I realized that they wanted a trade show to boost agribusiness. I explained that my idea for an exhibit focused on my collecting and scholarship on southern rural life, a story that held no charm for these gentlemen. After clearing their throats and politely promising to think about my idea, they left, and I knew they were gone forever, or at least until I retired.

In the midst of depressing trends, Harry Rubenstein and Peter Liebhold curated an imaginative exhibit on sweatshops, *Between a Rock and a Hard Place: A History of American Sweatshops, 1820–Present*, that ran from April to December 1998. Although it was balanced and discussed both sweated labor and the fashion industry, the exhibit elicited an anguished howl from the fashion world. Both the *New York Times* and the *Washington Post* weighed in, reporting that the fashion industry was aghast that the exhibit was pro-labor, instead, evidently, of being pro-exploitation. No doubt the Castle was wringing its hands over not having more severely eviscerated the script, removing all evidence of compassion for workers.[11]

My life had settled into a routine of face time at the moribund museum and rushing home to work on the 1950s book. I was losing contact with the weak pulse of the museum and sadly watched entropy creep into every niche of museum work. In late November 1995, Spencer Crew admitted at a staff meeting that we were operating in a new "climate" that necessitated avoiding the displeasure of politicians and donors, implying that ideas outside a narrow conservative bandwidth might provoke a charge that the museum was leftist or politically correct. Secretary I. Michael Heyman, of course, proctored exhibit scripts to ensure that donors and politicians were pleased. Given the Smithsonian's century and a half of conservative and solid accomplishments, eagerly sucking up to its critics was inexcusable, shameful. As I looked at the dwindling number of curators, the lack of nerve among those of us left, and

leadership tiptoeing lest it stub a toe and set off donors or Congress, I became more distressed. The Smithsonian should have done better.

Having grown up in the 1950s South, when challenges to segregation dominated white discourse, I learned and then unlearned defenses of white supremacy, a fiercely protected ideology. Both at college and in graduate school, I read scholarship that undermined white supremacist accounts of Reconstruction and Jim Crow and considered myself fortunate to be involved in that revision. The Smithsonian's reluctance to confront controversial subjects in scholarly exhibitions outraged me, but more important, it denied museum visitors the benefit of scholarship and permitted dangerous mythologies to fester.

7

Research Road

The facts are always frightening, and in all of us fear of the facts is
constantly at work constantly being fuelled; but this morbid fear must not
lead us to conceal the facts and so to falsify the whole of human history.
—THOMAS BERNHARD, *Gathering Evidence*

T he word that I had won the Smithsonian Regents' Fellowship
arrived the day after Wang Siming and I enjoyed a Rolling Stones
concert. "Start Me Up" suggested to me a fast car and open road
leading to documentation on the 1950s. Exhausted after *Science in American
Life*, disgusted by Smithsonian leadership's lack of vision, and tormented by
useless museum meetings, I was eager to race down research road and leave
the museum behind. Such fellowships had been crucial to my scholarship. A
National Endowment for the Humanities (NEH) postdoctoral fellowship in
1970 provided a year at the Johns Hopkins University to revise my disserta-
tion for publication, another NEH fellowship had sprung me from exile at the
University of Tennessee and allowed a year of research in Washington, and
the fellowship at the Wilson Center permitted me to draft *Breaking the Land*.
These fellowships allowed me to focus on research and writing and escape
the daily grind that fractured concentration.

"Doing research" is a cryptic, even opaque, term describing the search for
documentation, and looking for insights into the South of the 1950s required
extensive travel as well as additional research at the National Archives. It
was necessary to explore both how racism united white southerners and how
civil rights activists attacked fault lines in white supremacist ideology. Even
as the civil rights movement gained momentum, popular culture expanded to
include working-class and white southern musicians and the stock-car racing

culture. At the same time, millions of rural southerners left the land, driven away by machines, chemicals, and discriminatory USDA policies. These trends opened into dozens of questions that challenged the notion that the 1950s was a decade of quiet consensus.

History is not written on tablets but rather is dynamic, as scholars add new insights and interpretations. When on August 30, 1993, ABC interviewed me at the National Archives for a program about peonage, I convinced the producer to use this as a teaching moment and organized the necessary props: statute volumes, federal cases, and an archival cart full of document boxes. When the show aired, nothing remained of my methodology lesson, and my remarks on peonage lasted about a minute. Methodology that was important to me obviously held little interest for TV producers. Researching and writing history is a solitary pursuit that requires focus and stamina, and while it may be exhilarating to historians it does not translate well into popular entertainment.

Beginning September 1994, I took two- to three-week research trips and then returned home to organize and file notes. Over my Regents' year, I looked at seventy collections, primarily in the South. Since I would be away from the museum for a year, I worked out an arrangement where Smita Dutta would replace me and also serve for several months as my research assistant.

I set off for Columbia and the South Caroliniana Library (at the University of South Carolina) and immediately found the open road exhilarating. In the extremely rich and revealing papers of the South Carolina Council on Human Relations, I encountered Alice Spearman, who fearlessly pushed for an end to discrimination, often at great risk. Several years later in a conversation with Jacquelyn Dowd Hall, who at the time headed the Southern Oral History Collection at UNC, I mentioned Spearman, and Jacquelyn asked if I had read her interviews. No, because I had not known that Spearman had married civil rights advocate Marion Wright and took his name. Jacquelyn's interviews revealed Alice Spearman as an independent, unorthodox, and strong-willed woman who in her early twenties spent a year touring the world, later worked in a New Deal agency, and in the 1950s championed civil rights.

"Research is really draining," I wrote in my notebook one evening, "and I've been going all day with only a lunch break. My eyes get tired." After a few days at the South Caroliniana, I began to calm down from my research frenzy and took time for coffee breaks with Kari Frederickson, who was engaged in research for what would become her study of the Dixiecrat movement.

In the Claudia Thomas Sanders Papers, I found not only biographical information but also documentation of a Ku Klux Klan bombing of her house in Gaffney. Sanders had attended Hollins College and did graduate work at Columbia University studying under anthropologists Franz Boas and Melville J. Herskovits. She had written an essay in the 1957 book, *South Carolinians Speak: A Moderate Approach to Race Relations*, arguing that separate laws for men and women or Black and white were outdated and that fears about school integration were unfounded. In November 1957 three Klansmen dynamited her house, breaking windows and cracking walls; fortunately, no one was injured. One of the Klansmen confessed but did not live to stand trial. As the press cryptically reported in February 1958, he was crushed when his automobile "apparently fell on him." In July a jury returned a not-guilty verdict for the two accomplices after the departed Klansman's confession was ruled inadmissible.[1]

In the political collections at the University of South Carolina, I looked at the papers of W. D. Workman, a newspaper correspondent and author. It turned out that, in addition to defending segregation, Workman attended the first Southern 500 NASCAR race at Darlington in 1950 and took photographs, some that I used in the book. During my stay in Columbia, I wrote extensively in my notebook about what this material might mean in the larger 1950s story.

After returning home and filing my notes, I drove to Louisville for the Southern Historical Association's convention and then continued to Nashville where I had lunch with Paul Conkin, the intellectual historian who taught me at the University of Maryland. He shared with me his extensive knowledge of the Vanderbilt Fugitives, authors of the influential *I'll Take My Stand*, a complex book of essays about encroaching modernism, literature, and changes in race relations. Donald Davidson, one of the authors, had taught at Vanderbilt and left behind a fascinating collection of papers that revealed his extreme discomfort with the implications of *Brown v. Board of Education*, feelings he shared with friends. He also wrote a very good novel on country music, *The Big Ballad Jamboree*.

I also looked through the Frank W. Owsley Papers at Vanderbilt, Charles S. Johnson Papers at Fisk University, and the Frank Clement Papers at the Tennessee state archives. Johnson, of course, was a prominent African American sociologist whose views about desegregation were the opposite of Donald Davidson's.

Next I visited Auburn University, arriving on December 7, fortunately after football season and during holiday break. Archivist Dwayne Cox suggested that I begin with the Alabama Cooperative Extension Service Papers (which I would return to nearly twenty years later), and then examine the Alabama Farm Bureau Papers, the very revealing files of Dean of Women Katharine Cater, and finally the papers of Ralph B. Draughon, who had been president of the university in the 1950s.

In mid-January I drove down to Athens to examine the Lillian Smith papers in the University of Georgia special collections. She had run a camp for girls on Old Screamer Mountain in north Georgia, and southern women who wanted their daughters to aspire to a life beyond the pedestal sent them to Lillian Smith. She founded a journal and wrote *Strange Fruit* and *Killers of the Dream*, both analyzing lynching and how southerners were educated to segregation and racism. Her papers opened a window on southerners who were restless with the strictures of segregation, tired of hypocrisy, and who envisioned a South freed from its racist demons. At times when I was going through her correspondence, I could almost hear her warning me, "Don't screw this up." As I moved within the academic community in universities during my research year, I enjoyed the power of intellectual life that was increasingly absent at the museum.

In April, I visited Oxford, Mississippi, where I looked at Congressman Thomas Abernethy's papers and those of historian James Silver, who had stirred substantial controversy with his presidential address to the Southern Historical Association convention in 1963, "Mississippi: The Closed Society" (he later published a book by the same name). That had been my first Southern convention. Silver's papers were revealing of life in the small town of Oxford, home of William Faulkner and the University of Mississippi.

After completing Oxford research, I drove down to New Orleans and stayed with my good friend Sylvia Frey, a professor at Tulane University. Happily, my stay coincided with the New Orleans Jazz and Heritage Festival, and over the weekend I enjoyed wonderful music and good food. I worked mostly in the Amistad Research Center at Tulane and found crucial documentation regarding civil rights. Shortly after I left New Orleans, a major rainstorm flooded much of the city, immersing Sylvia's car and coming within one step of flooding her house.

During the summer, I continued writing and realized that the Common-wealth Fund Lecture, an article on World War II, the fire-ant article, and the

talks that I had given over the years furnished a solid foundation. Still, I was mired in documentation that included urbanization, agriculture, chemicals, popular culture, and civil rights and had headaches trying to organize those disparate elements. Nearly every time I mentioned that I was doing research on, among other things, rock 'n' roll, the listener would say, "Let me tell you about rock 'n' roll." The same thing with stock-car racing. I listened politely.

Then, time ran out, and I faced returning to the museum on October 1. When I looked back over the year and saw twenty thousand miles on my new Honda, notes from some seventy manuscript collections, four lectures delivered, and five hundred pages of drafts, I was satisfied that I had put in a good year's work. The book, however, was far from finished, and I continued travel, research, and writing as time permitted.

When I gave lectures, I tried out new terms and interpretations. On October 10, 1995, I gave a talk at the University of North Carolina Wilmington (UNCW) where I had taught from 1963 to 1966. There I introduced the term, "lowdown culture," a seemingly oxymoronic expression I coined to describe working-class Black and white southerners—stock-car drivers and fans, mechanics, blues and country musicians and fans, and people who hung out in juke joints and honky tonks—all of whom delighted in offending proper people. I used *lowdown* in praise of people who ignored ("didn't give a damn," as they might say) middle-class culture. It was lowdown folks, by and large, who in the 1950s propelled stock-car racing, blues, rock 'n' roll, and soul music into an international seismic cultural shift. Their lowdown and untamed brilliance illuminated working-class musical talent, and their profound mechanical understanding of race cars and fearless driving attracted enthusiastic fans. It was interesting to return to a much larger UNCW, but when I considered that I might have stayed on there with an MA or remained at the University of Tennessee as full professor, my escape to the Smithsonian seemed especially fortunate.

As I was away focusing on research and writing, the museum's reorganization and strategic plan were finalized. During my absence, the Division of Agriculture and Natural Resources was abolished. In the reorganization, I was placed in the Division of the History of Technology, headed by Steve Lubar. Spencer Crew asked later if I might head a new division, but I told him that I had spent enormous energy making Agriculture and Natural Resources the best division in the museum only to watch it picked apart with no one hired to replace invaluable staff. I was not about to exert the effort to build

another division that, in a director's whim, could be decimated. Although I escaped some of the reorganization chaos while on the road, I was not amused that this transformation occurred while I was away and never given opportunity to defend my turf.

I was always prepared to learn more about the 1950s, but at times information blindsided me. At a February 1996 Natchez conference, historians and a crop of Mississippi novelists discussed southern culture. On the second night of the conference, held at the First Presbyterian Church, Joel Williamson spoke on William Faulkner, Elvis Presley, and Tennessee Williams while I held forth on lowdown culture. As Joel described Tennessee Williams's search for his gay self and I praised lowdown culture, the young pastor sat at the back of the church with a studied nervousness that passed for reflection, although he was probably expecting God to hurl bolts.

In my talk I mentioned a Muddy Waters performance at the University of Mississippi in 1960 and his recollection that as young women twisted in their short skirts "their little white panties [were] showing." Alarmed university officials shut down the dance, turned off the lights, and sent the band members outside in the rain to await their checks. It was unclear whether authorities panicked because they feared flashing white panties' effect on young white men or were mortified that Muddy Waters and his fellow Black band members were privy to the view. On the way back to the hotel, a woman sitting across the bus aisle turned to me and said, "I was there," and excitedly recalled the moment. As I listened, I realized that Sandra Scarborough Kramer probably had more to say, and the next day in an interview she unraveled an incredible story of growing up in Mayesville, outside Natchez, learning to dance in a Black juke joint, and visiting shady dance halls across the river in Ferriday, Louisiana. After graduating from the University of Mississippi, Sandra moved to Washington and worked for US senator John Stennis and later was a leader in the women's movement.

The Southern Historical Association convention in 1996 held in Little Rock was a combination of family reunion, intellectual exchange, and socializing. I had a fascinating conversation with my friend Connie Curry, who wrote with Mae Bertha Carter the remarkable book *Silver Rights*, which had won the Lillian Smith Prize. Connie had attended the founding of the Student Nonviolent Coordinating Committee (SNCC) in the spring of 1960 and knew Jane Stembridge quite well and eventually put us in contact for an interview. Jane joined SNCC in the summer of 1960, ran its tiny office in Atlanta, edited

SNCC's newsletter, worked in Mississippi for several years, and exchanged remarkable letters with author and activist Lillian Smith. I also got in touch with Joan Browning, another SNCC member whose religious conviction led her into civil rights and out of her family's favor. We exchanged letters about rural life, civil rights, research, and her essay for *Deep in Our Hearts*, "Shiloh Witness."

Researching the civil rights movement put me in contact with activists, and in addition to Joan Browning and Connie Curry, I met Casey Hayden, another of the nine SNCC women who contributed essays for *Deep in Our Hearts*. It was extremely dangerous in the 1960s South for white women to work openly with Black men in a cause that threatened segregation, and it took remarkable bravery to bear not only shunning by whites, and by family in Joan's case, but also the constant threat of violence. As I was writing *Dispossession* years later, Connie put me in touch with Elaine DeLott Baker, who contributed an essay to *Deep in Our Hearts*, and who took photographs during her stay in Mississippi in 1964–65 and shared them along with her personal correspondence from the time. One of her photographs became the cover for *Dispossession*, my study of discrimination against African American farmers. These women and other women and men in the movement were among the most talented, creative, and brave of their generation.

In my talk at the SHA convention, I observed that the press distorted the crowd outside Central High School as low class, bib overalled, and out of control, but photographs and newsreel footage contradicted that image and showed working-class men in khakis and sport shirts and women in dresses; many were parents of the white students. There were violent people in the crowd, to be sure, as beatings demonstrated. Wardrobe fascinated me, and I found images of youth suggesting the influence of James Dean and Elvis Presley as well as Confederate iconography. At Harold Woodman's presidential address, I sat beside Stephanie McCurry, a former museum fellow, who insisted that she sit by the aisle because during the awards ceremony she would accept the Charles S. Sydnor Award for *Masters of Small Worlds*.

As the SHA convention ended, I rose on Sunday morning before light and headed home, queuing up Mozart's Fortieth Symphony to launch the trip with enthusiasm. As I emerged onto the Arkansas prairie and the fourth movement began, grain elevators stood backlit against a reddening horizon. It gave me chills. I had not intended to drive all the way home on Sunday, but once I turned north on I-81 outside Knoxville and recalled that I had made

the five-hundred-mile drive from Knoxville to Washington numerous times when I was in exile at UT, I thought, why not? At about ten on Sunday night when I parked on Emerald Street my speedometer recorded the Little Rock to DC dash at 1,040 miles.

I discussed publication both with Joyce Selzer at Harvard University Press and with Kate Torrey at the University of North Carolina Press, and with their permission sent the 824-page manuscript to both presses. All four readers called for extensive revisions and suggested cutting several hundred pages. These excellent suggestions forced me to focus more sharply on organization and thesis. I decided to go with UNC Press and began the exacting process of revision. UNC Press allowed me ample photographs, and while those from Magnum and Black Star were extremely expensive others from the Library of Congress and the National Archives were public domain, and images from university collections could be used for a reasonable charge.

Preoccupation with the book and increasing duties on the Memphis music project did not curtail my curatorial duties, and Larry Jones and I continued our collaboration with agriculture issues. Collecting trips continued as one of the most satisfying elements of my job. In early September 1997, I went down to southern Maryland to visit the tobacco farm of the Frank Robinson family. Frank Jr. worked in the Archives Center at the museum, and we occasionally discussed the charms of Maryland and of flue-cured tobacco. The Robinson home sat on a hill, and the fields stretched to the river below, and on the day I visited they were cutting tobacco. I went down to the field, where I was introduced to Frank's sister, Theresa, dressed in jeans, cutting knife in hand. In a conversation over lunch, I learned that she drove a truck each night from Washington to Richmond delivering the *Washington Post*. I allowed that cutting tobacco all day and driving most of the night didn't leave much time for sleep. She smiled and said, "No, but when I sleep, it's good sleep." I collected some objects for the museum to represent the Maryland tobacco culture, which was under stress and would soon dwindle away. Claudia Kidwell, curator of costume, collected clothing from the Robinsons.

When Paul and Pam Jones, who had purchased an old hardware store in Rutledge, Georgia, contacted me to announce that they had discovered a Cole Boll Weevil Killer still in its original heart pine crate, I listened attentively. It had arrived in 1943 during the war but attracted no buyers. After the war, synthetic chemicals and tractors quickly replaced such mule-drawn implements, so the boll weevil killer had collected dust in the Rutledge hardware store.

The SHA convention held in Atlanta in 1997 offered the opportunity to visit Paul and Pam. I also interviewed Perk Whittaker, then in his eighties, and he recounted derailments, fires (arson), suicides, auto crashes, business cycles, and even recalled mopping for boll weevils by hand. To convince the collections committee of its significance, I described the machine's operation and stressed the significance of securing one of the last draft animal–propelled contraptions before synthetic chemicals and machines ruled the countryside.

Back at the museum, I continued to champion scholarly exhibits and curatorial prerogatives. In May 1998, I attended a meeting with Provost Dennis O'Connor, curators, and museum directors. O'Connor, who was a biologist and before arriving at the Smithsonian had been chancellor at the University of Pittsburgh, bore a remarkable resemblance to Dudley Do-Right from the *Rocky and Bullwinkle* TV show: square jawed, overly purposeful, vacant, and inattentive. When some of my NMAH colleagues complained of the exhibit review process, Spencer Crew grew agitated and, after a few defensive remarks, stalked out of the meeting. Sadly, exhibit review panels included administrators and non-curatorial members who knew little or nothing about exhibits or history. Exhibits, I argued, should grow out of a vision of history embedded in scholarship, but as I made that point O'Connor had wandered to the snack table. Given the feckless behavior of museum directors since the *Enola Gay* fiasco and Secretary Heyman's directive to avoid controversy, any exhibit proposal containing challenging interpretations would be suffocated.

The destruction of the Division of Agriculture and Natural Resources and reorganization were forcing me to move to another office. I had filed a claim on the corner office looking northwest but was blindsided in July 1999 when it went to Steve Lubar. My assistants on the music exhibit, Rebecca Lynch and Andrea Woody, were consigned to what had been a ten-by-ten storage room. Lubar insultingly claimed that, since both the music and the stock-car exhibits were being done outside the museum, my work and staff housing were not a priority. His condescension did not settle well. "So, I'm a second-class citizen," I countered, and asked that if I gave up this outside work, which, by the way, was part of my job, might I gain back my status? He did not reply, nor did he respond to my other numerous questions about his decisions. Eventually I moved from the old John Hoffman place that I had reclaimed some seventeen years earlier to a similar office at the other end of the hall. Room 5028, the division's primary storage area, was thus at the other end of the hall from my new office. So much for years of efficiency studies. It was also a hike up

the hall to my colleague Helena Wright's office where we often discussed
the museum's health. Helena combined expertise, integrity, and wisdom and
could be relied upon to support curatorial excellence.

Around the fourth of July 1999, Larry Jones forwarded me an email from
Roger White in the transportation division, who, following a Steve Lubar
idea, suggested that we condense several objects in the Agriculture Hall to
make way for a 1949 GMC pickup truck that Roger had collected. My email
back to Larry joked that perhaps the Agriculture Hall had become another
storage area and that we might also shoehorn in a few more tractors and
assorted implements. Additional scarcely labeled objects would not matter
so long as visitors could squeeze by. And since Roger had found this fresh
interest, I suggested to Larry that he hold a symposium on the significance of
pickups in rural life, including lectures on gun racks, bumper stickers, long
beds, short beds, big wheels, four doors, four-wheel drive, and four-, six-, and
eight-cylinder engines, and, of course, whether or not Humvees should be
considered pickups.

I also faced a rising tide of emails related to museum issues and historical
organization business. Email was fast and useful, to be sure, but at this stage
of internet technology, I was unsure when I pressed "send" if the message
went anywhere, and arriving emails were cluttered with a half-page of sym-
bols that designated something important, I am sure. I also endured failed
modems, sketchy connectivity, data loss, and a gap between the promised and
the delivered. I can see in my correspondence file the transition from carbon
copies to dot matrix to ink jet printers and recall that my first ink jet printer
demonically ate paper, refused to print entire documents, failed to recognize
itself in my computer, and naggingly chirped and whirred.

Computers, the web, and email created eager gleams in the eyes of col-
leagues who euphorically prophesied a communications revolution. In the
long run, of course, they were right. So far as the museum was concerned, the
long-lasting effects of email substituted digital messaging for paper memos
and face-to-face contact. The human interactions that had generated friend-
ship and cooperation suffered, replaced by formal, digital-heavy processes
that further stifled productivity. The workplace became more routinized and
less imaginative. Although I had been using computers for writing since 1981,
when I was at the Wilson Center, email sputtered and then came to life for
real by the mid-1990s. Management never figured out that computers and
email did not magically replace secretarial and support staff, so curators,

Mrs. Fannie Lou Hamer, Mississippi Freedom
Democratic Party Convention, Jackson, Mississippi,
spring 1971. *Author photo.*

specialists, and secretaries suffered unintended consequences of the digital
revolution.

Along with exciting exhibit projects, research, and writing, I often reflected
upon cultural distress—drastic cuts in Smithsonian appropriations, unre-
placed curators and specialists, universities favoring business over humani-
ties, TV programming alternating between violence and silliness, newspapers
cutting staff and coverage, and general attenuation. Having grown up just
as TV was emerging from snow into images with resolution (at least in my
hometown, Spring Hope) and being preoccupied with sports in high school, I
seldom had time for TV and early on realized that I was allergic to advertise-
ments. When people bitch about the mediocrity of TV, I remind them that
TVs have an off switch. From a historian's perspective, stripping funding from
arts and humanities, portraying university faculties and museum curators
as leftists, creating a despised class of politically correct scholars, and slash-
ing Congressional funding for exhibits suggested that historical research and

analysis, controversial art, and challenging exhibits were considered danger-
ous. With a diet of constant entertainment and an obsession with TV, film,
music, and famous personalities, people's minds had receptors only for the
next show, the next famous personality, the hit tune and seldom opened
to ideas that required notable consciousness. Entertainment became habit-
forming and smothered curiosity.

It was a mid-May evening in 1998, and I was at home writing about the
1964 Democratic National Convention and Mrs. Fannie Lou Hamer's stirring
testimony before the Credentials Committee and the Mississippi Freedom
Democratic Party's decision to refuse two token seats amid the all-white and
officially segregationist Mississippi Democrats. Disgusted, the Freedom Party
delegation went home. "When Freedom Summer ended," I wrote, "so did the
promise of spontaneous grassroots revolution. The moment was lost." I sat
there looking at the screen a while before realizing that the book was fin-
ished and that I was at the end of research road, and at that moment realized
I needed to add a word to my tentative book title, *Revolutions*, and it became
Lost Revolutions.

8

Rock 'n' Soul

But music, there is no single thing that I know of that has
affected more people favorably, that has done more diplomatic
work for us than rock 'n' roll and the music that was started
and created in the fifties and sixties around the world.
—SAM PHILLIPS, *Rock 'n' Soul* interview

The kingdom of music is not the kingdom of this world,
it will accept those whom breeding and intellect
and culture have alike rejected.
—E. M. FORSTER, *A Room with a View*

In 1988 Director Roger Kennedy appointed me to lead a team to reignite a twentieth-century exhibit, an initiative that had sputtered to life in 1981 but quickly expired for lack of money to pay for it. Curator Charlie McGovern, a former museum fellow, and interns Margaret McKinnon and Kristin Ann Hass completed the team.

Lack of funds doomed our promising start, and we dejectedly discussed salvaging a small exhibit. We were keen on the role of Sam Phillips and his Memphis Recording Service, which issued records by African American blues musicians and then released a string of rock 'n' roll recordings on the Sun label. We also hoped to present the history of soul music at STAX and Hi studios. A case could not contain this story, so we boldly suggested to the exhibits committee a three-thousand-square-foot exhibit. Blues, rock 'n' roll, and soul music, we argued, would offer the opportunity to explore the tangled musical traditions that emerged both from Memphis's rich heritage and from the surrounding countryside. Thus began an initiative that consumed a dozen years and would involve funding, research, logistics, collecting, design,

Rick Patterson, Lee Woodman, Gary Geboy.
Author photo.

installation, and intrigue. Some of our research seeped into my book on the 1950s; fortunately the book and the project ran parallel to each other.

In early April 1990, film producer Karen Loveland at Smithsonian Productions, the Institution's prize-winning audio-visual component, suggested video interviews and secured funding from the Smithsonian special exhibits fund. Lee Woodman, an award-winning producer at Smithsonian Productions who combined charm, warmth, and a demand for perfection, produced the interviews. Lee and I would meet most evenings in the Peabody Hotel lobby to analyze the day's interviews. We joke that I taught her to drink bourbon, and she taught me video production. Even in my wildest fantasies I had never placed myself face to face with musicians whose music was the soundtrack of my high school and college years.

We began interviews in Memphis on May 10, 1992. Charlie McGovern and I worked closely with Lee, cameraman Gary Geboy, and sound expert Rick Patterson. David Less, my Memphis ethnomusicologist friend, scheduled interviews, located venues, did some of the interviewing, and made sure we were near a barbecue restaurant at lunchtime.[1] Peter Guralnick, who had written several important books on 1950s music, also joined us and lent

both his expertise and the goodwill he had accumulated during his Memphis research.

On an off day, Smithsonian Production's John Paulson and I drove down to Sumner, Mississippi, to visit with Frank Mitchener and his wife, Judith, and her brother, Leroy Deavenport. Judith and Leroy had donated to the Smithsonian a 16mm Kodachrome movie film shot at the Delta and Pine Land Company in the late 1930s and 1940s by their father, Samuel Leroy Deavenport. He filmed a moment of major transformation in the cotton culture from labor-intensive plowing with mules and picking by hand to the Rust brothers testing their successful mechanical cotton harvester. He also filmed a crop duster skimming over cotton plants leaving a white cloud and then the duster at rest on an air strip with a clear view of the Delta Flying Service logo, the parent of Delta Airlines. Judith, Leroy, and Frank narrated this silent film, and John Paulson handled the recording. This remarkable film footage is in the public domain at the NMAH Archives Center.

Lee suggested that we begin with several audio interviews to test our methodology, and our video interviews began on May 18 revisiting Malcolm Yelvington and Cordell Jackson.

David Less booked a studio for our interview with Jim Stewart, who along with his sister, Estelle Axton, founded STAX studio, which recorded Otis Redding, Sam and Dave, and a host of other soul groups. Stewart sat at a control board, and he spoke with passion about his life and work.

On May 24, we drove to Newport, Arkansas, for a video interview with Billy Lee Riley. I was fond of Billy Lee, who grew up rural and poor in Arkansas, served in the military, cut records at Memphis Recording Service, and came very close, with "Red Hot" and "Flying Saucers Rock 'n' Roll," to becoming a star. His band, the Little Green Men, served as the Sun house band.

On a day off Lee and I drove down to Columbus, Mississippi, to visit with Birney Imes, the photographer especially noted for his book *Juke Joint* and his study of Whispering Pines, a restaurant/roadhouse owned by Blum Triplet who had recently died. Birney was managing the estate, and we hoped—in vain it turned out—that we might find objects there for the exhibit. In the bar's glory days, there were speakers in the trees surrounding a concrete dance pad and inside separate Black and white bars, but with time and inattention to the color line, all customers drifted to the white side. Eventually Birney put together his images in the book, *Whispering Pines*.

Back in Memphis we interviewed Bobby Manuel, who played guitar in the

Cordell Jackson.
Author photo.

Jim Stewart.
Author photo.

Lee Woodman, Billy Lee Riley, Author.
Smithsonian photo.

STAX house band. Young, talented, and white, he began sitting in with Black musicians on Beale Street and, because he needed a place to crash during the day, joined a fraternity at what was then Memphis State. One evening some of his fraternity brothers happened upon a performance, and at the break they confronted him and said, "Damn, Bobby, we didn't know you were that good." Later, Manuel played with the Coolers and often performed at Automatic Slim's, a notable restaurant across from the Peabody Hotel.

On May 20, we went to the Old Daisy Theater on Beale Street and interviewed Fred Ford, an African American musician who still performed around Memphis. He told us of his experiences playing in Memphis and out in the countryside at dances.

Carl Perkins talked with us at the hot and stuffy Old Daisy on May 20. He had a practiced narrative as he unwound his youth as a sharecropper's son, picking cotton, singing in the fields, and finally escaping rural work for a job in nearby Jackson, Tennessee. After he heard Elvis Presley's "That's All Right" on the radio, he made a pilgrimage to Memphis, talked with Sam Phillips,

Fred Ford.
Author photo.

and recorded legendary rock 'n' roll records, including "Blue Suede Shoes." By the end of the interview, Perkins had sweated through his shirt, but he agreed to sing "Matchbox" on camera, and we used that as the soundtrack for film credits in the introductory exhibit video.

As we set up for the video interview with Sam Phillips on May 22, he called us to his office, gazing at us with those powerful eyes that were a cross between Charles Manson and God, and set the ground rules for the interview. He instructed us not to interrupt him, which we discovered meant permitting him to ramble about his importance for a half hour.

I sat for two hours eye to eye with Sam Phillips, asking about his growing up near Florence, Alabama, his move to Nashville, then to Memphis, his recording big bands at the Peabody Skyway, and opening Memphis Recording Service. Who but Sam Phillips could have coaxed dozens of young inexperienced white men to create the golden age of rock 'n' roll, or, for that matter, recorded Howlin' Wolf, Ike Turner, B. B. King, Rufus Thomas, and other

(*Above*) Carl Perkins.
Author photo.

(*Left*) Sam Phillips.
Author photo.

Black artists in the age of segregation? Phillips sensed the collision of rhythm and blues and country and pushed his white Sun artists toward a new sound.

We went back to Memphis on August 4 for more interviews and context footage, including Elvis Presley "Death Day" at Graceland and a Rufus Thomas performance at a Little Rock music festival. Jim Dickinson sat at his piano and unwound marvelous recollections of his musical evolution, which started when he was a kid and heard a jug band on Beale Street. We met his wife, two sons, and their dog. The sons, Luther (guitar) and Cody (drums) would go on to found the North Mississippi Allstars. Jim Dickinson had a profound understanding of how music evolved, and, of course, was a successful artist and composer. He made several notable albums produced by David Less.

We interviewed Rufus Thomas at the Old Daisy, and he took us through his illustrious career, which included time with the Rabbit Foot Minstrels, recording both at Sun and STAX studios, his legendary radio show on WDIA, and his career as a performer.

The setup and breakdown for the Rufus Thomas interview at the Old Daisy ate up time, and we were late for our audio interview with Willie Mitchell, who was justifiably miffed. Mitchell was one of Memphis's most important artists. His band played at the Plantation Inn, across the river in West Memphis, where white Delta planters and their sons and daughters along with Memphis swingers mixed on the dance floor while Mitchell's African American band performed on stage. He also produced music for Hi Records and was a Memphis icon.

On August 6 we met Bettye Berger, who had moved to Memphis from rural Tennessee at seventeen, got married, had three children before she was old enough to vote, and got divorced because her husband objected to her flourishing modeling career. She worked as a DJ on WHER, the all-woman radio station started by Becky Phillips, Sam's wife, dated Elvis Presley, hinted at her affairs with several notable artists, composed songs, and for years booked artists for the Plantation Inn, run by her husband.

At Graceland on Death Day, we interviewed people lined up for the pilgrimage to the burial site behind the house, talked with fans touring Graceland, had our own private tour, and at night filmed the solemn line of people passing by Presley's grave.

On August 7 we interviewed Calvin Newborn, whose brother, Phineas Newborn Jr., was a notable jazz pianist. Calvin played guitar and had a

(*Left*) Jim Dickinson.
Author photo.

(*Below*) Bettye Berger
attended by Gary Geboy, Rick
Patterson, and Lee Woodman.
Author photo.

(*Right*) Young Elvis Presley understudy near the front of the line on Death Day. *Author photo.*

(*Below*) Candlelight pilgrimage to Elvis Presley's grave on Death Day evening. *Author photo.*

remarkable career that included a stint at the Plantation Inn and a career with big bands. That afternoon we interviewed David Porter, who, as a young man bagging groceries, visited nearby STAX Studio and ultimately became a notable performer and songwriter.

On August 12, we talked with Morse Gist in Helena, Arkansas. David Less had gone to school with one of Gist's sons, so we had an excellent introduction. Gist had run his family's music store since the 1930s and sold instruments to area musicians and also distributed records to local jukeboxes. He would often get calls late at night when a jukebox broke, he recalled, and arrive at the venue and be quickly surrounded by surly patrons. He first tried to get something playing, he explained, and then make the repair. In those days the machines opened from the back, giving him a strategic shield to avoid whatever chairs or bottles might fly by. He complained that putting jukebox access in the front was a dreadful mistake. He was also disgusted, he admitted, with movies that featured assaults on jukeboxes with chairs or bottles or, occasionally, with flying persons.

On the thirteenth, we interviewed Scotty Moore and D. J. Fontana. Moore, of course, had played guitar on Elvis Presley's first hit, "That's All Right." Given his influence on a generation of guitarists, Moore was modest and humorous. Fontana had begun backing Presley on drums during his Shreveport performances on the *Louisiana Hayride* TV show. He carefully watched Presley's suggestive moves and accented them with his drums. Listening to Moore and Fontana brought us very close to the big bang of rock 'n' roll.

Bernard Lansky welcomed us into in his closed Beale Street store; his new business location was off the upscale Peabody Lobby. As a kid, Elvis Presley would gaze into the store fantasizing an outfit, Lansky recalled, and as his career began he asked Lansky for something that would define his style. "I put him in these great clothes," Lansky smiled, "and he went out a billboard for Lansky's." He still recalled Presley's shoe and hat sizes. Beale Street was the center of the Black community south of Union Street before it was razed to force African Americans out of the central city. Fred Ford and others spoke of the area "before urban renewal," code for the vibrant African American community before bulldozers.

As we gathered interviews and continued research, project manager Camy Clough was disturbed at the museum's apathy toward our exhibit and sent a memo to Director Spencer Crew about lax fundraising. The exhibit was to open first at NMAH and then travel to Memphis, so NMAH needed to raise

Photograph for album cover.
Author photo.

several million dollars for its share. Spencer was unenthusiastic, if not hostile, toward the exhibit and to our team, as if featuring lowdown culture was beneath his and the Smithsonian's dignity.

In August 1996, our *Rock 'n' Soul* team traveled to New York in search of funding and made our pitch to EMI, BMI, and MTV. In a discussion at EMI, I observed several artist collections on display and boldly mentioned that if they ever issued a Leon Russell compilation that I had an excellent photograph for consideration, one I had taken in 1972 while in Knoxville exile from my third-row seat using a 105mm lens and no flash. It turned out that EMI did release a two-CD set of Russell's work with my photograph on the cover. Our *Rock 'n' Soul* team returned from New York no richer than when we left.

Despite pressure from the Castle and from the two Tennessee US senators, Spencer obstinately refused to commit the museum to matching Memphis's $2 million and petulantly insisted that it was his decision whether or not to continue with the exhibit. The scenario changed abruptly when in January

1998 Carol Coletta and Charlie Ryan, representing the Memphis initiative Memphis Rock 'n' Soul (MRNS), offered to fund the exhibit for $2 million if it were installed permanently in Memphis. Assistant Director for Curatorial Affairs Lonnie Bunch asked our team if we could recalibrate the exhibit to fit $2 million. Spencer embraced the offer, his eagerness symptomatic of his uneasiness with installing the exhibit at NMAH.

Scaling down meant that designer Hank Grasso, who had been on the team from the beginning, had to reimagine dimensions and space as we pared down the script. It was September 8 before we made a five-day trip to Memphis to begin collecting. Charlie McGovern had a proprietary attitude toward collecting Memphis objects such as instruments and wardrobe and closely guarded his contacts from contamination from other team members while continually boasting of his contacts and promised objects. While Charlie remained in Memphis, Hank, Dick Rachelson, and I drove down to Mississippi in search of rural objects. Dick taught anthropology at the University of Memphis and was a keen student of music. Taylor Brooks had collected "things" for years, and his lease was not being renewed for the several acres of buildings near Byhalia that housed substantial material culture of northern Mississippi; an auction was imminent. Brooks was eighty-three years old, and still alert, but an illness rendered him unable to speak clearly. His daughter, Beverly Watkins, who was visiting, translated and helped us wade through the bulging rooms of objects.

Dick spotted two screen doors with "Open Come in Air Conditioned" across the top and "White" on one and "Colored" on the other, objects that shouted segregation.

We also found a cotton weigh-up scale and pea, a battery radio, a Victrola, lye soap, a wash basin, a wash tub, a snuff bottle, a coffee jar, a harmonica, chairs, and other rural objects. "I am one happy puppy," Hank exclaimed.

On October 5, Hank and I drove over to Newport, Arkansas, transporting a white chocolate charlotte cake purchased at the Peabody for Billy Lee Riley's sixty-fifth birthday. Hank and I dined with Billy Lee and his wife, Joyce, at a nearby restaurant and had the cake and ice cream for dessert. We purchased a Silvertone guitar, harmonica case (inscribed with titles of his songs), several harmonicas, a sport jacket, slacks, and black and white shoes (his trademark), plus he lent us more family photographs to copy.[2]

When the team met with the MRNS board, one member ridiculed the rural part of the script, declaring that no one cared about farmers and that

the section was irrelevant. I took a few deep breaths (a sure sign I'm pissed off) and then reviewed the rural South's substantial contribution to music, Memphis music in particular. Like many folks, this man did not understand that rock 'n' roll did not suddenly appear full-grown at Sun Studio but developed within a historical context. Another backer wanted to know what the "wow" component was. At that point, both Hank and I took deep breaths.

We returned to Memphis on November 2, and I was in a terrible mood, in part because of my workload and also because MRNS and the Smithsonian were still splitting legal and budgetary hairs. I had lunch with David Less, who mentioned that I should see some objects in Hal Lansky's building, so we walked to 92 Front Street, where I met Hal, Bernard Lansky's son. Upstairs there was a large cluttered storage room, and David pointed to a "sandwich board" advertising a 1956 rock 'n' roll show featuring Fats Domino and a half dozen other musicians. In the middle of the board in small print, "White show at 8:00," and across the top, "Buy your tickets at Lanskys." Hal generously loaned it for the exhibit.

As the exhibit sputtered along, Camy Clough managed the details, lobbied for funds, kept us abreast of threats, and did heroic work largely unappreciated by museum administrators. Our staff was strengthened when Andrea Woody, a former intern, joined the team. Meanwhile, Charlie and I were writing script, and our styles were starkly different. In February we completed a draft and mailed it out to readers, mostly historians of music. When the drafts returned, I was impressed with the close scrutiny these scholars brought to the script that saved us from serious errors. I attacked the script and attempted to edit it to one voice.[3]

Charlie McGovern convinced Charlie Ryan and Carol Coletta that he needed to live in Memphis for several months to complete collecting, so MRNS arranged for an apartment for his family and dog. Although Charlie mentioned leads on important objects, Hank and I were growing edgy about his silence on specifics. After his return, we met on July 7 to hear Charlie's long-anticipated collection report, expecting, of course, a sensational list of objects. He began telling stories about the people he had met until Camy interrupted, reminding him that we were meeting to discuss objects. He took out several packages of photographs and began thumbing through them, holding one up occasionally to indicate a lead, or possibly, a loan. It was an embarrassingly disorganized presentation. There were no dimensions for Hank and no definitive list of promised or even potential objects. I was incredulous,

deflated, and feared that the exhibit was doomed. Given the team's pride in teamwork, I was outraged not only that Charlie had failed to nail down objects but also that he refused to admit this to the team and ask for our help. When word of Charlie's lack of objects reached Memphis, both Charlie Ryan and Carol Coletta were irate and demanded to know what Charlie had been doing while living in Memphis. We never found out.

On July 19, I flew to Memphis and discussed the situation with David Less. From David's knowledge of the Memphis musical landscape and with Charlie's notes, we put together a list of contacts and potential objects, and David discovered what was definite and what was not. Charlie had talked with a number of people, David learned, but after initial contact often failed to follow up. When David re-contacted these people for potential loans, he sometimes met hostility. I marveled at David's calm demeanor, politeness, and reassurance. It was crucial that I convince Charlie Ryan and Carol Coletta that we could complete the exhibit. David Less was doing a spectacular job, I assured them, and with his help we could complete a significant object list.

They were adamant, however, that Charlie McGovern leave the exhibit and hinted that they meant to ask Spencer for additional retribution and even threatened to sue the Smithsonian. It was a grave moment. The MRNS board would meet in a week and decide our fate, and I knew that Carol and Charlie Ryan's report about McGovern's several unsuccessful and expensive months in Memphis would be devastating. In addition to demanding McGovern's dismissal from the project, this crisis prompted our Memphis supporters to raise questions about acquisitions, payments, and design, and to demand more control over Smithsonian contractual responsibilities.

When I met with Charlie McGovern after my Memphis trip, I reminded him of our commitment to teamwork and providing mutual support and then voiced my perplexity over why he acted like the Lone Ranger. This was a stressful meeting, given that I was tasked with relaying the decision that he leave the project. I had been one of Charlie's staunchest supporters during his museum career and was devastated by this crisis.

Shortly after these tense meetings, I headed to Nags Head for my long-planned two-week holiday. Every day, I talked with David Less and the *Rock 'n' Soul* team. UNC Press sent the copyedited manuscript of *Lost Revolutions* to the beach. I walked down to the water's edge, sat under my umbrella, started reading, and immediately encountered the editor's suggested changes and was irate—for about three pages. Then I began to understand that Paula Wald's

editorial skill was making the book much better. She also asked for numerous fact checks and clarifications that kept me scrambling once back home. Still, it was idyllic sitting by the ocean and reading the edited manuscript.

Because of the object crisis, MRNS insisted on a Memphis fund manager, and Glen Campbell, who orchestrated Memphis Wonders, an international cultural series featuring such exhibits as Napoleon, Catherine the Great, and Egyptian themes, assumed control of the budget and sometimes maliciously intruded into our work. He continually asked what the "wow" object would be, as if we might find a mummy of Robert Johnson deep in a Delta cemetery or a hank of Elvis Presley's baby hair in a nook of his Tupelo homeplace. Hank had worked practically without compensation for a year and intuited that the louche Glen Campbell wanted to drop him and take control. I sensed haunting echoes of the crisis with David Allison and the *Science in American Life* exhibit as I listened to Glen's aggressive suggestions.

Head of curatorial affairs Jim Gardner's comments on my draft of the script pissed me off. Jim grew up in Memphis and had been executive director of the American Historical Association before moving to the museum. He questioned that whites patronized Beale Street music venues, so I pointed to Hal Lansky's sandwich board that stated the time of the white show. He challenged my observation that Black and white women chopped and picked cotton, obviously ignorant of Farm Security Administration photographs. He even doubted that white folks listened to WDIA (all Black DJs) or to Dewey Phillips on WHBQ (Phillips had a listening audience of 100,000). He sneered at my description of women washing clothes in a wash pots over a fire and claimed that by 1900 people did not wash clothes that way. "Yes, they did," I heatedly replied, "in my own yard in Spring Hope when I was a kid." Jim replied to my comments with a nasty memo, and I composed an even nastier one that I never sent. Instead, I met with Lonnie Bunch and told him that Jim could read and suggest at will but that I would not change history to placate him. Coming from a southern working-class background, I wrote to designer Hank Grasso on September 30, 1999, "I am accustomed to my 'betters' attempting to define culture and control history. Those days are over."[4]

After the Southern Historical Association convention in November, I flew up to Memphis to continue our interviews. Wrestler Sputnik Monroe arrived from Houston the night before his interview, and Andrea Woody, who by this time was managing the team in Memphis, and I escorted him to dinner. He exuded charisma, charm, and good-hearted menace in equal parts. My

favorite restaurants were closed on Sunday evening, so we went to the fancy Dux restaurant at the Peabody. As we walked through the lobby, Sputnik spied Bernard Lansky in his store, and they happily chatted about old times. The Dux restaurant was upscale, and as the three of us looked at menus in a formal nonsmoking room, Sputnik lit up. Andrea and I looked at each other and then at the waiter, a young man who seemed to be pondering whether to confront this very impressive wrestler or resign. Andrea walked over and gently said, "Perhaps you should bring an ashtray."

The next day we interviewed Sputnik at the New Daisy, and as we walked along Beale Street after the session, a Black woman spied Sputnik, rushed up, and gave him a hug, excitedly explaining that in the early 1960s her father watched him wrestle every week on TV. Sputnik detested segregation, and indeed, got his wrestling name after giving a Black hitchhiker a ride during a drive from an event in Missouri to one in Alabama. After arriving at the Alabama venue, he was joking around with his new friend and had his arm around him when a woman, after being cautioned about her abusive and profane language, shouted, "You're nothing but a damned Sputnik." The name placed the time and association, since in the fall of 1957 the Soviet Union put the first satellite, Sputnik, into orbit. The name stuck. In Memphis, Sputnik had strutted along Beale Street (he showed us his strut), always well dressed, and ridiculed segregation laws. He was so popular that ultimately the Memphis wrestling auditorium management moved the overflowing Black fans from the balcony to the main floor, integrating the arena.

On another trip to Memphis in December 1999, the flight was late, clerks at the car rental counter loitered with calculated indifference, the staff at the airport Hampton Inn was totally incompetent, FedEx planes roared in and out all night, and I missed dinner. On Thursday, December 9, we interviewed Becky Phillips, Sam's wife (they had never divorced), and George Klein, an articulate Memphian who had known Elvis Presley in high school. Becky founded WHER, an all-woman radio station, and she announced along with Bettye Berger and handled much of the business. These two independent women deserve more attention from historians.

John Meehan had taken over as interview producer after Lee Woodman was assigned to the Smithsonian Castle for other projects, but Gary Geboy and Rick Patterson continued to handle camera and sound. David Less and I conducted the interviews. On December 9, we interviewed Ben Cauley, who arrived dressed in a white shirt, polka-dot tie, black jacket, and a white

Becky Phillips.
Author photo.

Sonny Burgess.
Author photo.

hat. Like many Memphis musicians, he had learned music in junior high school, and in high school his band played at dances. He eventually ended up at STAX, backing Otis Redding and others. In the winter of 1967 on tour in Wisconsin, their plane crashed into a lake, and Ben was the only survivor.

On the two trips, we interviewed some thirty people, including Andrew Love and Wayne Jackson (the Memphis Horns), Floyd Newman, the Hodges Brothers, and Sonny Burgess.

We ultimately completed over sixty-five interviews with people involved in Memphis music. These video interviews and typed transcriptions, now in NMAH's Archives Center, are invaluable sources of information on the history of rock 'n' roll and soul music as well as the music business and civil rights.

By mid-January 2000, my book was in production and scheduled to come out in early April, at about the same time as *Rock 'n' Soul* was finally scheduled to open. On March 2, I held the first copy of *Lost Revolutions: The South in the 1950s.*

As with every exhibit I've ever worked on, the countdown to opening produced frayed nerves, even panic. On February 26, I was reading fellowship proposals at home when I checked my email messages. Hank, fed up with the Memphis Wonders staff, was leaving the project and had a call in to his lawyer. More perfidy from Campbell, Hank said, who refused to sign a contract to pay for a lighting designer. When I spoke with Glen Campbell a short while later, I stressed that contracts were not my responsibility but opening the exhibit on time was. The solution was simple, I told Glen; write a check for $12,000 for a lighting designer. A month later Hank was broke, and I talked to Lonnie Bunch about our options and then called Glen, who began denouncing Hank and threatening to toss him—until I reminded him that Hank and I were a team and that if Hank left so did I. So, funds were funneled to Hank, and the exhibit was saved—again.

On a rainy Monday morning in early April, the team watched the driving rain in Memphis as we waited for a call from Phoebe Lewis on whether or not we would be interviewing her father, Jerry Lee. He had undergone two root canals on Friday, she told us, and was not feeling well. That afternoon as we approached his estate just across the line in Mississippi, we paused to admire graffiti on the wall beside the road. Phoebe told us to set up and she would prepare her dad for the interview. When he came out, he was sweating profusely, had cut himself shaving, and was not particularly welcoming. Andrea managed to aim a fan at him, towel off the sweat, and blot the blood

on his neck. Restless, temperamental, and in pain from the root canals, he seemed likely to bolt, and I held my breath as Phoebe kept asking him if he really wanted to go through with this. Finally, he glared at me, "When is this damned thing going to start?" I looked back at Gary. "We're rolling." When I looked back, Jerry Lee was a different person—composed, alert, and ready to talk, a real pro. He lasted about forty minutes and gave us very good material. We packed up, had celebratory drinks at the Peabody, and walked across the street for dinner at Automatic Slim's. It was one of those perfect days, for we had just interviewed one of the most volatile, unpredictable, ornery, talented, and fated of musicians.

I dutifully met with Glen Campbell and discussed budget, prompt payments, and the staff that would install the exhibit. All I heard from him was cut, cut, cut, and his opinion that this was a short-term project (it's still up). I wondered how much money was actually left, for Glen carefully guarded the balance sheet. A number of contractors were irate at Glen's tardy payments, and I deplored his treatment of working people.

On April 6, I drove down to Oxford for the Conference for the Book, an event that attracted dozens of authors, and participated in a massive signing at Square Books where all of my books were available. The 1927 Mississippi flood book, Deep'n as it Come, proved more popular than Lost Revolutions. My table was near that of Steve Yarbrough, and I walked over and admitted that I had read all of his books, and he allowed that he had read some of mine. William Gay, who had just published The Long Home, a southern Gothic novel with brimstone and stink singeing the pages, was one of the stars. According to the press, Gay had labored in obscurity for years before finally getting this book published. He was a wizened little man who had an army of women trailing him. I made the observation that novelists were hot; historians were not.

A week before opening, John Meehan announced that he was having trouble with the three exhibit videos, and on April 23 called me from Florida to say that he was in the final stages of video production and needed to be able to reach me at any moment. I thought about the installation space in Memphis with no phones and John's anxiety; I bit the bullet and bought a cell phone.

Just before I left for Memphis with the exhibit opening a week away, I learned that neither newly installed Smithsonian secretary Lawrence Small nor anyone else from the Castle would attend the opening. Spencer's office

Sputnik Monroe, Author, Jim and Brenda Lanier.
Jeff Tinsley. Smithsonian Institution.

called me in panic about what he might say at the press opening. Until that moment, Spencer had never asked about exhibit content or engaged me in a conversation about its significance. I was not about to write his speech and wondered what he might say when a reporter asked why he could not raise funds for the exhibit to open in Washington, as first intended. Since Spencer had to leave after the press conference the day before the opening, Martha Morris would be the Smithsonian spokesperson. I did not wish the people well who had tried to kill the exhibit and now were tasked with extolling it. MRNS naturally considered the Castle's absence a major affront.

When I got to Memphis on April 24, Delta had lost my luggage, the hotel modem did not work, and the elevators went out; I was on the sixth floor. Sputnik Monroe greeted me on April 30 when I arrived at Burke's Book Store for the *Lost Revolutions* signing. I introduced him to my friends, flattered that he attended. When time came for my talk and signing, Sputnik pulled a chair up beside me behind the table full of books. I signed the first book for a young woman, and she then boldly smiled at Sputnik and asked if he would sign his

Hank Grasso, Author, Camy Clough.
Jeff Tinsley. Smithsonian Institution.

photograph. "Page 127, sweetie." Smithsonian photographers, including Jeff
Tinsley, were buzzing around taking photos, friends were chatting, people
were asking me questions as I signed books, Sputnik was carrying on with
his charming mischief, and spirits were high.

As with any exhibit, there were last-minute crises, hurt feelings, and doubt
that it would open on time, but it moved inexorably toward completion,
thanks primarily to Hank. The final crisis, the videos, resolved when we dis-
covered that they had been delivered to the wrong office.

Hank, Camy, and I sat on the sharecropper porch and relaxed knowing that
behind us the exhibit was completed. By this time, friends were arriving, includ-
ing Judy and Mary Reardon, dear friends who dated back to my University of
Maryland days, along with my daughter Laura and her husband, Mark.

The exhibit chronicled the history of Memphis music as rural traditions
collided with urban sounds. Sputnik Monroe's wrestling kit and the two
"white" and "colored" doors separated Black and white musical cultures, until
they met at STAX studio in the 1960s.

Hank and I stood aside as NMAH leaders awkwardly took credit for the

Hank Grasso and Author on top of the world.
Jeff Tinsley. Smithsonian Institution.

exhibit. At some point on press day, we went up on the roof to enjoy some fresh air and joked about museum officials downstairs soaking up accolades for the exhibit they had demeaned but now were forced to praise.

The actual opening was a black-tie affair with Memphis political, artistic, and financial heavies in attendance, including Sam Phillips, Jerry Lee Lewis, Billy Lee Riley, Scotty Moore, Rufus Thomas, and many more notables. Sleepy LaBeef and Rufus Thomas, along with a host of others, performed on four music stages. I found Sam Phillips in front of the Memphis Recording Service/Sun Studio exhibit that explained his role in recording Black and white artists. He was chatting with Jerry Lee Lewis and Scotty Moore, so I joined in. I wandered from section to section, visited music stages, and talked with hundreds of people even as my voice had almost shut down. At times I resembled the Godfather, hoarsely whispering to people. Up on the roof I finally met my guests, Paula Wald, who had edited my book, and her husband, Jim.

The next morning, I met Taylor Brooks and his daughter, Beverly Watkins, who had practically furnished the rural part of the exhibit from his antique

Paula Wald and Author.
Jeff Tinsley. Smithsonian Institution.

business, and we walked through the exhibit before it opened to the public. Then I left the Memphis Rock 'n' Soul Museum for others to claim. As I wrote to Smita Dutta, "I'm shut of it," and added, "it's one hell of an exhibit."

 That night I had dinner at Automatic Slim's with Laura and Mark, Jim and Brenda, David and his wife, Angela, and Paula and Jim. Since Jim at the time was a wine importer, he ordered excellent champagne for the table. After dinner we crossed the street to the Peabody for nightcaps. It was the perfect ending.

9

Defending Exhibit Standards

Retrospectively it was clear that the wealthy had found each other,
I thought, they had a sixth sense for their mutual background.
—THOMAS BERNHARD, *The Loser*

Proverbs for Paranoids, 3: If they can get you asking the wrong
questions, they don't have to worry about answers.
—THOMAS PYNCHON, *Gravity's Rainbow*

We might say, by the way that success is pretty awful.
Its deceptive resemblance to merit has people fooled.
For the hordes, success looks just like supremacy.
—VICTOR HUGO, *Les Miserables*

Although I did not diagnose it at the time, after the *Rock 'n' Soul* opening and publication of *Lost Revolutions*, I suffered from post-orbital remorse, Tom Wolfe's term for astronauts who returned from space knowing that nothing would ever match that experience. I gradually and reluctantly resumed curatorial duties, not really expecting that the museum might have somehow gained resolve to move beyond accepting donor intrusion and bought exhibits or that Smithsonian leadership would welcome bold exhibits. But I did not anticipate that NMAH and the Institution could continue deteriorating so dangerously.

In January 2000, Lawrence M. Small had become the eleventh secretary of the Smithsonian Institution. At first, I was taken, as were the search committee and the Board of Regents, with Small's pretense of being a Renaissance man who played flamenco guitar and had collected rare masks and feathers during his years in South America with Citicorp. Despite his never having dealt with curators, scientists, or academicians, his banking background

and cultural claims dazzled the regents, who expected him to tighten what they saw as the Smithsonian's lax management, employees' poor work habits, reputed political correctness, and academic-like disorganization. Despite Small's less than sterling career both at Citicorp and at Fannie Mae, to the regents he personified qualities they hoped would transform the Smithsonian into a more efficient and businesslike organization. He would wean curators from unprofitable scholarship, direct them to mount celebratory exhibits, and, with a backward glance at accusations of political correctness and radicalism, proctor the staff for deviance. Museum visitors should be treated to feel-good exhibits and given every opportunity to visit shops and buy trinkets. The regents ignored the scholarly mission of the Smithsonian and failed to realize that it was neither a corporation nor a university but a vast research and educational complex engaged in myriad projects that could not be tallied on the bottom line of a spreadsheet. The Lawrence Small administration bequeathed a legacy of ethical bankruptcy, irresponsible and damaging decisions, and shame that still haunts the Smithsonian.[1]

I discussed with my museum colleagues Small's bullying of museum directors, erratic decisions, violations of Smithsonian decorum, and astonishing ineptness. He created bitter opposition at the heart of the institution, its scholars, and while they deplored his devious actions, they could not bring him down. At NMAH, director Spencer Crew's lack of a major exhibit agenda came back to bite him when the secretary ordered him to mount an exhibit on the US presidency and have it up by the January 2001 presidential inauguration only eight months away. "This is something I want to do," Small warned Spencer. "And I want *you* to do it, but if you *don't* want to do it, no threats, but it's going to happen."[2] Instead of declaring the secretary's plan ludicrous, ill-conceived, impossible to research properly, and disruptive of museum programs, Spencer appointed an exhibit team.

The museum had scarcely been able to mount a major exhibit in six years, so facing an eight-month deadline for a huge extravaganza provoked anguish and chaos. With abundant new scholarship on women, Hispanics, and African Americans in particular, an unscholarly exhibit on Great White Men was not likely to substantially increase knowledge and was sure to set off historians who demanded that current scholarship inform exhibits. Secretary Small scoffed at scholars who wanted more time for research, suggesting that the staff could find all they needed in encyclopedias. Encyclopedias, of course, offer brief chronicles of accepted facts and interpretations but as

a rule are years, even decades, in arrears of current scholarship. Historical research, after all, moves beyond the known by exploring fresh sources and offering new analyses and interpretations, and curators needed time to become conversant with the latest scholarship and do some digging of their own. Warmed-over presidents did not seem promising. *This Land is Your Land*, an exhibit on Woody Guthrie (that I had worked on), occupied part of the space selected for the presidency exhibit, and daughter Nora Guthrie was not amused that the exhibit was closed on July 16 instead of September 4, as the contract had promised, and threatened to sue for breach of contract. Woody Guthrie was arguably more significant than any number of presidents.

It was unclear how much input and control Kenneth Behring's $4 million, and $1 million from the History Channel, exerted on the $12 million *American Presidency* exhibit. Small had extravagant, if naive, expectations for a blockbuster; predicting crowds circling the block to see Lincoln's hat, Harding's pajamas, Jefferson's desk, and a chair that George Washington sat in shortly before he died. Small insisted on a ticketing system with roped-off lines, a plan that proved unnecessary. The public evidently agreed with most reviewers that, while there were interesting objects on display, the presidency was surely more complex and exciting than what the exhibit presented. I couldn't decide which was worse, Spencer's lack of a major exhibit agenda and obsession with process or Small's bullying.[3]

No matter how hectic and frustrating life was in NMAH, we kept our peripheral vision tuned toward the Castle and Lawrence Small, whose bizarre secret deals with funders and destructive decisions immediately created intense opposition, and by the summer of 2001 "Dump Small" stickers circulated around the Smithsonian.[4]

Evidently Small believed that he could tamp down discontent with his high-handed and flawed decisions by appearing in person at the National Museum of Natural History (NMNH), and on April 29, 2001, he arrived at the museum in his chauffeured black limo; his office was directly across the Mall, several hundred yards distant. Scientists objected not only to his threat to consolidate all science projects but also to close the National Zoological Conservation and Research Center (CRC), a world-renowned research facility near Front Royal, Virginia, that among its other programs worked with endangered and rare species. The decision was not based on analysis of the CRC's quality of research or a conversation with the staff but simply attributed to budget considerations. Indeed, in nearly every controversial closing, Small

consulted neither the affected staff nor those served by the program. His smiling platitudes registered as insults to NMNH's internationally prominent scientists. Even when CRC was later spared, Small continued to pick on it.

When Small announced closing Smithsonian Productions in April 2001 to save money, NMAH's Cultural History Division sent the secretary a detailed memo of protest that summed up the unit's role at the Institution. The office had collaborated with National Public Radio, Public Radio International, Smithsonian Folkways, among others, and created prize-winning radio and television shows and series, recordings, and exhibition audio and video, their productions winning prestigious Peabody and Emmy awards. The memo mentioned several productions, including *Jazz Smithsonian*; *American Encounters*; *Black Radio*; *Wade in the Water*; and *Remembering Slavery*. I had worked closely with Lee Woodman on the *Rock 'n' Soul* exhibit and with John Paulson on other projects and knew first-hand the office's excellence.[5]

Small visited NMAH for a "town meeting" in early June 2001 and discussed the deteriorating buildings, falling attendance at museums, and other generalities before allowing questions. The staff immediately questioned the impact of donors, especially Catherine Reynolds, and Small replied with retreaded platitudes. I asked Small to explain his policy on curatorial research. He pontificated that the traditional freedom of exploring any subject, that is, the increase and diffusion of knowledge, was over but that some research might be allowed in connection with exhibits. His preposterous statement again demonstrated his glaring ignorance not only of the Smithsonian's scholarly tradition but also of the performance guidelines that defined our duties. My scholarly career was based on what he labeled forbidden research. Raising money and planning dubious blockbuster exhibits might have its place, but the Smithsonian's reputation rested on its significant scholarship and thoughtful, well-researched exhibits. Barney Finn wrote a detailed response to Small, castigating him for placing Behring's name on the museum, enabling donors to bully curators, closing Smithsonian Productions, and especially deemphasizing research. "From the beginning, scholarly research has been central to the Smithsonian mission," he wrote. "It has been the basis of our reputation." Perhaps nothing demonstrated Small's aggressive ignorance as clearly as his contempt for research.[6]

The National Museum of Natural History's senior ornithologist, Stors L. Olson, lambasted Small and insisted that "he has become what is surely the

most reviled and detested administrator in the institution's history" and added that the secretary's "only way of measuring anything is in the value of dollars."[7] At a small dinner meeting with curators from American History, Natural History, and Air and Space that I attended in the summer of 2001, Stors explained that the cover of the *Smithsonian Magazine* that featured Small posing before some of his Amazonian feathers revealed matches from endangered species. It turned out that Small, who boasted that he had personally collected the feathers and other objects while working for Citicorp in South America, had actually bought the collection for $400,000 in 1998. He later pled guilty to a class B misdemeanor for owning endangered objects and was sentenced to two years' probation plus community service and ordered to write an apology to *National Geographic* magazine. The Board of Regents continued to enthusiastically support him.[8]

Small's minions at Smithsonian Business Ventures (SBV) in 2005 struck a deal to allow HarperCollins publishers to have first dibs on books by Smithsonian authors. It had never occurred to me to offer anything to HarperCollins, and to my mind the SBV-HarperCollins deal enslaved me to a collusive business plan. I strongly argued that an author's right to select a publisher was inviolate, and I ignored the mandate. A year later, SBV signed a TV deal with Showtime Networks giving it in effect exclusive access to Smithsonian film resources while allowing only incidental use to others. Showtime would also exert first refusal of films that used Smithsonian sources, and this provoked a howl of protest from documentary film producers. SBV also concluded a deal with Corbis to handle the Institution's photographs. The Small administration seemed intent on privatizing the country's national museum complex.[9]

In April 2002, Dennis O'Connor resigned his position as director of the NMNH, a position he assumed after Robert Fri's resignation, making him the seventh museum director to leave since Lawrence Small became secretary. O'Connor had created antagonism among scientists as he offered ill-considered plans to reorganize Smithsonian science research. The other six directors who left were extremely dissatisfied with Small's high-handed administration: Spencer Crew, NMAH; James Demetrion, Hirshhorn Museum and Sculpture Garden; Robert Fri, NMNH; Alan Fern, National Portrait Gallery; Michael Robinson, National Zoo; and Milo Beach, Sackler and Freer Galleries. The Castle put the resignations down to the usual rotation of

leadership, but there was nothing usual about the chaos caused by Small's flawed priorities and meddling and directors' complaints that they could not, in good conscience, carry out his directives.[10]

As Small increasingly garnered poor press, the Castle ruled that all media requests, including calls for information, were to be cleared by communication chief David Umansky, whose ill humor and presumptuous demeanor generated substantial antagonism. All queries by news media, including the *Washington Post* and *New York Times* plus TV networks and national news weeklies, were handled by Umansky. He claimed that his directive would assure that stories were placed in a larger Smithsonian context. He had it backward, of course. The higher up the chain, the less context would be furnished, for the directive was intended not to inform but to obfuscate. It was a glaring example of Small's attempt to control information and insulate himself from criticism.

In late June 2000, Small abruptly announced his confiscation of 402 funds. Curators were prohibited by law from accepting honorariums, and so their speaking fees, book royalties, and other project income went to 402s and could be drawn on for research, contracts, seed money, travel, and other academic purposes. My book advance, royalties, and honorariums, for example, resided in the division's 402 fund and subsidized my research, travel, and speaking engagements. Both NMNH's Senate of Scientists and NMAH's Congress of Scholars registered outrage. Small's confiscatory action, then, threatened funds that curators earned from their creativity and then used to increase and diffuse knowledge. Faced with a curatorial rebellion, Small relented and left the 402 funds intact.[11]

Even as Small persisted in his poor judgment, on September 19, 2000, the official announcement broke that Kenneth Behring was giving NMAH $80 million—with strings. Behring personified the Horatio Alger notion of upward mobility. Brokering his affection for automobiles into dealerships and car washes, he was a millionaire by age twenty-seven. He also became a successful real estate developer in Florida and in 1972 moved to the San Francisco Bay area.

Behring hunted, and he often killed large and rare game—elephants, lions, rhinos, leopards, and, controversially, endangered sheep. In Kazakhstan in 1997, he shot one of the hundred Kara Tau argali sheep left on the planet but because it was endangered could not import the carcass to the US. Robert S. Hoffman, former director of NMNH and an avid collector, applied for per-

mits from the Department of the Interior to import four trophy carcasses of endangered sheep only weeks before Behring's final decision to donate $20 million to the museum for a hall of mammals. The timing of his donation aroused significant controversy.

In another controversial hunt in 1998, Behring's party killed three elephants in Mozambique, although the country had banned sport hunting of elephants in 1990. Behring's party managed to add "problem elephants" to their permits for taking lion, leopard, and buffalo. Behring's hunting party thoughtfully donated $20,000 to a local hospital and pledged aid to the provincial government's wildlife plan. Aarlito Cuco, head of Mozambique's wildlife service, revealed that the three bull elephants taken were not problems and their killing was illegal. Behring, of course, insisted that he had obtained proper permits for all of his kills, but the stench of bribery and poaching hung in the air.[12]

Lawrence Small convinced Behring that NMAH offered a better platform for his generosity than NMNH. Behring and Small, would-be Machiavellians, agreed upon generous and secret donor benefits. Not secret was the renaming of the museum: National Museum of American History, Behring Center (it would have taken an act of Congress to rename the museum the "Behring Museum of American History").[13]

Catherine Reynolds, like Kenneth Behring, made a fortune and leveraged it to enhance her social ambitions. In the late 1980s, she joined EduCap, a company that loaned money to students to attend college. In 2000 EduCap was sold to Wells Fargo for a confidential figure rumored in the neighborhood of $200 million. This is an intriguing stairway to prominence but does not include a step featuring a sophisticated understanding of history.[14]

On May 10, 2001, *New York Times* correspondent Elaine Sciolino reported that forty-three-year-old Catherine B. Reynolds, "a self-made multimillionaire who models herself after Brooke Astor," would give the Smithsonian's NMAH $38 million for a Hall of Fame of American Achievers. Reynolds suggested that this ten-thousand-square-foot hall be named *The Spirit of America* and honor such achievers as Michael Jordan, Jonas Salk, Steven Spielberg, Oprah Winfrey, and Martha Stewart. Sciolino helpfully added that Kenneth Behring, "a California real estate developer who has been criticized for his trophy hunting of endangered species," had given NMAH some $80 million for a voice in the *American Presidency* exhibit, his name on the building, and future options not itemized. Behring wanted, among other things, to

fund a twenty-thousand-square-foot exhibit that would focus on "American legends and legacies." Two celebratory exhibits that would paint a thirty-thousand-square-foot smiley face on the museum was not only preposterous but also humiliating to curators who formerly came up with exhibit ideas. Director Spencer Crew once suggested solving the issue by having Behring's exhibit focus on dead and Reynolds's on living heroes. Neither the contract with Behring nor that with Reynolds was made public, so museum staff, the press, and the public were not privy to what else had been promised to the donors. Writing for the *Washington Times*, Georgie Anne Geyer reported that Reynolds's threat to Smithsonian integrity came neither from the left nor the right "but from an overwhelming sense of entitlement in corporate and moneyed individuals, who believe that they are the true dispensers and disposers of our national reality."[15]

I was wary of the Smithsonian following the trajectory of radio advertising as networks emerged in the late 1920s and 1930s. Sponsors in large part dictated content that was produced by advertising agencies as illustrated by shows such as *Cities Service Hour*, *General Motors Family Party*, *Palmolive Hour*, and the Ipana Troubadours. A corporation considered purchased airtime its property to fill as it pleased. Both Kenneth Behring and Catherine Reynolds no doubt expected that their money would buy museum space.

Curator Barney Finn, who battled efforts to dilute scholarship or to commercialize the Smithsonian, wondered when the public might realize that the Smithsonian was no longer independent but was "just renting out space." Spencer, on the other hand, saw merit in the achievers idea. "If you can highlight how people are successful and give kids the sense of possibility, that's a good thing," he said. While it was claimed that the museum was promised final say on who might be included in the exhibit, the contract stipulated that Reynolds would appoint ten of the fifteen members of the selection committee, in fact giving her control of the exhibit.[16]

The Catherine Reynolds hall of achievers idea closely resembled the American Academy of Achievement run by her husband, Wayne Reynolds, who had earlier attempted to interest Kenneth Behring in a museum of achievement. Each year, Reynolds's academy chose thirty prominent achievers from across the country to receive a Golden Plate Award and sponsored an annual four-day retreat where four hundred gifted teenagers mingled with achievers. The tie between Catherine Reynolds's gift to NMAH and her husband's Golden Plate Awards largely escaped scrutiny, although the people

she mentioned as potential great achievers for the exhibit were all members of the American Academy of Achievement. Wayne Reynolds was president and CEO of the academy, Catherine Reynolds vice chairman, and among its vice presidents was Kenneth Behring. Significantly, the Reynolds announcement came shortly after Lawrence Small received his own Golden Plate, billing the Smithsonian $14,600 to charter an executive jet to attend the award ceremony in San Antonio. This tangle of backslapping, self-praise, donations, and Smithsonian exhibit space did not displease the ever-complicit Board of Regents.[17]

National Museum of American History curators wrestled with the implications of the Reynolds gift, especially the demeaning and marginalization of curators, disregard for procedures, and acceptance of the hemorrhaging curatorial staff. At a Congress of Scholars meeting, it was pointed out that the proposed achievers exhibit did not resonate with any scholarship of the past century and, more importantly, that it was not the role of curators to do the bidding of donors but rather to propose exhibit ideas informed by scholarship. Neither Reynolds nor Behring possessed more than a superficial notion of the American past and focused narrowly on success rather than engaging in the more complex, exciting, and inclusive history of the country. When someone at a June meeting suggested to Catherine Reynolds that the exhibit would need to be grounded in history, her reply was, "Oh, you mean in chronological order." The couple had no more business dictating exhibit content than curators had telling them how to run their businesses. If donors dictated encyclopedia-informed exhibits, then museum curators were superfluous; anyone could curate exhibits.[18]

The proposed Reynolds gift challenged curatorial integrity, yet in a money-hungry museum starved of exhibit funds the hall of achievers proposal found purchase. My reaction was negative, even hostile, and I was impatient with my colleagues who hoped to doctor a sick proposal into a healthy exhibit. The apple in Eden came to mind; bite into this $38 million, and curators would stand naked in their humiliation and be damned to wander in donor hell.

Predictably, a Congress of Scholars memo to the Board of Regents in the summer of 2001 complaining that the Reynolds exhibit proposal violated museum protocol provoked a harsh response from Spencer Crew, not in support of his curators but rather of the Reynolds proposal. He was "extremely disappointed," he replied, "with the timing and the tone" of the memo and suggested that questions could have been addressed to Small when he

spoke at NMAH. The donor agreement review went through the Office of
the General Counsel, the Under Secretary, the Secretary, and the Board of
Regents, Spencer reminded us, and he condemned our memo for demon-
strating "a lack of respect for this exhaustive review process." He avoided the
fact that the great achievers exhibit came not from museum staff but from a
donor, and it drew upon the donor's hubris and achievement obsession rather
than upon scholarship. Spencer's reply to our memo had Castle fingerprints
all over it.[19] In retrospect, of course, that system of checks failed miserably,
not only with such donors as Reynolds and Behring but also, it would turn
out, in monitoring Secretary Small and his minions.

Legitimizing great achievers fell to curator Peter Liebhold, and he insisted
that the museum could take the $38 million and install a great achiev-
ers exhibit without sacrificing integrity. I doubted it. In a staff meeting, I
denounced the achievers idea, stressing again that there was no scholarship
to support it. Peter meekly declared that there was a book. Scholarship, I
sneered, not a book. If the Smithsonian abandoned scholarship for money,
then exhibits would only reflect public relations. Still, Peter and his team
moved ahead vainly attempting both to maintain historical integrity and
to please Catherine Reynolds. Visitors would learn about achievers, Peter
insisted, "by taking famous icons off their pedestals and showing them as
real people in a real context that visitors can identify with and relate to." Real
people, not icons? What would museum visitors learn from a series of success
stories that they couldn't get from *People* magazine?[20]

On June 8, 2001, Public Radio International aired the Smithsonian con-
troversies on *To the Point*, and Warren Olney began by asking the *Chicago
Tribune's* Michael Kilian his take. He reviewed the staff revolt, Behring's name
on the National Museum of American History, and Catherine Reynolds's gift
with attached strings. "And to make things worse, I mean, none of these ideas
came from the curatorial staff, whose job it is to come up with these ideas,"
he stressed. Curator Barbara Clark Smith complained that the contract with
Reynolds had not been made public, that it was negotiated with no input
from either NMAH director Spencer Crew or museum curators, and that the
exhibit idea had not gone through proper channels. Barbara made an eloquent
statement of the situation when she rejected the charge that curators were
"kind of crazy and stone throwing." To the contrary, she explained. "We're a
very conservative bunch of people. We're historians. We are paid for by tax-
payer dollars. We love doing exhibitions. We love getting money from donors

to do exhibitions. We wouldn't be objecting if this was not an extraordinary case, and this wasn't a big change of policy."[21]

Donors' meddling in exhibit generation was nothing new, for there was a long train of exhibitions favoring donors. As scholarship became central to exhibits and donors more demanding, the Society for History in the Federal Government (SHFG) created Museum Exhibit Standards in 1997, and quickly most scholarly organizations signed on. Victoria A. Harden, historian at the Office of NIH History and its Stetten Museum, headed a SHFG committee that drafted standards that staunchly defended curatorial control. "The process of selecting themes, photographs, objects, documents, and other components to be included in an exhibit," the standards stressed, "implies interpretive judgments about cause and effect, perspective, significance, and meaning." Exhibits should be "founded on scholarship, marked by intellectual integrity, and subjected to rigorous peer review," it continued. Museums should identify stakeholders, be aware of diversity, and when dealing with controversial subjects "acknowledge the existence of competing points of view." Lonnie Bunch, associate director for curatorial affairs at the museum, and curator Paula Johnson joined the SHFG committee that, under the direction of Victoria A. Harden, authored the standards.[22]

In April 2001 the Organization of American Historians (OAH), the largest group of historians who studied US history, supported NMAH curators demanding that the Smithsonian adhere to the History Standards.[23] James Bruns, former director of the Smithsonian Postal Museum as well as a former curator at NMAH, had moved to the Castle as Director of Operations and clumsily attempted to invent a scholarly conspiracy against Catherine Reynolds. On June 11, he attacked the OAH resolution on history standards, charging inaccurately that it "relied almost entirely on one-sided opinions and media accounts" as well as its contacts with the museum's Congress of Scholars and "has now become part of the spin surrounding this subject." He praised NMAH curators who were working with Reynolds and, echoing Secretary Small, fantasized that the Behring and Reynolds gifts would "transform that museum into a 21st century showpiece," a startling notion and demeaning judgment of the museum. His argument implied that curators were simply to dress Catherine Reynolds's achievers in academic robes. His mean-spirited letter, Umansky's gag rule, and Small's secret contracts did not inspire confidence in the Castle's integrity.[24]

Bruns would have more letters to write, as on June 14 the National Council

on Public History complained to the Board of Regents that "donors should not control the content of exhibits." On June 18, the Council of the American Historical Association (AHA), the country's largest organization of historians that included all historical disciplines, unanimously approved a resolution reaffirming the History Exhibit Standards and mentioned other organizations that subscribed. There was a solid wall of support for curatorial control among the country's leading scholars. The AHA resolution called upon the regents to revise the agreement with Catherine Reynolds. Small's support of Reynolds in particular and of donor intrusion in general had drawn protests from eighty scholarly organizations, but incredibly, or perhaps predictably, such heavyweight fire from the country's leading scholars bounced off Small and his prime backers—the regents—revealing contempt for academicians, public historians, and especially museum curators.[25]

On February 4, 2002, Catherine Reynolds pouted and took back her $38 million. "Never in our wildest dreams," she wrote to Small, "did we anticipate that the notion of inspiring young people by telling the stories of prominent Americans from all disciplines would be so controversial." Her idea for the exhibit, she explained, focused on the power of an individual to make a difference and was "the antithesis of that espoused by many within the Smithsonian bureaucracy, which is 'only movements and institutions make a difference, not individuals.'"[26] Several curators were aghast that Reynolds so poorly understood and gravely misarticulated their arguments. Neither Reynolds nor Behring was interested in history but rather intent on celebrating a conglomeration of callous capitalists, jocks, and TV personalities, and their donor desire floated without a historical anchor. There was a wax museum sophistication to it. Catherine and Wayne Reynolds never understood that what grated on the staff was not only their simplistic *Spirit of America* idea but also the threatened fracture of curatorial prerogatives that traditionally originated, shaped, and mounted exhibits. Even all the resources of the Castle could not batter down the will of NMAH curators, who, while attempting cooperation with Reynolds, held to history standards.[27]

That the institution had gone so far down the appeasement path troubled me, and my correspondence recorded contempt for what I construed as Peter Liebhold's overeagerness to please Reynolds. Peter talked incessantly about humanizing achievers by bringing them to life, but would that mean warts and all? Great achievers were inexorably caught in the flow of history, and amplifying their achievements drowned out other historical actors.[28]

Catherine Reynolds might have improved her understanding of history by applying for a student loan herself and signing up for a few history courses and even awarding Kenneth Behring a student loan to join her. Lawrence Small had eagerly ushered them into his Smithsonian dungeon with his secret deals, contempt for museum professionals, and haughty disdain for Smithsonian history and tradition.

In the aftermath of the Reynolds affair, the *Washington Post*'s Bob Thompson found the couple bitter, with Catherine maliciously suspecting that the curators had a difficult time raising funds for their exhibit ideas and her husband contemptuously querying, "Why don't you ask them what *they've* ever done for America." Marc Pachter, acting director of NMAH after Spencer retired, allowed that with proper coddling an achievement hall could have been done to the satisfaction of both Reynolds and NMAH curators. He pontificated that the museum should serve as a "cathedral of national identity" and that visitors should commune with significant objects. Curator Katherine Ott took exception to Pachter's fuzzy vision. "The idea seems to be that you don't have to tell a story, that you can just show cool objects and that will interest people." She believed in a larger mission. "I think Marc Pachter is very much in the camp of the secretary, that it's okay to commercialize us." Although Catherine Reynolds vindictively departed, Kenneth Behring continued to fund and promote his notion of history.[29]

Despite the fallout over the Reynolds gift, Kenneth Behring's celebratory vision had not diminished, nor had his estimation of NMAH exhibits improved. "I think they should all be taken out," he judged. "We'll keep the presidents and the first ladies. Maybe update both a little bit. Basically it is stale." He wanted a visitor to emerge from exhibits "proud to be an American." Barney Finn remonstrated in March 2002: "We're getting into a chauvinistic, flag-waving type of thing." A month later, Barney argued that the Castle was selling the Smithsonian name, thus threatening its integrity. "We are trying to present history in an unbiased professional way using the best scholarship, but the public will get the impression the Smithsonian is for sale."[30] Some observers saw the new generation of wealthy donors as far more demanding than previous supporters; they believed that, had the Smithsonian held to its standards and protected its reputation, donors would not have breached its wall of integrity.

In the midst of Catherine Reynolds's assault on exhibit standards, the Emory University History Department offered me a one-year position as

Rebecca Lynch walking the track.
Author photo.

distinguished professor of southern history. This offer coincided with another opportunity. Andy Ambrose, the executive director of the Atlanta History Center, had earlier approached me about an exhibit on stock-car racing. Andy had been a graduate student at the University of Tennessee when I taught there and later completed his PhD at Emory University.

Even before I left for Emory, our *Speed and Spirit* team had interviewed several dozen men and women stock-car drivers, mechanics, and wives and were anxiously awaiting funding as Bob Staples and Barbara Charles began design. Gary Geboy and Rick Patterson again handled video and sound, Rebecca Lynch, a former intern, handled logistics, and I became producer.

Drivers, mechanics, owners, and hangers-on were all working-class, some World War II veterans, others "trippers" (drivers of moonshine cars), and others who simply liked to drive faster than the next guy. Among the women

Clay Call's garage.
Author photo.

drivers, Louise Smith was fast and fearless. She told us, for example, about becoming infuriated with a driver who did not want her to race at Richmond while other drivers insisted that she drive, and how, on a poorly lighted track, she got up with the offensive driver and put him through the fence.

We interviewed Junior Johnson at his home in Wilkes County, and he told of his ambition as a young man to pitch baseball, of learning to drive liquor cars, and his career both racing and then owning a winning team. He admired Tom Wolfe, who wrote "The Last American Hero Is Junior Johnson. Yes!" for *Esquire*. After the interview, Johnson directed us to the house of one of his neighbors, Clay Call, reputed to be the best bootlegger in Wilkes County, and thus, the nation. "He's the stoutest man I've ever known," Call said of Johnson. We interviewed Call in his garage, which housed a dozen liquor cars. Like many of the musicians we interviewed, the stock-car community was not highly educated but was intelligent and articulate. We interviewed some thirty people, and the videos are housed at the Atlanta History Center.

Even before I left for Atlanta, a Blue-Ribbon Commission had reported that NMAH was gloomy and disorganized and that visitors needed an introductory exhibit, a chronological map, as it were. Commissioner Roger Mudd "felt

that one of the problems with the teaching of American history, at least in the last 20 or so years, was that American history got cut up in little pieces of gender study, black study, gay study, labor study and so forth," and lost "the grand sweep of American history." Had Mudd paid attention, he might have noticed that the "little pieces" were being sewn by historians into a quilt that included rather than excluded previously neglected Americans.[31] The Commission's vision, it seemed, was to rehearse myths and keep white men sacrosanct.

My move to Atlanta went well, primarily because Andy Ambrose arranged for me to rent his friend Paula Chance's condo in the Virginia Highland community, several miles from Emory. I often drove over to the Atlanta History Center to meet with Andy, director Rick Beard, and the staff to discuss the as yet unfunded stock-car exhibit. The center was energetic, visionary, and ambitious, and shined much brighter than NMAH. I also enjoyed walks along Highland Avenue, lined with coffee shops, restaurants, residencies, and stores. On one of my first outings as I walked toward Virginia Avenue, a young woman walking toward me smiled and said hello. I'm sure I flinched before responding. I imagined smiling and saying hello to a woman walking along Pennsylvania Avenue on Capitol Hill and hearing her scream or even slap me. There was an easygoing civility in Atlanta that encouraged a smile and a greeting

The History Department at Louisiana State University had invited me to give the 2004 Walter Lynwood Fleming Lectures, named for a prominent LSU history professor. Since the series' 1936 founding, distinguished historians such as C. Vann Woodward, John Hope Franklin, Drew Faust, and Jacquelyn Dowd Hall spoke and significantly revised not only the Fleming generation's interpretation of the Civil War and Reconstruction but also much of southern history. There was enormous pressure to present three significant lectures, and in addition the Fleming lecturer was also committed to LSU Press for a book manuscript. Still intrigued by earlier research on toxicity, I had returned to the National Archives and to the Agricultural Research Service (ARS) records and discovered a wealth of documentation on health issues, bureaucratic perfidy, and leads that directed me to the Library of Congress Law Library and eventually to southern state cases and trial transcripts. Emory University subscribed to LexisNexis, which allowed me to locate state and federal court cases involving toxic chemicals, and proximity to the Federal Records Center in Atlanta allowed follow-up.

Crop dusters (or aerial applicators, if you prefer) opened a dark window

into pesticide dangers. Documentation at the records center yielded rich material, for example, the flying credentials of Jose G. Gonzalez, a young Mexican crop duster who in August 1961 crashed while spraying in South Carolina to earn money to continue medical school in California. Nearby field hands had rescued him, and at the hospital doctors treated his injuries but, as he continued to weaken, turned their attention to the Folex powder that spilled on him when the plane flipped. They sent for the label on the bag, but unfortunately it cited neither ingredients nor antidote. Suspecting organophosphate poisoning, they administered antidote, and Gonzalez rallied but remained hospitalized from August 29 until November 17, 1961. He successfully sued the Virginia-Carolina Chemical Company for damages sustained because the Folex label did not warn of dangers or list an antidote.[32] In other cases, the regional archives files included photographs, partial trial transcripts, and biographical information.

A tantalizing lead in the ARS papers led to the Library of Congress law library and on to the Mississippi state archives, to a court transcript in the significant *Lawler v. Skelton* case, and finally to Drew, Mississippi, to the plaintiff lawyers' records. Attorney John McWilliams brought out a thick stack of documents from the vault and I began reading, but suddenly it was nearly noon and I had to be in Oxford that afternoon for a talk at the Southern Foodways conference. When I asked John if I could xerox some of the material, he replied, "Why don't you take it with you and when you finish just send it back." With the threatening, even punitive, echoes of National Archives and Library of Congress security haunting me, I said that I couldn't take the documents. John smiled and explained that all the people involved in the case were dead and when he and his partner, Lawson Holladay, retired all the material in the vault would be trashed. I took the documents and back in Atlanta pored over the material and xeroxed invaluable documents before sending them back. The case became the central story in the Fleming lectures.

On November 6, I met with Rick and Andy to review our funding prospects. With forty-three race cars each week circling the tracks proudly displaying sponsors, I wondered why none was interested in a major exhibit in Atlanta that would obviously be good for NASCAR and its brand. By this time Rebecca Lynch was looking for a job, since her funding ended first of the year.[33] With a brilliant design by Bob Staples and Barbara Charles, with the video interviews, and with people sharing their knowledge of stock-car

Lawson Holladay and John McWilliams.
Author photo.

racing, it could have attracted new visitors to the Atlanta History Center and explained how working-class people constructed a remarkable racing series.

Most of my time in Atlanta was spent preparing and presenting lectures and advising students, in particular graduate students. Both the graduate and undergraduate writing seminars yielded excellent papers, and I enjoyed pointing students to productive topics, directing them to sources, and reading their drafts. As much as I enjoyed teaching, I was always looking over my shoulder toward the Atlanta History Center and the Smithsonian.

The heavy dose of new technology needed to prepare lectures confronted my Smithsonian computer, and it burped and then seized. I emailed my supervisor, Steve Lubar, insisting it be replaced, and was offended when he snidely replied that my laptop should be sufficient. The laptop was my personal computer, I countered, and not up to the heavy duty of manipulating images. His knee-jerk negative reaction pissed me off, for the new computer would be billed to my 402 honorarium fund, flush with my advance for *Lost Revolutions*, or so I thought. Although I got a new computer, Steve evaded my request for a balance of my 402, no doubt because his lack of oversight had

allowed the staff member in charge of the accounts to bungle them, and all my funds had vanished.

As head of the division, he evaluated staff performance, although he had never asked me about my work for half the year in Washington or the half in Atlanta. On January 3, he faxed my performance plan that had been due back in September, and he only sent the cover page for a signature—not pages with discussion of my work.

I would miss the intellectual stimulation and more vigorous social life in Atlanta. In one week, for example, I dined with visiting Larry and Cornelia Levine and others after his talk, had dinner with the Betsy Fox-Genovese and Gene Genovese, enjoyed a drag show with friends, and had a pint at Manuel's on Tuesday, as was customary. My good friend Helen Rozwadowski, a former museum fellow, was teaching in Atlanta, and we conspired to continue the traditional Tuesday evening gatherings, and she and Connie Curry were regulars.

As my time in Atlanta was running out, I drove over to Helena, Arkansas, for the installation of an exhibit on the 1927 Mississippi River flood at the Delta Cultural Center. Heather Guy, the designer, worked closely with me on labels, images, and music, and the center staff was intent on getting everything perfect. In 2003, *Water Steals the Land: Arkansas' Great Flood* was judged the year's best exhibit by the Arkansas Museums Association.

On July 3, I attended a going-away party hosted by my friend Dana Randall, a Georgia Tech mathematician who had spent time at Microsoft and in the UK at Cambridge. I said my goodbyes and the next day drove the 650 miles to Washington and arrived in time for the fireworks.

10

Entropy

His education was small, like his mind.
—GEOFFREY CHAUCER, *The Canterbury Tales*

If you're stupid, how can you tell?
—IAN MᶜEWAN, *Nutshell*

My tenure with Emory was for the academic year, so I did not officially report back to the museum until September 2002. I continued research for the Fleming lectures, renewed my contact with museum fellows, attended the Irish Times Tuesday evenings, and hosted a celebration for two museum fellows who finished their degrees. The museum was transitioning from director Spencer Crew through acting director Marc Pachter to incoming director Brent Glass.

At a planning session for a fiftieth anniversary exhibit on the 1954 *Brown v. Board of Education* decision on school segregation, I raised questions about the team's focus on the contribution of Howard University Law School attorneys rather than featuring local people who brought the legal challenges at great risk, especially in South Carolina. The exhibit offered the opportunity to go deeply into the separate and unequal nature of education, discuss the sacrifices of Black plaintiffs, and analyze the racism of southern whites who resisted the ruling. Acting director Marc Pachter minimized *Brown's* importance, while I argued that it was vastly significant and needed to be contextualized by broader civil rights history. Down in Charlotte, former intern Robin Morris was working on a *Brown* exhibit at the Levine Museum of the New South and wanted to display Jesse Helms and Strom Thurmond as lawn jockeys.[1]

In September, I submitted an ambitious exhibit proposal on the rural South from George Washington to Jimmy Carter to the Exhibits Program Committee, often dubbed the "Exhibits Prevention Committee." It was late

November before Jim Gardner tardily replied that the museum was "in limbo" but the committee would keep my proposal "on the table for discussion." I never heard another word about it. The museum, of course, had been hogtied installing the *American Presidency* exhibit, catering to Catherine Reynolds's fantasy of great achievers, and clearing space for Behring's upcoming celebratory military exhibit. The devilish arrival of Kenneth Behring and his architects and designers dictating the exhibit agenda while museum curators stood idle on the sidelines portended disaster.[2]

For years I had criticized the old Agriculture Hall for being a conglomeration of machines without farmers and without context. It was an exhibition that suited the museum's technological aspirations when it opened in the mid-1960s but was hopelessly outdated in the new millennium. Still, I found myself defending the hall against those who desired to banish agriculture altogether. A rumor spread that the three tractors sitting in the north window of the hall, the Case No. 1, Rumely Oil Pull tractor, and Waterloo Boy, would be moved. More significant, I learned that the American Agriculture Movement (AAM) tractor would be taken off exhibit, a move that would not only upset AAM members but also raise questions about keeping on exhibit a quilt made by AAM member Ruth E. Stude of Dodge City, Kansas, that was an important reminder of the work of farm women.

The AAM tractor had belonged to Gerald McCathern, wagon master of the February 1979 demonstration that tied up Washington traffic and led to nineteen arrests and seventeen tractors impounded. Police corralled the remaining farmers and tractors on the Mall in sight of USDA headquarters. Smithsonian photographers roamed the Mall, capturing dramatic action amid the snow and protests. When Washington stopped cold after a twenty-inch snowfall, farmers' tractors transported doctors and nurses, assisted the fire department, and taxied government officials. AAM women volunteered to cook and clean in hospitals when regular staff could not get in. This volunteer spirit challenged unfavorable press reports and USDA condemnation. Over the years, AAM gained influence in US agricultural policy and each year sponsored a dinner on Capitol Hill that Larry Jones and I attended.

The AAM tractor had been a popular exhibit that stood near the entrance to the Agriculture Hall with a plaque listing the donors and with Ruth Stude's quilt mounted on a nearby wall. Word spread that Secretary Small had promised a major donor, the owner of a Pontiac convertible (driven by its owner across America supposedly establishing its uniqueness) that his car would be

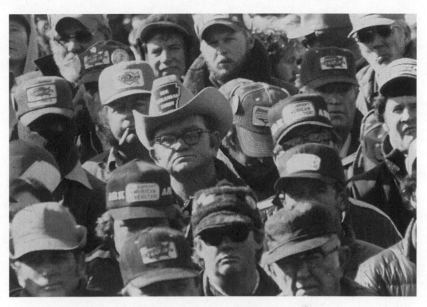

American Agriculture Movement members at
the 1979 demonstration. *Author photo.*

on permanent display, presumably replacing the tractor. Larry Jones tagged it
the world's most expensive parking spot. Fortunately, the Pontiac was parked
elsewhere.

Even after he retired, Larry came up with significant questions. The "Old
Number 1" steam engine, manufacturer J. I. Case's first portable steam engine
dating to 1869, was one of the agriculture collection's iconic objects. It had
been on display in the Constitution Avenue window until removed for res-
toration. Larry learned that it had been "discovered" on a Minnesota farm
in 1925, and three years later Case donated it to the Henry Ford Museum
only to borrow it back in 1942. When the Henry Ford asked for its return,
Case problematically claimed that it had only been loaned. After the object
had made a few appearances at celebrations, the Smithsonian requested cus-
tody. Given this shaky legacy, Larry questioned if the Smithsonian actually
owned the No. 1, and we never found a deed of gift in the accession file.
Larry also raised questions about its authenticity, observing that documents
indicate Case No. 1 was constructed on a wagon frame and had a prototype
engine, while the Smithsonian's Case did not rest on a wagon frame and had a

Case No. 1, restored.
Richard Straus. Smithsonian Institution.

production engine. Likely, Case updated the engine and frame, although it is possible that No. 1 was not really No. 1.[3]

When the announcement came on October 18, 2002, that Brent Glass was appointed director of NMAH, he seemed promising, a University of North Carolina PhD in history, experience with oral history, and head of the Pennsylvania Historical and Museum Commission. According to a flattering *Washington Post* article published when he assumed duties, Glass championed "The American Dream" and a celebratory version of US history, but despite its resemblance to the Behring/Reynolds achievers notion, the staff desperately hoped that he would blow a much-needed scholarly breeze into the museum.[4]

On November 20, before Glass arrived, the NMAH Congress of Scholars sent him a memo outlining the preoccupations of the curatorial staff. Research and collections headed our priorities, and the memo observed that "both the

understanding of and appreciation for research have eroded dramatically over time and precipitously in the recent past." In addition, staff attrition undermined many programs. Curators also protested moving the Archives Center to make way for Behring's war exhibit and asked that the fellows program be restored and strengthened after being zeroed out by Secretary Small. Finally, Brent was invited to attend Tuesday colloquiums, visit collections, and informally discuss issues with the staff. So far as I know, he attended only one colloquium, avoided collections, and discussed issues only with his poppets.[5] He had no vision to offer the museum but cocked his ear to Behring's desires and blindly followed Secretary Small's misguided leadership.

As the new year approached, I was eager to welcome the new director, and especially to pursue Organization of American Historians (OAH) president Jacquelyn Hall's initiative that she shared with me to create a program that would bring academicians to the museum for lectures and informal discussions. On December 31, the day Brent arrived, I dropped by his office to welcome him and offer my cooperation. Preoccupied with installing his new computer, he barely looked up from the tangled wires to mumble thank you, sourly uncongenial. He had earlier dismissed my good wishes offered at the Southern Historical Association convention. Naively, I had thought that because of his connection to UNC and Jacquelyn he would take a lively interest in scholarship and bring the museum out of its death spiral. I even foolishly fantasized that he might call upon me for exhibit ideas and to discuss history projects. He never engaged me in a discussion of history or mentioned to me, or so far as I know, to anyone else Jacquelyn's idea of distinguished lectures, and when the subject came up at an OAH board meeting several years later, I explained that Brent had killed and buried the idea.

As the museum drifted ever further into commercialism, it embraced simulators, adding a carnivalesque dimension. Jim Gardner asked my opinion of placing the Richard Petty No. 43 race car, the one he drove for his two hundredth win at Daytona, on exhibit beside a NASCAR simulator. "Juxtaposing an important, even iconic, object with a carnival ride cheapens the object," I replied. "What labeling could possibly span the distance between the career and significance of Richard Petty (and his family) and the NASCAR simulator?" While Brent and his minions might deign to exhibit Petty's race car to pump money into simulators, they no doubt would refuse to consider an exhibit on stock-car racing, even though it would bring visitors into the museum who might otherwise never darken its doors.

Brent called me to a meeting on Tuesday August 26, 2003, ostensibly about exhibits, but instead announced his decision to move the AAM tractor out of the museum. The Pontiac's finding another parking space had caused me to hope that the AAM tractor was safe, but Steve Lubar and Brent lamely claimed that the tractor, seventy-five feet away from the entrance of the *America on the Move* exhibit, would impede the flow of visitors. Brent, ever feckless, cautioned me about allowing his decision to leak out and provoke AAM members to demonstrate, as if I could control untamed farmers. A few years later, after I had watched him totally dismember the Agriculture Hall and endured more of his pettiness, I would have championed a demonstration. At the time, though, I still naively hoped Brent might be persuaded to do an exhibit on rural life. In fact, shutting down the Agriculture Hall and removing the AAM tractor was part of Brent's design to erase rural America from the museum. The tractor left on September 9, 2003. I do not expect it to return.[6] Rural life, rock 'n' roll, and stock-car racing evidently lacked the charm of great achievers or war.

Museum visitors occasionally discovered erroneous labels or brought issues of authenticity to our attention. On August 26, 2008, for example, I got a call from Dale Graves about our Snapping Turtle lawn mower, which was on exhibit in *Science in American Life* and purported to be the first mower off the line. It was not the first off the line, Graves insisted, for the engine color and make did not match the chassis run, and he wondered about the engine serial number. I emailed Larry about this, and he admitted his suspicions from the beginning about the first-off-the-line claim. Such inquiries as those by Dale Graves and Larry's skepticism about Case No. 1 made museum work more interesting and taught a healthy skepticism of donor claims. It never bothered me when a visitor raised questions about labels, for I always learned from being corrected.

I doggedly continued to pursue funding for an agriculture hall based upon my scholarship. Back in the 1980s, the museum development office worked with me on a proposal to John Deere, the implement manufacturer, for an exhibit on rural life in the South that included, of course, poor Black and white farmers. We produced a slick brochure with themes and objects and made it to Deere headquarters assured that funding would follow. Deere refused, to my mind because our proposal was not celebratory but focused on the rural working class. As I was dejectedly leaving the office, the Deere

officer said to me, "Why don't you do wheat?" It felt like a slap. Biting off the vulgar reply that sprang to mind, I only said, "It's already been done."

Still, in January 2003 I had lunch with a John Deere executive, and we again discussed possible sponsorship of an agriculture exhibit. In late June a delegation including representatives from Deere and the Kellogg Foundation arrived at the museum, and Brent led a tour through the old Agriculture Hall (the part still open) and the closed *Engines of Change* space and mumbled vacantly about an exhibit on business, something I'd never heard articulated by any curator. Months later, my contact at Deere called and asked what was going on, that there had been no response from Brent. He had not spoken to me either, no surprise there. His stiffing a possible funder was, to say the least, rude and irresponsible. "So much potential, so much waste," I wrote in my notebook during an August 19 staff meeting.[7] I wondered why agriculture was offensive to Brent until I figured out that it was me who was offensive.

Despite this fiasco, another meeting took place on October 15 when six Deere representatives met with Brent and several other staff. While Brent, obviously unfocused, was rambling through exhibit halls and speculating about future exhibits, I recalled that earlier in the morning I had been in the photo studio chatting with photographer Hugh Talman. Rushing back to the studio, I asked Hugh to abandon the project on his screen and print two eleven-by-fourteen-inch copies of his striking photograph of the iconic John Deere plow, thinking this was just the public relations gesture that might create a warm feeling for the museum. I handed the prints to Brent to present to the Deere delegation. Hugh's eagerness to help me was a remnant of the old system of favors that required no requisition, but sadly this kind of cooperation had almost dried up, and it certainly meant nothing to Brent. He never thanked me or even acknowledged Hugh's effort, and I'm not even sure he gave the photographs to the Deere delegation.

In mid-summer 2003, I drove the 720 miles to Penfield, Illinois, for the I & I Antique Tractor & Gas Engine Show to see the coming out of the Hart-Parr No. 3 tractor restored by Oliver Schaefer and his crew. Larry Jones was already there when I arrived late afternoon just ahead of a dark rain cloud. The No. 3, manufactured in 1903, is the oldest surviving internal combustion tractor, and it had arrived at the Smithsonian in 1932, a gift from the Oliver Chilled Plow Company. It had been on exhibit in the Agriculture Hall for years until Larry decided that the drab tractor, missing its canopy and

Unrestored Hart-Parr tractor loaded for trip to Illinois.
Author photo.

painted black over its original paint scheme, should no longer be on exhibit but instead restored to its original specifications.

Oliver Schaefer's shop in Greenville, Illinois, won approval, and amid snow flurries in late January 2003, Ollie and his daughter Sherry and several other people from Illinois, along with Landis Zimmerman from Pennsylvania, loaded the No. 3 on a flatbed and headed off to Illinois. Done according to exacting Smithsonian conservation requirements and supervised by Larry, the restoration turned out immaculate. John Tichenor overhauled the engine, keeping detailed records of what survived in good shape and what had to be replaced (keeping the old parts), and Sherry built a canopy using photographs and original specifications. Ollie discovered original paint that had resisted earlier sandblasting, matched it, and restored the tractor to its original colors. Larry and I interviewed Ollie's team, and Ollie and Sherry Schaefer and John Tichenor provided invaluable information on restoration. The formidable Darius Harms handled our association with the I & I museum and calmly presided over the hundreds of machines and thousands of visitors to the event.

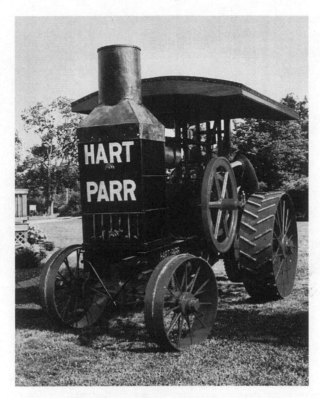

Restored Hart-Parr No. 3.
Original in color. Sherry Schaefer.

Visitors to the event lined up to watch us start the Hart-Parr and listen to its distinctive hit and miss firing order and drive it from the museum to its place on the showground. Larry and the restoration team answered questions from people who loved machines and had expertise in restoring and running them. The No. 3 joined the Saturday parade and pulled a threshing machine through the grounds. I watched tractor pulls, kicked tractor tires, and chatted with farmers and restorers. On Sunday morning I started home at 4:30 just as the first faint light appeared and the full moon set. The fields were shrouded under knee-high ground fog, and the rising sun over the fog created a breathtaking landscape.

The museum was gradually losing a group of specialists that over the years had provided enormous expertise. Bill Worthington, a skilled craftsman who

Bill Worthington, Stan Nelson, and Larry Jones
in Larry's home shop. *Author photo.*

had a keen understanding of heavy machinery, retired in May 2003. Bill was
part of the group of specialists that included Larry Jones, Stan Nelson (an
expert on printing presses who retired in October 2003), David Todd (time-
keeping), and Ray Hutt (electricity). Bill complained that Steve Lubar, his
supervisor, never utilized his talents, and this, of course, dispirited him. His
retirement party was held away from the museum and included only invited
guests. Years later, Larry declared that when these men retired "all of that
expertise went out the door with us," since no apprentices had been brought
on to learn their skills or tap their institutional memory. "We were thought
of as odd balls, obstructionists and non-team players," Larry wrote in 2008,
because they refused to buy in to the "never ending stupid impractical ideas."
The only time they were recognized, he continued, was "when management
got their balls or boobs in a crack and needed someone to wedge the crack
open." He summed up how his colleagues, and by extension many of us, felt.
"One of the best things NMAH and maybe the Smithsonian as a whole does
best, is waste talent. They excel in that area."[8]

On November 1, 2003, Larry Jones retired, and although I was happy for
Larry for me it was a sad day. I thought back to our trip to collect the Smith

cotton gin in Georgia, the tractor posters, collecting tractors and threshing machines, threshing on the Mall at the Folk Festival, and our unique relationship in handling museum work and agricultural inquiries. I don't recall a harsh word between us in all those years, and we built mutual respect that allowed us to serve the museum, in my case as a historian of rural life and in Larry's as an expert on machinery and manufacturers. When Larry left, there was no longer anyone in the museum who could reply to inquiries about technical aspects of farm machines and, in a more sweeping way, no one with his deep well of common sense and problem-solving acumen. Larry and I stayed in contact, and when I was stumped he would graciously help me. With more resources, I am sure, Larry and I could have continued to develop projects that both added to the museum's collections and increased and diffused knowledge.

It was fortunate that I was working on the Fleming lectures, involved with historical organizations, and cooperating with Larry on projects until he retired, for it was obvious that neither the staff nor the leadership of the museum gave a damn about my work. Brent Glass listened only to a few staff intent on pleasing him, had no vision for the museum, was consumed with planning the renovation of the museum's central core, and fawning over Kenneth Behring's exhibit enthusiasms.

I continued speaking and doing research and in October 2002 had participated in a conference, "Revolution in the Land," at Mississippi State University. I spoke on pesticides and mentioned Dr. Mary Elizabeth Hogan, a physician who in the mid-1950s ran a clinic in Glen Allan, Mississippi. In 1957 Black farmers crowded the yard outside her clinic, confused, running high fevers, coughing, and spitting up blood, and Dr. Hogan diagnosed the illness as organophosphate poisoning from parathion being sprayed in the area, and treated them successfully with atropine, the antidote. When she shared her diagnosis with the press, planters quickly denied toxicity, and state health officials conveniently diagnosed the illnesses as the Asian flu. Because her clinic windows were open, parathion from crop dusters drifted in, and she fell ill, left the Delta to recover, but she could no longer tolerate organophosphate mist and so could not return to her clinic. The year before her illness she had talked with Charles Lawler from Sunflower County, who in 1956 had been poisoned and was bringing a suit. Dr. Hogan testified in the Lawler trial, but an objection halted her diagnosis of organophosphate poisoning although on appeal the Mississippi Supreme Court ruled that her testimony should have

been allowed. Fortunately, the files in prosecution attorney Pascol Townsend's office contained her deposition. After leaving the Delta, she studied psychology and spent the remainder of her career at Whitfield, the Mississippi institution for the insane.

It was March 2003 before my historian friend Martha Swain put me in contact with Dr. Mary Elizabeth Hogan, who was living in Pearl, Mississippi. Unfortunately, she had dementia. Helen Neal, a friend from her days in Glen Allan, cared for her and answered many of my questions as Dr. Hogan looked on. At one point, I asked if she recalled after she had diagnosed and publicized parathion poisoning that Mississippi health authorities claimed it was Asian flu. "The Asiatic flu," she exclaimed as the words penetrated her dementia; she was still upset that health authorities covered up pesticide poisoning. Dr. Hogan kept neither personal nor work-related papers, and Helen Neal told me that her friend's life had been spent caring for others with no thought of her historical role. I copied several photographs, including a black and white image of her standing beside her red Chevrolet convertible in Glen Allan after a rare snow.

On July 22, 2004, Claire Sargent, a close relative of Dr. Hogan, notified me that she had died and asked me to write an obituary. Both Dr. Mary Elizabeth Hogan and Elizabeth Hulen, one of the attorneys for the prosecution in the *Lawler* case, were among the first generation of Mississippi women who gained professional status in medicine and law. Neither left personal papers, and both have sadly faded into the mists of history.

In the late winter of 2003, I polished the Fleming lectures, read manuscripts, advised fellows, and emailed Larry Jones about Sherry Schaefer's new magazine, *Oliver Heritage*. I was also calling people with the last name *Lawler* in north Mississippi, east Arkansas, and west Tennessee hoping to find a relative of Charles Lawler who could tell me how long he lived after the 1960 trial and more about his family. He had been poisoned in 1956, testified in the 1960 trial, but then disappeared.

At last I headed south to Baton Rouge for the Fleming lectures and stopped in Memphis to visit Jim and Brenda Lanier. On Saturday, Jim and I drove out to the Velsicol chemical plant, for I wanted to see the facility that poisoned millions of fish in the Mississippi River in the early 1960s with its discharges of dieldrin, a chlorinated hydrocarbon. The plant had also occasionally given off fumes that sickened workers or nearby residents, and the Wolf River and its banks had been contaminated with dieldrin runoff. Velsicol also disposed

of chemical residue in the nearby Hollywood dump, which occasionally overflowed and washed chemicals into the river. I took some photographs of the facility.

On Sunday evening the Laniers hosted a dinner party that included my good friends David and Angela Less, along with their daughter, Emma. Angela is from Arkansas and occasionally goes on about family. "Emma McGuire Less," she said, looking at her daughter, "was almost named Emma Lawler Less." I flushed. "Lawler?" I thought I must have misheard her. "The crucial case in my talk down in Baton Rouge," I quickly explained, "is about a man who was poisoned by a crop duster in 1956, Charles Lawler." Angela casually replied, "Oh, Uncle Charlie; he was poisoned." It was suddenly quiet around the table as we digested this unlikely and remarkable coincidence. Angela continued that she recalled when they visited the Lawlers her uncle Charlie was always on oxygen and remained in poor health. She also put me in contact with the family, and I secured photographs and biographical information that proved invaluable in completing the story.

The *Lawler* case epitomized the larger story of pesticides and health that I developed in the three Fleming lectures, and I had collected numerous images, including photographs of ARS officials, Velsicol chemical drums in a flooded Hollywood dump, crop duster photographs taken by the Smithsonian's Laurie Minor Penland, pesticide packaging from deadly lindane vaporizers, and images from trial evidence. I felt assured that the lectures were compelling and well-illustrated and lived up to the high Fleming standards.

In the fall of 2004, I was back in Memphis for the Southern Historical Association convention and had dinner with Sue Culver, one of Charles Lawler's daughters. I learned from Sue the harrowing family history after her father was poisoned. He was a skilled workman, a gin manager, and a solid family man. After the poisoning, he could no longer manage the gin and was fired. The family broke apart, Sue told me, and the children were dispersed among relatives. She was not confident that she could even talk about this part of her life because it had been so traumatic, she admitted. I thought about how her father was callously dismissed from his job, provided with scant workers' compensation, and sentenced to taking oxygen and suffering the remainder of his life. The slippery expert witnesses, perjury, and sustained objection to Dr. Mary Hogan's testimony again outraged me, even though the trial had taken place forty years earlier.[9]

Back at the museum, the inertia was frustrating, as if trying to get started

with the emergency brake engaged. Brent's staff meetings were boring, unin-
formative, and poorly articulated. He droned on about plans for renovation of
the central core that remained in flux as architectural dreams were trimmed
to fit financial stringency. Always focused on scholarship, on March 23, 2004,
Barney Finn put forward a proposal to install a small case outside the Archives
Center featuring works that demonstrated the scholarship that flowed from
fellows who used Smithsonian resources. The case never appeared, but the
effort to create it could serve as a poster of Smithsonian bureaucratic paralysis
as first the Exhibits Program Committee delayed approval, followed by end-
less meetings about placement of the case, its restoration (it was a rescued
case), contents, and design. Museum leaders should have made this case a
priority, but evidently scholarship was better ignored.[10]

The Lawrence Small administration, meanwhile, continued as malign
background noise, until after seven years of his incompetence the Board of
Regents awoke from its stupor. On March 20, 2007, it appointed a three-
person independent review committee to examine the Inspector General's
report on Small's "compensation, expenses and donations" and also appointed
a committee on governance. Small's transgressions were so blatant that even
the somnolent regents acted with alacrity and accepted Small's resignation
on March 24, 2007. They wisely (so out of character) appointed National
Museum of Natural History director Christian Samper as acting secretary.
He immediately increased funding for Smithsonian fellowships.[11]

The Smithsonian Board of Regents was composed of the chief justice of the
Supreme Court, the US vice president, senators and congressmen, plus citizen
regents nominated by the board and ultimately approved by Congress. Instead
of taking seriously its fiduciary responsibility to analyze the Smithsonian
budget and to review the Secretary's performance, it had been complicit in
Small's transgressions and poor decisions.[12]

On June 20, acting secretary Cristian Samper discussed the indepen-
dent review committee's findings on Lawrence Small's compensation and
expenses. "The report identifies many problems relating to leadership and
oversight of the Smithsonian in recent years," he wrote, "and makes a num-
ber of recommendations to strengthen the Smithsonian going forward." The
regents, he continued, "have accepted their responsibility and have taken
steps to strengthen their oversight of the Institution." Given the seriousness
and duration of Small's perfidy, this smelled of cover-up, although one would
hardly expect the chief justice, the vice president, several US senators and

congressmen, and wealthy corporate people to resign in disgrace, although the situation clearly demanded it. Governance by ceremonial heads of state and wealthy achievers had failed, and Small's appointment and the regents' approval of his disastrous decisions demanded a governance overhaul.[13] Instead, the regents shamefacedly admitted culpability but insisted that they would do better.

On June 27, a *New York Times* editorial titled "The Fall of Mr. Small's Empire" evaluated the review committee's findings. It illuminated the "governance crisis," Small's "self-isolating and 'secretive' management style," and declared the regents "largely ceremonial—and lackadaisical." In his seven-year tenure, Small took 950 days off from his job, received $5.7 million from corporate boards, and bilked the Institution for dubious perks. He was far less successful as a fundraiser than former secretary I. Michael Heyman. Instead of personifying enlightened corporate leadership, as the regents had expected, Small furnished a cautionary tale both of greed and of decisions that violated Smithsonian tradition and rules.[14] Historians in the future with access to Board of Regents minutes and oral histories will no doubt investigate the inner workings of the Small administration and reveal fully how the Smithsonian suffered under his tenure.

11

The Wages of Mediocrity

There are people who will go to great lengths to have influence
and to be made a fuss of; where they can't be oracles,
they turn themselves into buffoons.
—VICTOR HUGO, *Les Miserables*

As the fell shadows of Kenneth Behring, a major donor to the American history museum, and Smithsonian secretary Lawrence Small shrouded the Smithsonian in 2004, I met with curatorial head Jim Gardner about my future in the museum. I was planning to retire in two years, when I would turn sixty-six. It was dispiriting, I complained, witnessing the museum decline and erase opportunities for curatorial initiatives since Behring's money and his architect were shaping museum priorities. Brent Glass sidelined many curators in his embrace of Behring, and I suggested to Jim that the shrinking role and number of curators was eviscerating the museum. Given my age and status as a historian, I requested that I be relieved from reporting to a supervisor who was unsympathetic to my work. I knew that curators with far less to show either in publications or exhibits had been rewarded with senior status and trusted to continue their productivity. My request was not even taken seriously.

David Allison, ever the dependable soldier, saluted and became curator of *The Price of Freedom* exhibit and began crafting a military exhibit that would satisfy Kenneth Behring's desire for glorification. Allison found ideological compatibility with Behring and Glass the same as he had with the American Chemical Society and before that with sponsors of the Information Age exhibit. It intrigued me that Allison and I were always on the opposite side of issues.

Predoctoral fellow Carole Emberton from Northwestern University was writing a dissertation that focused on African Americans during the Civil War/Reconstruction era, and as her colloquium date neared she requested that David share his script so they might discuss the exhibit. Her request went unanswered, she told me, so I memoed David and stressed that in her talk Carole was focusing on the complex question of citizenship for African American soldiers, part of her larger dissertation project and a topic that might interest his team. David replied that his script was under development, and the team would not release it to anyone until it was complete, and, moreover, it would be "inappropriate." Inappropriate to discuss with a scholar a developing exhibit script? Preposterous. I thought back to my reliance both on Edmund Russell's research on DDT and his valuable script suggestions for *Science in American Life* and of circulating the *Rock 'n' Soul* draft script to a half dozen scholars and receiving back invaluable suggestions and corrections. When I introduced Carole for her colloquium, I suggested that while she was not allowed to see the exhibit script that the exhibit team might well benefit from Carole's scholarship.[1]

In mid-November 2004, *The Price of Freedom* opened to mixed reviews. Carole, meanwhile, had been assigned to review it for the *Journal of American History*, and her review appeared in the June 2005 issue. Allison had sanded down the country's military experience into a splinterless celebratory narrative, she observed, and the eagerness to focus on freedom and to glorify war led to an "utter collapse of analysis." She perceptively criticized the inclusion of artifacts from the World Trade Center and contemporary images from Afghanistan and Iraq as "sheltering them under the protective umbrella of freedom and sacrifice here placed over earlier wars." Carole also questioned the hall's name, the Kenneth A. Behring Hall of Military History. "The relationship between the production of public history and corporate/private financing is a thorny one," she warned, "and no doubt will continue to plague institutions such as the Smithsonian as long as the politics of historical exhibitions, like the politics of warfare, are written out of the record." In August 2005 when I congratulated Carole on completing her degree, I added that Brent Glass "has taken to wearing a red vest and leading VIPs through the *Price of Freedom*. It has become quite a joke."[2]

In May 2006, Air and Space curator Roger Launius gave a colloquium at NMAH analyzing how museum exhibits were suffering from donor intrusion and weak scholarship. He focused sharply on *The Price of Freedom*. "He read

from your review," I wrote to Carole, "even as *Price of Freedom* curator David Allison squirmed. There was the sweet smell of retribution in the air."[3] Brent continued to give red-vest tours, no doubt unmindful both of his Barnumesque spectacle and of military history. Carole's excellent book, *Beyond Redemption: Race, Violence, and the American South after the Civil War,* appeared in 2013. Sadly, former curator David Noble's warning twenty years earlier about donor intrusion had come to pass: a donor aggressively ignorant of history desiring a celebratory exhibit on war, a pliant museum director, and a curator intent on pleasing both. Scholars, as Emberton argued, were appalled at the exhibit's superficiality and neglect of significant historical questions.

By 2004 my efforts to collect objects were increasingly stymied. I had been negotiating to collect another cotton gin and a pea sheller and drafted my justification to the collections committee and asked Ed Ryan in objects processing to estimate shipping costs and Steve Hemlin in storage to find space. Hemlin replied categorically that there was no longer space for large objects. I joked with Ed that perhaps I could collect a pea. No one from Peter Liebhold on up replied to my argument that denying space meant that I could no longer perform a key part of my job; most rural objects were larger than peas. There was space, of course, testified to by the numerous items, large and small, collected and stored since then. The only thing the museum asked of me anymore was a list of my publications to convince higher-ups that despite low morale the staff was productive.

I distressingly witnessed some of my colleagues attending meetings, chatting in the hall, and staring at computer screens, appearing idly busy all day; still, many were discontent. A 2002 Smithsonian-wide staff survey had revealed ruined morale and distrust. Only 33 percent of NMAH staff deemed senior leadership "trustworthy" and but 39 percent believed leaders were "open and honest in communication." The evaluation of Smithsonian senior leadership (the Castle) was scandalously low, with 10 percent finding it trustworthy and 11 percent honest in communication. Only 10 percent of the staff thought promotions fair, and incredibly, only 28 percent would recommend the Smithsonian as a good place to work, down from 51 percent two years earlier.[4] Some administrators might regard distrust of leaders, poor morale, and lack of a constructive agenda a call for corrective action, but for Smithsonian leaders it only intensified denial.

In February 2005, after a year of planning, Brent announced his reorganization (every director reorganized thinking it would solve problems; it never

did). His plan promoted some specialists to associate curators, and several staff moved to more hospitable divisions. Some promotions were deserved; others not. I wrote to Larry Jones on February 22 that "the museum has wasted a year's time going through unnecessary hoops, reinventing rules, and generally pushing everyone to a short fuse. The people who do not get what they want, either in the requested division or the promotion to associate curator, are going to be pissed and surly, and the general morale will be even worse."[5]

Neither Brent nor Secretary Small looked kindly on academicians, and after the science exhibit NMAH practically stopped hiring curators, who, after all, might propose yet another controversial exhibit or take exception to Secretary Small's grand design that seemed likely to destroy the Smithsonian. While the museum appeared to be at full curatorial strength after the promotions to associate curator, it was a mirage. Few of those promoted to associate were involved in scholarly research and publication. My request to become a historian or senior curator was ignored, much to my regret. The unscholarly Peter Liebhold became head of the Division of Work and Industry and my supervisor, and he had not a clue to what I did as a historian or curator and undermined me with his ignorance and spite.

In November 2003, Brent assigned me to an introductory exhibit team charged with shaping an exhibit that introduced visitors to a comprehensible stream of US history, as the Blue-Ribbon Commission had suggested. I joined a dozen excellent curators, specialists, designers, and public programs staff, a remarkable cross section of players necessary to conceive and mount an exhibit. Dwight Bowers from cultural history headed the team, and from the first meeting there was a feeling that we could create an exceptional exhibit.

Museum exhibits, of course, are not textbooks, and curators probably over-optimistically assume that visitors have a basic understanding of US history, making it unnecessary to provide an exhaustive chronology that tiptoes across familiar milestones. Rather, our team focused on broad themes that offered a visionary and original sweep of US history. We met every week to share ideas, sometimes invited scholars and innovators to suggest new concepts and methods of presentation, and worked toward an exhibit that would be dynamic, scholarly, and fun. By late summer 2004, the team had moved into object selection and script preparation, and I had selected objects and was writing script for my nineteenth-century section. Our morale was high.

Brent had continually assured Dwight that he approved our work, although he never bothered to attend a meeting. In November 2004, a year into the

project, we submitted another enthusiastic progress report announcing that we were ready to finalize an object list and complete a draft script. Then in early December, Brent and Jim Gardner replied with the puzzling suggestion that the exhibit should have focused on how the land "shaped us as a people and as a nation." This revival of the Frederick Jackson Turner thesis of the frontier shaping US history was a bit dated, having appeared in the 1890s, and scholars had filled shelves with books complicating the idea. The memo continued with the warning that we had focused too much on "mythmaking," for "it runs the risk of being negative." Mythmaking was not a theme in our script, but there was that troubling word again, *negative*. Then came the bombshell: "The work of this planning team is now completed." We were shocked and confused, for we were moving toward production, certainly not about to abandon the project.[6]

Brent called the team to a meeting and with insulting indifference blandly dismissed our efforts and refused to explain why he had led us on for a year. Several team members earnestly defended our work, thinking that if Brent better understood its scope and originality he would relent and let us proceed. I argued that the Smith cotton gin, a key object in my nineteenth-century section, was not only a magnificent object but also that it resonated with significant nineteenth-century issues such as slavery, the transition to free labor, and the nearby Trail of Tears. Not only that, I continued for Brent's edification, we hoped to connect cotton growing and ginning in the South with textile manufacturing in the North and contrast the southern slave labor system with young white women who worked in northern textile mills.

We could have been talking to a mule, for Brent impassively ignored our remarks and with stale bureaucratic breath suggested some isolated events in Pennsylvania history as more familiar and thus acceptable for an introductory exhibit. His insultingly inappropriate response, clumsy fixation on Pennsylvania, dismissal of contemporary historical scholarship, and inability to envision larger themes was embarrassing and showed contempt for our team. We left the meeting in shock and anger, cursing Brent's duplicity for leading us on for a year. We heard that our exhibit concept did not please Kenneth Behring. Whether Behring looked over our team's work and rejected it or Brent decided that it would not please Behring, this version of an introductory exhibit died.

A few months later Brent surreptitiously appointed a smaller introductory exhibit team of four, this one lacking a historian and meeting in secret.

Evidently this team could not please Behring either. Brent's official position was that Behring had no input on the exhibit, but a weekly museum report to chief operating officer Sheila Burke in the Castle in December 2006 dispelled that notion: "Work on development of the exhibition concept has stopped until further discussions with Mr. Behring have occurred." I was intrigued about these clandestine discussions and fantasized access to them.[7]

Meanwhile, Peter Liebhold continued to frustrate my curatorial work. Former fellow Angela Lakwete, author of *Inventing the Cotton Gin: Machine and Myth in Antebellum America* (2005), informed me of a significant 1796 cotton-gin patent by Hogden Holmes, a gifted southern mechanic who perfected Eli Whitney's engine by using saws instead of the wire nails that damaged the fiber. Saws are used to this day. Angela scoffed at Whitney's "inventor" claim, observing that for centuries roller gins had been separating cotton lint from seeds. The New Jersey document firm that held Holmes's patent, signed by George Washington, Timothy Pickering, and other notables, agreed to reduce the price for the Smithsonian.

In addition to its major importance in the history of invention, the patent fit into the collecting plan that I had pursued since arriving at the museum. In 2005, I composed a compelling request to the collections committee that we pursue this patent stressing Holmes's significance, the prestigious signatures, and how the document challenged Whitney's invention claims. Peter Liebhold brazenly refused to sign or forward my request to the collections committee, pontificating that he did not think the Holmes patent important. With no understanding of the issues, Peter vacuously dismissed the supporting opinion of Angela Lakwete, who had written a prize-winning history of cotton ginning. My temper spooled to redline, and I swallowed a stream of profanity and stared at Peter with disgust, but quietly said I was extremely disappointed in him and surprised that he would not support this request. Peter's effrontery—or was it aggressive ignorance, perhaps hostility?—was nothing new, for he frequently blathered bizarre and irrational opinions.[8] I demanded that I be allowed to pursue the patent on my own but never obtained funding.

Meanwhile, indecisiveness about museum renovation had become numbingly tedious, for at staff meetings Brent inarticulately commented on constantly shifting plans to renovate the central core of the museum as Skidmore, Owings & Merrill (SOM), noted for its airport designs, sketched open areas that would minimize objects and create aerodrome-like open space. Unless

Brent counted on his secret Introductory team to produce a Behring-approved extravaganza, there was no plan for post-renovation exhibits.[9] Brent was an agent of lethargy, far from a visionary museum director.

Brent incrementally revealed SOM's vacuous design, which would leave the central core of the first and second floors startingly empty. The labor-intensively and expensively restored Star-Spangled Banner would be entombed in a holy of holies on the second floor and guarded outside by expensive metal swoops assigned to reflect light and colors but once installed surrendering blankly as wrinkled stainless steel. The grand staircase's glass steps were dizzyingly nonnegotiable. Artifact walls, that is, tall cases containing barely labeled objects, lined the walls of the vast central core of the building. The hypnotic Foucault pendulum that had entranced young and old as it knocked over small pegs testifying to the earth's rotation, was long gone, and there was no major object, such as the majestic African elephant in the National Museum of Natural History rotunda, to serve as a meeting landmark. For months, Brent bedeviled the staff over whether and when the entire museum would be forced to close for renovation, and in July he finally announced that the museum would close in September 2006 and remain closed for a year and a half.

While the curatorial ranks were depleted at NMAH, the Smithsonian at large employed many world-class scholars and scientists. For several years, I served on the Secretary's Distinguished Lecture selection committee, which evaluated brilliant, creative, and energetic candidates. On October 24, 2005, I shared lunch with Tom Crouch from Air and Space, Virginia Mecklenburg from the Smithsonian American Art Museum, and several others on the selection committee before the afternoon lecture. Much of our discussion centered on Secretary Small's savage disruption of scholarship. In his intro-duction of the speaker that afternoon, Small mouthed prepared platitudes before Burt Drake, a distinguished plant physiologist at the Smithsonian Environmental Research Center, gave his lecture. As Small was speaking, I reflected on the irony of a man antipathetic to scholarship mouthing hypo-critical platitudes about Drake's distinguished career.

Hurricane Katrina struck in September 2005, and the inept rescue and relief effort contrasted with the 1927 Mississippi River flood rescue and relief directed by Secretary of Commerce Herbert Hoover, who coordinated the Red Cross, the Coast Guard, Army, National Guard, Federal Extension Service, and other organizations. People were plucked off rooftops and out of

trees, and thousands lived in tents in Red Cross camps for weeks or, in some cases, months. The Red Cross provided segregated but adequate shelter and relief, and, indeed, many refugees (a term many people despised) had better food and entertainment in the camps than at home. Where are the boats, I wondered, as helicopters pulled terrified people from New Orleans rooftops? In 1927, the Coast Guard had brought in thousands of lifeboats and made heroic rescues along the river. It was the first time that airplanes were used to spot survivors and lead rescue boats to them. The Katrina relief effort, on the other hand, was miserably coordinated despite modern technology. The radio program *Democracy Now* asked me to join a discussion on Katrina rescue and relief, and I contrasted Hoover's achievements with those of the Bush administration, stressing the racist dimensions of allowing New Orleans residents to suffer and die. In an interview with History News Network's Rick Shenkman, I offered historical context again, comparing rescue and relief in 1927 with the Bush administration's pathetic efforts.

Given the relevance of disasters, the museum asked me to assemble an exhibit case on the 1927 Mississippi River flood. I lent the lantern that Newman Bolls, head of the Board of Mississippi Levee Commissioners in Greenville, Mississippi, gave me after our interview in 1975, several Red Cross publications, a 78 rpm recording by Vernon Dalhart titled "The Mississippi Flood," and several photographs, all collected as I had worked on *Deep'n as It Come: The 1927 Mississippi River Flood* (1977). There were sordid issues such as refugees being held until the planter they were indebted to claimed them (peonage), sexual depredations by the National Guard, and not-unexpected issues arising from segregation. In one sentence of the exhibit script, I had juxtaposed a series of words conveying the complexity of the moment including "heroism and cowardice." The script had moved through three levels of vetting before Brent Glass objected to the word *cowardice*. The editor and I exhausted likely synonyms and decided to delete that juxtaposition. Jan Davidson, who had moved from NMAH to the Cape Fear Museum in Wilmington, North Carolina, reported to me in November 2005 that "Brent made us move the What Happened after Plessy? label in AOTM [*America on the Move*] out of the railway station to a wall (segregating it no less!) because the Am. Assn. of Railroads objected." Jan was still steamed, she wrote. She was referring to the landmark 1896 *Plessy v. Ferguson* Supreme Court decision that upheld segregation on railway cars. Museum editors were keeping a list of "Brent words." The flood case finally went up on December 16.[10]

After Brent announced that the museum would close for a year and a half, the Agriculture Hall, a remnant of the mid-1960s when the museum opened, came down. For twenty years, I had lobbied for a new exhibit on rural life that would focus on people and history, not machines, but now even the machines were doomed to storage. Every object had to be checked against catalog cards and accession numbers, and the large and fragile Holt combine taken apart for transport. I suspected that few of these objects would ever return. No cafeteria or coffee bar was provided for the staff, and those brave enough could buy from vending machines with the comforting assurance that sandwiches were freshened every several days. Many staff members brewed their own coffee, and I threatened lightheartedly to open a coffee bar where staff could gather and commiserate. Sadly, morale plunged even more as staff haunted a closed museum.

At the museum, I was watching, not supervising, the take down of the Agriculture Hall. Vince, the foreman for Kreitz, the excellent rigging firm, was sardonic and dyspeptic and reminded me of the foreman of a sewerage plant construction crew I had worked on one summer. I liked Vince, and he tolerated my observing his crew. My primary concern was the Holt combine, a mammoth machine that had operated in the Palouse country of Washington state at the turn of the twentieth century. A team of forty mules or horses pulled the combine, and power came from a bull wheel that through various chains and connections energized the operating parts. It was built primarily of wood, and there were weak and partially rotted areas, loose bolts, and fragile innards. Kreitz removed the header bar, and Terry Conable, a museum specialist (who drove a Lotus), supervised the operation. Terry and I conferred often, both about the Holt and the Lotus. The entrance doors to the museum had to be removed to expel the huge combine, and the operation took place in the still of the night to avoid traffic. Somehow the combine made it to the Fullerton storage facility, but I was tempted to follow the truck to look for parts that might have fallen off.

In April 2007, I went to Charlotte, North Carolina, to meet with the staff of the Levine Museum of the New South to discuss curating a small exhibit on stock car racing to prelude the opening of the city's NASCAR Hall of Fame. Bob Staples and Barbara Charles, who had worked with me on the Atlanta History Center's doomed stock-car project, were on board as designers. Indeed, when the Levine approached me, I said I was too busy to accept the offer, but upon reflection I said that if Bob and Barbara did the design

Fullerton crew and Vince (on the truck bed) move the
Macon gin and Smith gin gears to storage. *Author photo.*

I would do the curating. Like the Atlanta History Center, the Levine failed
to secure funding. "It's like the dogs chasing the artificial rabbit," I wrote to
Larry Jones about funding for a stock-car exhibit, "we never seem to be able to
catch funding." Suspicious Peter Liebhold questioned my work on the exhibit,
assuming that I was a hired consultant. No, I explained, I was a representa-
tive of the American History museum, just as I was on the Atlanta History
Center project.[11]

Coincidently, Teresa Earnhardt, Dale's widow, came to the museum to
explore our archives and conservation work. Pat LeGare, who coordinated
the trip for Teresa, explained that Dale Earnhardt Inc. (DEI) possessed a vast
quantity of objects, films, photographs, and other material and needed advice
on storage and care. John Fleckner and Deborah Richardson arranged a tour
of the museum's Archives Center, and Teresa and Pat also met with cloth-
ing conservators. Roger White, curator of automobiles and road transporta-
tion brought out the museum's Dale Earnhardt's No. 3 helmet for Teresa to
examine.

She had expressed interest in learning more about the National Archives,
and my friend David McMillen there arranged a behind-the-scenes tour. I did

Bob Staples and Barbara Charles.
Author photo.

not advertise Teresa Earnhardt's visit widely in the museum, for I knew that
Brent would insist on taking over her visit, bringing in publicity and devel-
opment folks, and ruining her search for information. I talked with curator
Ellen Hughes, who collected sports objects, and told her what had transpired,
and we compared notes. I found Teresa thoughtful and focused, and could
imagine how she ran DEI with an iron hand.[12] Dale Earnhardt personified the
last of NASCAR's untamed drivers, and after his death no subsequent driver
ever embodied the values that he brought to racing.

It often seemed I was becoming more a museum clerk than a curator,
what with all the fetching and forms I dealt with. This was brought home to
me when I attended the mandatory GovTrip training session. Theoretically,
this travel program was similar to commercial travel sites, but in practice
it more resembled an unwinnable video game. The Smithsonian bought it
from Northrop Grumman, and I always suspected that this flawed program
was foisted off on Smithsonian secretary Lawrence Small, another of his idi-
otic decisions. The move to GovTrip quickly bit me when my complex travel
plans for a European lecture series in 2008 got bounced back because the trip
extended into June, when the new system kicked in. Carol Ailes and her three

Teresa Earnhardt with the No. 3 helmet.
Author photo.

coworkers in the Smithsonian Travel Office had supremely handled travel the old-fashioned way and had booked both my international and internal European flights with their customary efficiency. I explained to Jim Gardner that for me to duplicate that feat on unfamiliar GovTrip would take substantial time (days or even weeks). By then I had learned that GovTrip would drop data, present labyrinthine puzzles, and then, when it seemed you had succeeded, time out. This fit into what I considered the museum's real strategic plan—to strangle creativity. By November many staff were outraged at the system and voiced complaints. Writing a draft for the Smithsonian Congress of Scholars, my colleague Harry Rand stated the issue succinctly: "Instead of 4 people doing travel papers for the whole SI, 6,000 people have become amateur travel agents." It was another example of how the promises of the digital age failed.[13]

Meanwhile, I left for Europe and on May 17 arrived in Munich for a visit with Hartmut Keil and gave a talk at the University of Munich's American Studies Institute. Hartmut and I drove up to Jena on the twenty-first for my talk at the Friedrich Schiller University hosted by professor Joerg Nagler. In Leipzig I gave a talk at the American Studies Institute and attended some of Hartmut's classes on American culture. In one class, students gave excellent reports on their 1950s projects, regarding me as an artifact from the decade and peppering me with questions about 1950s youth culture and my experiences.

I took the train to Berlin where Renate Semler and her husband Jorn hosted me. Renate and I took a tour boat that wound through massive buildings along the Spree, and as usual Max Preisler escorted me around the city. Renate and Jorn hosted a dinner for old friends, including Max and his wife, Luise, Nikki Floess, and others from the 1986 seminar discussed above. I gave a talk at the Free University hosted by Professor Ursula Lehmkuhl and was delighted to see Inge Schulze-Reckzeh for the first time since the 1986 seminar. On May 27, I went to Krakow and gave a talk at the Institute of American Studies and Polish Diaspora at the Jagiellonian University. The students there were not so fluent in English or so keen on American studies as in Leipzig. Professor Adam Walaszek coordinated my stay there, and he took me on an informative tour of the city, and then his wife, who teaches art, joined us for dinner. The next day I roamed the city and enjoyed everything from an Internet café to beautiful architecture. As I walked through the city, I saw a young girl dressed in white standing on church steps amid massive statues, perhaps awaiting family members for her confirmation, and took a photograph that has become one of my favorites.

Finally, I went to Prague and met my host, Milos Calder. We had a pint, walked around the city, and that evening attended a jazz concert on the Petřín Hill. During all of my trips and lectures, I took pride in representing the Smithsonian as a professional curator and historian. On June 2, I returned home and promptly re-requested that I be relieved from some of the more onerous museum duties and gain relief from Peter Liebhold's punitive oversight.

The museum, meanwhile, more and more became a work site, and jackhammers shook the building and, according to some specialists, threatened to vibrate objects off shelves. There were disturbingly strange smells, rumbling sounds, whacks, and hammering, and there was still no gathering place for

Girl in Krakow.
Author photo.

staff to meet, have a cup of coffee, and bitch. The West Conference Room, long the site of Tuesday colloquiums, was redesigned as Brent Glass's office. It had been a room in which during late winter afternoon colloquiums, I had faced west and, as the sun set, watched flights into National Airport twist down the river and sail past the Washington Monument.

12

Dismissive Indifference

Half of what he said meant something else;
and the other half didn't mean anything at all.
—TOM STOPPARD, *Rosencrantz and Guildenstern Are Dead*

Well, though many an arraigned mortal has in hopes of
mitigated penalty pleaded guilty to horrible actions,
did ever anybody seriously confess to envy?
—HERMAN MELVILLE, *Billy Budd, Sailor*

It was jealousy that was at the bottom of it—
jealousy which survives every other passion of mankind.
—VIRGINIA WOOLF, *Mrs. Dalloway*

On November 5, 2003, at the Southern Historical Association convention in Houston, I had spent the day in an executive council meeting, and at the reception that evening, John Inscoe, secretary-treasurer of the SHA, called me aside. He told me that the nominating committee had selected me president elect of the organization. I thought back to unruly days in exile, a migrant laborer trajectory before landing at the museum, and my history work, and felt a mixture of pride and humility.

Several weeks after the convention, I encountered Director Brent Glass downstairs and as we waited for the elevator and the doors opened, I told him of the SHA presidency. As the elevator ascended to the fifth floor, he avoided eye contact, mumbled that the Southern was a small regional organization, offered no congratulations, no handshake, no civility at all, just the belittling comment and dismissive body language. Could it be that he was jealous that I was joining a distinguished line of SHA presidents?

The 2006 presidential address would demand a major research project, for it would be published in the *Journal of Southern History*. Archivist Joe Schwarz at Archives II suggested I look at a series in the Secretary of Agriculture papers that included the files of William Seabron, an African American appointed head of the USDA's civil rights effort in the mid-1960s. Seabron's files, it turned out, documented widespread discrimination throughout the Washington bureaucracy and in state and county USDA offices. Later I looked into the records of the US Commission on Civil Rights, and in the first box found transcripts of interviews that were the basis of the Commission's 1965 publication that revealed widespread discrimination, *Equal Opportunity in Farm Programs: An Appraisal of Services Rendered by Agencies of the United States Department of Agriculture*. As often happens, these sources pointed to other documentation, including congressional hearings and legal sources.

My museum responsibilities continued, but I kept one eye trained on the approaching SHA convention in 2006. There are prerogatives that follow elevation to a leadership position in a major history organization, and professors, for example, were usually relieved of some courses and furnished other support, and the institution funded a reception honoring the president. No one up the museum supervisory chain showed the least interest in discussing with me what being president of the SHA might bring in the way of additional duties or institutional responsibilities, so on July 13, 2004, I wrote a memorandum to Brent Glass stressing the museum's responsibilities. I reminded him that the SHA was the third largest history organization in the country (in case Brent didn't know) behind the American Historical Association and the Organization of American Historians and that the presidential duties were hardly negligible. I also needed a firm commitment that the museum would host the presidential reception in 2006. Already, program chair Joe Reidy, a dean at Howard University and a former museum fellow, had enlisted southern novelist Ernest J. Gaines to give the opening address, and photographers Birney Imes and Debbie Caffery were scheduled for a session. I reviewed the lack of released time to prepare either for the 1992 Commonwealth Fund Lecture or the Fleming lectures at LSU in 2004, building a case for released time for research. Given that the museum was out of gear and coasting, slowly, my duties could easily be adjusted.

Then ensued some of the most bizarre and upsetting chapters of my tenure at the museum. A month after I sent the memo, Jim Gardner, head of curatorial affairs, informed me that Brent refused to provide funds for the

presidential reception. Incredulous, I demanded a face-to-face meeting, and Jim Gardner attended. It was one of the few times I had talked with Brent, and it did not go well. Supporting the reception, Brent began, would set an unwelcome precedent, and I quickly countered that it would set an even more unwelcome precedent to be the only institution ever not to support its president. After only a few minutes, it was obvious that Brent's series of lame excuses only exposed his animosity toward me. His pusillanimous demeanor brought out the worst in me, and I called out his lies and demanded that he put his ridiculous claims in writing. He was obligated to inform the SHA executive council of his decision, I insisted, so it could make alternate plans for funding the reception. When he asked that I not take his decision personally, I leaned closer and heatedly replied that of course I took it personally, that he insulted not only me but also the Southern Historical Association. When he then suggested that I should have consulted him before accepting the position as SHA president, I stared at him with contempt. That I would ask Brent if I could become president of a major history organization was preposterous. Disgusted with his lies and drivel, I caustically said, "It's your decision," and walked out.

After a few days of reflection, Brent's devious performance at our meeting prompted me to send a memo reminding him that he owed the SHA executive council an explanation of his unprecedented lack of support. My memo went through Peter Liebhold, who of course advised against sending it on, then to Jim Gardner, and finally to Brent. I summarized our meeting to ensure there was a record and reiterated that I expected a letter to the SHA executive council.

Meanwhile, I warned the SHA's John Inscoe that the museum would not fund the reception. Brent had not replied to my memo, so on October 5, I stressed that John Inscoe agreed with me and had written, "Your unprecedented decision requires a written explanation for us to take to the executive council. Your refusal to comply with this simple request shows contempt for the Southern Historical Association and its traditions." The next day, Jim Gardner called me aside and reported that Brent had instructed him to tell me that he would not reply to my emails or write a letter to the Southern Historical Association. "Let me get this straight," I said to Jim. "He told you to tell me that he would not answer my emails." He nodded. "That's chickenshit," I judged.[1]

The Southern Historical Association's executive council at its annual

meeting decided that a frank letter to Brent was in order. The letter, largely composed by Michael O'Brien, an intellectual historian from Cambridge University, reviewed Brent's "unprecedented" decision. The council expected that the museum "would eagerly join with the Southern Historical Association in celebrating Daniel's achievements," the letter observed, "not least because he is the first scholar from a museum to hold the presidency of the Southern Historical Association (or indeed of any major historical organization)." Brent's decision, the letter continued, "is puzzling, not to say counterproductive, since it necessarily tells the scholarly world that your Museum looks upon intellectual accomplishment with dismissive indifference."[2]

In late November 2005, Brent at last replied to the SHA executive council. Although his director's discretionary fund could easily have covered the reception with no impact on other programs, he claimed that the museum "is facing major financial challenges in meeting our regular obligations" that "are a higher priority for us than the sponsorship of receptions." He lathered hypothetical soap to wash his hands of the decision. His research, he claimed, revealed that the museum had not sponsored a reception at a professional meeting for the past decade, failing to mention if anyone had requested one. He was advised, he continued in the passive voice, that no policy was in place to justify using museum funds for receptions, awkwardly avoiding whether there was a policy prohibiting such use. For appearance's sake, he admitted respect for the SHA and even for me.[3] It was embarrassingly pathetic. Meanwhile, several presses and my alma mater, Wake Forest University, contributed generously to the presidential reception.

The SHA convention in November 2006 opened with a compelling address by novelist Ernest J. Gaines. Debbie Caffery and Birney Imes's session explored their remarkable photographs and careers. Debbie was especially impassioned about the aftermath of Katrina and showed haunting photographs. "African American Farmers and Civil Rights," my presidential address, went well. I thanked Joe Reidy for managing the innovative program. Bad weather had stalled my daughter Lisa's trip from California, so she missed the lecture but made the reception. There were former fellows and friends for her to meet, and she knew that few things pleased me more than seeing interns and fellows publish books and succeed in their careers. I am now (2021) into the fourth shelf of books written by Smithsonian fellows who have either worked with me or joined in Tuesday discussions at the Irish Times about scholarly

work and life. I joked with museum fellows that those who joined us at the Times were more productive than those who didn't.

At every opportunity, I continued research on discrimination against African American farmers, for it was growing into a book. In early January 2007 after attending the American Historical Association meeting in Atlanta, I drove over to the University of Georgia in Athens for research. Later I spoke in Macon at the "Georgia in the 20th Century" lecture series and visited with Andy Ambrose, who was flourishing as the director of the Harriet Tubman Museum in Macon. It was good to see Andy and his wife, Terri, again, and with an eye on the Atlanta History Center and NMAH, we commiserated about good museums suffering from incompetent directors.

After my stay in Macon, I drove over to Fort Valley State University, hoping to find material in its archives on the Negro Extension Service. Unfortunately, I found nothing archival but did interview Robert Church, a ninety-seven-year-old retired extension agent, still lucid and proud of his career. He drove himself over to the university for the interview, he explained, because there wasn't anyone at home to drive him. Then I went to Tuskegee University, which I had first visited in 1968 when working on the Booker T. Washington Papers. Because Alabama's Negro Extension Service worked out of Tuskegee, I had hoped to find important information before its staff was sent to Auburn University in 1965. Unfortunately, the Tuskegee Archives were closed because of budget issues.

Dwayne Cox, head of the Auburn University Archives, had told me that former African American extension agent Willie Strain, who had edited the *Negro Farmer* until 1965, was living in Tuskegee Institute, and I interviewed both him and Bertha Jones, who was head of girls' 4-H in the Negro Extension Service.

Strain, an energetic and imaginative extension service agent, handled communications and taught county agents photography and encouraged them to utilize radio broadcasts. When the order to integrate came down in 1965, Strain, Jones, and other leaders moved from Tuskegee Institute to Auburn University but were shunned and given no responsibilities. This was the white extension service's idea of integration.

No publication replaced the *Negro Farmer*, as if Black farmers no longer deserved information. After taking leave to pursue additional graduate studies at the University of Wisconsin, Strain returned to Auburn but was passed

Willie Strain.
Author photo.

Bertha Jones.
Author photo.

over for a leadership position that went to a less qualified white man. He brought a major discrimination suit, *Strain v. Philpott*, against the university and the Alabama Cooperative Extension Service, a decision that went a long way toward creating equal opportunity both at Auburn and in county extension offices. Later I would use these two interviews plus material from Auburn and legal literature for a chapter on the unintended consequences of integration.

At the SHA convention back in November 2006, I had chatted with Susan Dollar, who taught in the School of Social Sciences at Northwestern State University in Natchitoches, Louisiana, and she asked if I might give a talk there. The university, she later explained in a letter, had an innovative Heritage Resources graduate program, and continued, "We train students to enter the workforce in the various agencies (local, state, and federal) that define, identify, and protect our nation's heritage resources." In the post-Katrina/Rita budget strain, they were attempting to keep a public lecture series alive. I told her that I would be in Baton Rouge for the American Society for Environmental History (ASEH) conference in late winter 2007 and could drive over and give an honorarium-free talk. I had a delightful time there, including talking with Susan and her colleagues after the lecture.[4]

At the ASEH conference in Baton Rouge, I had only a small part, and this left time to sit on the nearby levee and watch river traffic. One morning, Jack Kirby and I sat on a bench for several hours watching the tows and oil tankers as we discussed history, gossiped, and recalled old times. Jack had been unable to attend the SHA convention and had sent me a congratulatory note a few weeks prior to the convention. I replied in early December, congratulating him on being chosen next president of the SHA. "Over the years," I wrote to Jack, "I have enjoyed our time spent talking history, drinking bourbon, and arguing fine and not so fine points."[5]

Having been away from home for two weeks, I rose at 5:30 Saturday morning in Baton Rouge and zipped by Knoxville and made it to Roanoke by dinnertime, hoping to find a motel with walls thicker than paper, but it was low-rent rendezvous territory. I pulled back onto I-81 and, still wide awake and alert, completed the 1,120 miles at about 11:30, exceeding my Little Rock drive of 1,030 miles several years earlier.

In April 2006 the Organization of American Historians (OAH) met in Washington, and as usual I eagerly looked forward to seeing old friends, making new ones, perusing the book exhibits, and hearing papers. On the

morning of April 21, I had attended a breakfast meeting of the Agricultural
History Society when OAH executive director Lee Formwalt told me that
Rick Halpern was looking for me, and a few minutes later Rick caught up
with me in the book exhibit. He asked if I would accept the nominating com-
mittee's decision to become president elect of the Organization of American
Historians. I'm sure I momentarily lost my composure and barely suppressed
an urge to look over my shoulder to confirm that Rick was actually talking
to me. To such an expression of confidence in one's work and ability, not to
mention the honor, there is only an affirmative answer. I didn't check with
Brent Glass. Paul Forman, NMAH's erudite historian of physics, emailed me
later that he knew I did not get the position by backslapping, one of the fin-
est compliments I have ever received. I had planned to retire at the end of
2006, after I gave my presidential address at the SHA convention, but with
the OAH presidency looming and needing my 402 funds for travel, I recon-
figured my plans.

The meeting with the OAH executive board in mid-October 2006 broached
issues that would consume me over the next six years. My first OAH executive
board meeting, more than a decade earlier and with a different set of leaders,
was also contentious, similar to a Johns Hopkins University history seminar
where abrasions and bruises, perhaps a little blood, were routine. Being new
to current OAH issues, I misunderstood the serious tensions during the 2006
meeting and only gradually deciphered the gravity of the problems and the
personal agendas.

Donald Ritchie and Leslie Brown headed my OAH program committee.
In early March, I wrote to Don that as I had breakfast at the Waffle House
in Slidell, Louisiana, I decided the program title should be "History Without
Boundaries." Since I was the first president in modern times (perhaps ever)
to come from the public-history sector, I knew the importance of moving
the OAH toward being more representative of public historians, community
college professors, high school teachers, and of ordinary people who craved
history. The other major duty lurking ahead was appointing scholars to book-
prize and service committees.[6]

Not surprisingly, Brent would not support my presidential reception at the
OAH, and again a meeting was called with Jim Gardner as referee. Brent
began by stating that his decision was based on the same reasons he denied
support for the SHA. "What reasons?" I belligerently interrupted, and before
he could concoct a bilious reply I asked if these were the same absurd reasons

stated in his letter to the SHA. He then launched into excuses and lies, incredibly claiming that a Smithsonian policy forbade support of receptions with food and alcohol. I reminded him of the almost nightly round of stodged and tipsy people at Smithsonian receptions. Where is that written, I demanded? Every time I asked him to give me a citation for one of his flimsy inventions or lies, he nervously shifted to yet another lie. I had never encountered such duplicity and was nauseated by Brent's hostility and concoctions.

Tired of his obliquity, I leaned menacingly toward him and said with contempt, "I've worked all my life for this honor, and I have to get you as museum director." At that point, a nervous Jim Gardner cautiously intervened and suggested that perhaps the museum might furnish support of some type, even if not dollars for food and drink. I suggested a concert of Ken Slowik's Smithsonian Chamber Music Society and got a blank stare from Brent. Jim ultimately gained a promise of some noncaloric support, perhaps because the museum's Congress of Scholars had sent a memo to Brent reminding him of the custom of the home institution funding a reception, stressing the importance of the OAH, listing my achievements, and observing that it would be good for public history. The memo was copied to Christian Samper, acting Smithsonian secretary, and to Richard Kurin, acting undersecretary for History and Culture. What they may have thought, I have no idea.[7]

Brent, it turned out, was head of the OAH public history committee, and my friend Grace Palladino alerted me that the convention program revealed that Brent was sponsoring the public history reception at the next OAH convention. That he would claim to me that Smithsonian policy forbade drink and food while simultaneously planning the public history reception not only stank of hypocrisy but also called his integrity into question. The reasons he gave for denying support for the SHA and the OAH receptions apparently did not apply to his own reception. Brent's lies and waffling were bad enough, but allowing even modest support for my OAH reception insulted the Southern Historical Association, which he had stiffed altogether. Brent had no ability, it seems, to analyze how his pettiness and duplicity affected a wider community of historians or how his lies rose to the surface like dead fish.

After the SHA convention in November 2006, I had returned home hoping for a few days of relaxation, but I found an OAH packet that included a January 15 deadline for appointing the program and local resources committees for the 2009 convention in Seattle. During the summer of 2007, I made committee appointments, patiently striving for geographical, gender, color,

type of institution, and other balances. Paradoxically, my last committee appointment was for a Committee on Committees that would in the future do the appointing task that had taken away my summer. This committee would certainly ease the president's burden, but it also lessened the possibility of reshaping priorities and leadership. The OAH workload drastically changed my schedule, as I rose earlier to handle OAH emails before going to the museum.

Because of OAH commitments, I attempted to negotiate my performance plan with Peter Liebhold, but he seemed jocularly indifferent, callously suggesting that I might disregard public inquiries. I was aghast that he would even suggest such a thing. He refused to understand, no matter how I put it, that I had two full-time jobs and seemed unaware that historical writing required research. He was belligerently inflexible, and it seemed to me that Peter, Jim, and Brent were intent on demeaning me. I don't recall a one of them congratulating me or asking about my presidential address.

In early December, Peter asked me to sign my performance evaluation, and I saw that he had marked me down on collections, pushing my overall rating down to highly successful, not outstanding. I was livid. Instead of adjusting my museum duties or fully weighing OAH work, as I thought we had decided, Peter faulted me in the collections category even though he had blocked several of my collecting requests. The rating was not embarrassing to me, I explained on December 9, for I knew I worked at an outstanding level. Rather it reflected poorly on the Division of Curatorial Affairs for approving it. A performance review was as much a review of those doing the rating as the one being rated, I observed. I signed it "so that it would stand as documentary evidence" of their incompetence. On December 20, Peter advised me that by "refiguring the mathematics of the system" he and Jim agreed I deserved the outstanding rating. That documented their malevolent malfeasance but did nothing either to adjust my performance plan or give me released time, which I immediately requested again. "This does not testify to the museum's support of scholarly distinction," I wrote.[8] How much a hand Brent Glass had in this harassment, I don't know.

Having been denied authority to collect objects relating to rural life because of space, in August 2009 I observed with interest that the Smithsonian collected the iconic *American Idol* desk and was not distancing itself from promotions of the film *Night at the Museum: Battle of the Smithsonian*. Both *Idol* and Fox, which produced the film, were shamelessly using the Smithsonian

name for their own corporate purposes. The desk appeared in an exhibit aptly named "Loot" in the Smithsonian Castle, prompting the Washington Post's Philip Kennicott to judge, "The main hall of the Smithsonian Castle is now a cluttered and not-quite-wholly-owned subsidiary of News Corp." This raised questions, he added, about "the line between displaying pop culture and giving free advertising to an ongoing commercial venture." The article raised serious questions about collecting and exhibiting popular culture but more importantly warned of the Smithsonian's cozy association with producers of TV shows and films.[9] Only two decades earlier, curators were fighting to prevent logos on credit panels.

My concerns with commercialism, donor intrusion, curatorial diminishment, and misguided leadership had become so grave that increasingly I spoke out publicly. It seemed that blank space everywhere was a lure for advertisements, even moving ads along the edges of football (soccer) venues and inserting ads between pitches at the World Series, but I strenuously objected to having advertisements deface museum exhibits. At a talk at the Society for History in the Federal Government, I announced that my theme for the Seattle OAH meeting was history without boundaries and observed that it harmonized with the Smithsonian's mission, "the increase and diffusion of knowledge." With diminishing scholarship, donor intrusion, unlettered Smithsonian secretaries, feckless museum directors, and meddling politicians, the Institution's mission was imperiled, I argued. Historians, I stressed, should resist any pressure "to bend the writing hand to suit a political purpose or a donor," for "history is simply too important to be a manipulative tool."[10]

My patience with Brent Glass's genuflecting to donors and demeaning his staff finally reached the breaking point, and my frustration with the museum's declining curatorial ranks, sinking intellectual power, and lack of leadership vision provoked me to write about it in my OAH Newsletter column. These were crucial issues, for the national history museum should reflect the best of recent scholarship and produce excellent exhibits. To allow a celebratory narrative unsupported by contemporary scholarship to misinform exhibits in the national history museum was a dereliction of responsibility by Smithsonian leadership. In my first OAH Newsletter column, I had championed history without boundaries, a plea for inclusion of all people interested in the study of the past. The second column that appeared in the summer of 2008, "History With Boundaries: How Donors Shape Museum Exhibits,"

reviewed the unfortunate tenure of Lawrence Small (and the regents' complicity), the increasing dependence on private donors, the diminishing number and role of curators, and the intellectual chill after the *Enola Gay* exhibit was scuttled. The *Science in American Life* exhibit, I argued, demonstrated how a determined exhibit team, backed by the museum director, could cooperate with a strong-willed donor and find common ground for an excellent exhibit. "In the years since the *Enola Gay* controversy," I wrote, "power has shifted from curators, who are, after all, employed to collect objects, do research, and work on exhibits, to donors and pliant directors who demand exhibits fatally lacking in scholarship." I reviewed the *American Presidency* exhibit concocted by Small and generously funded by Kenneth Behring, Behring's military hall so roundly denounced by reviewers, and Catherine Reynolds's $38 million great achievers gambit.

I then focused on the aborted introductory exhibit project. "We met weekly, created themes, selected objects, began writing the script, and were assured all along that Director Brent Glass approved our approach," I wrote. "Then, abruptly, he pulled the plug. Our work did not please Kenneth Behring, we heard." There was the potential to mount significant exhibits, I continued, but museum leadership had lost its nerve and gained "an aversion to portraying the U.S. as anything but perfect." The museum had "settled for donor-demanded exhibits, ignored recent scholarship, marginalized curators, and now strives for mediocrity." I warned that exhibits should adhere to accepted museum standards. "History with boundaries not only demeans museum staff but also cheats museum visitors."

Brent, of course, was outraged. Recently appointed Smithsonian secretary Wayne Clough called me in and assured me that I was within my rights to write the column but avoided my concerns. I stressed that the museum no longer had the players to do excellent work, especially under a director who abhorred scholarship and lacked vision. Secretary Clough offered no strategy either for beefing up the museum's curatorial staff or for reining in Behring's influence on exhibits. I left knowing that nothing was going to be done to reestablish traditional relationships between donors and curators.

Brent called me in on August 8, this time with both Jim Gardner and Peter Liebhold in support. To my mind, Peter's attendance affirmed my suspicion that he was Brent's poppet. In a hectoring tone, Brent began preaching how exhibits were different from books until I abruptly interrupted him and suggested he read my column more carefully; I had covered that. It became obvi-

ous that he was woefully unprepared for this meeting, as he had been for those regarding receptions or when he dismissed the introductory exhibit project. I asked why he pulled the plug on the introductory exhibit and reminded him that in my column I implied that it was because Behring did not like it, and I also asked why it had gone through so many futile iterations. He ignored my questions but boasted that there was now an excellent exhibit script. I looked him in the eye and asked, "With no input from Mr. Behring?" He flinched. "No." We locked eyes until the silence was embarrassing; he blinked and asked if there were anything else. No, there wasn't, I said. Everyone in the room knew that Behring's architect was again due in the museum the next week to discuss the introductory exhibit. Despite Brent's claims, no introductory exhibit was ever completed. In all three meetings, Brent had been untruthful. He warned me that he was penning a reply for the *OAH Newsletter*. A few weeks later, I left for Africa and spent some middays amusing myself with profane responses to Brent.[11]

Brent's reply to the *OAH Newsletter* basically repeated what he had earlier said to me and evaded my questions about the decline of curators and donor intrusion. My column certainly did not achieve what I had hoped, which was to focus scrutiny on donor intrusion and the distressing decline of curators. I naively hoped that publicizing the decline of Smithsonian veracity might lead to change. I was wrong. The emotional jolt that I formerly enjoyed when I entered the museum each day had morphed into dread as I endured wretched leadership. I looked back with a feeling of loss, even nostalgia, and I think that anyone who had come to the museum, as I did in 1982, would be struck by the sharp difference, especially in the fatigued esprit de corps and decline of scholarly conversations among staff. Had I not needed logistical and financial support, I would have retired. I'm sure many of the staff wished that I had. Meanwhile, I was awarded the Agricultural History Society's Wayne Rasmussen Award for my SHA presidential address, published in the *Journal of Southern History*.

I had been mulling over possible topics for my OAH presidential address and even considered airing Smithsonian issues or producing a video from *Rock 'n' Soul* and stock-car interviews. Then I recalled that my friend, Leonard Rapport, in 1939 had escorted Farm Security Administration photographer Marion Post Wolcott around Durham, North Carolina, tobacco warehouses and the surrounding countryside. During the New Deal, Leonard had worked for the WPA Southern Writers Project and conducted interviews with tobacco

warehouse workers in Durham. When Leonard had died earlier in the year, those memories came flooding back.

I had met Leonard years earlier when he worked at the National Archives and learned he was born in Durham, North Carolina, and grew up in the shadow of a tobacco factory. He graduated in 1935 from the University of North Carolina, where he studied under R. D. W. Connor. He served in the Army from 1941 to 1948, and collaborated with Arthur Northwood Jr. in *Rendezvous with Destiny: A History of the 101st Airborne Division*. His mentor, Connor, became the first Archivist of the United States, and Leonard joined the staff there after the war and became an expert on the eighteenth century, in particular documentation for the Constitutional Convention of 1787 and the Bill of Rights. He loved to talk, and when he called, I would put everything aside and settle in for a lengthy chat.

I wrote an address on the collaboration between Leonard Rapport and Marion Post Wolcott featuring his WPA interviews and her photographs of the tobacco warehouse culture. Leonard was ninety-five when he died on March 17, 2008. In early 2009, I met Tim West, head of the University of North Carolina's Southern Historical Collection, at the Rapport home to peruse his papers and books and advise on what was archival. Jody Rapport, Leonard's daughter, later scanned and shared photographs from her father's early career as she organized the material. I also went to the Library of Congress looking through the papers of Roy Stryker, who headed the FSA photographic section and had corresponded with Wolcott.[12]

In late March 2009, I traveled to Seattle for the OAH convention and for two and a half days chaired the OAH executive board meeting. Amy Stark, OAH convention manager, suggested that I display some of my photographs, mostly wildlife, and she arranged to have them professionally mounted and hung. I counted twenty-four former museum fellows on the program, plus four colleagues from the museum.[13]

I also thanked a number of people who made the convention a success, in particular Don Ritchie, who along with Leslie Brown chaired the program committee. "I am sure that with the richness of the program, key appointments, and superb work that we have embedded public history deep within the OAH," I wrote to Don. I was fortunate to have "immensely competent people helping me at every moment." Susan Armeny, associate editor of the *Journal of American History*, was awarded the Roy Rosenzweig Distinguished Service Award. She had edited my first article to appear in the *Journal* in 1972

as well as several others and, with good humor, held my feet to journal style and proper usage. Dylan Penningroth, a former museum fellow, shared the America: History and Life Award for his essay, "The Claims of Slaves and Ex-Slaves to Family and Property: A Transatlantic Comparison," published in the *American Historical Review*. My duties as president ended as the convention concluded. Abruptly, emails and phone calls from Bloomington (where the OAH has its administrative offices) and from members were routed to the new OAH president.

13

Not Fade Away

I soon discovered that I was getting used to being happy and unhappy
at the same time, as if that were the new inevitable law of my life.
—ELENA FERRANTE, *The Story of the Lost Child*

History has been the great enabler of that undeservedly easy conscience,
and it is time that the producers and consumers of history together concede
that there is no narrative of progress that might justify a moral wrong.
—PRIYA SATIA, *Time's Monster*

As Organization of American Historians president, I appointed service committees, ran executive board meetings, pushed through a strategic plan, headed the search committee for a new executive director, handled numerous daily issues (some extremely unpleasant), faced budgetary issues, worked closely with *Journal of American History* editor Edward Linenthal, and pushed for reforms in the OAH office. The OAH had given me the opportunity to head a large organization of some nine thousand wonderful, if sometimes contentious, scholars. The museum, on the other hand, was a black hole that swallowed my talent. It was difficult working at a job that asked nothing creative of me and demanded that I tolerate inept leadership and bureaucratic nonsense.

My attempt to reveal the marginalization of curators, donor intrusion, and poor leadership that threatened the integrity of the museum failed. In Brent Glass's flawed reorganization, of course, some specialists and historians had been promoted to associate curator, but this sleight of hand not only failed to correct the dearth of scholars but further decimated the specialist ranks. If one had set out to de-intellectualize the museum staff and numb curators with trivial duties, it is difficult to imagine a better strategy.[1] Budget cuts dictated constraints, no doubt, but failing to replace departing curators

over some fifteen years came either from the director's lack of vision or a contemptuous plan to dumb down the staff and orphan major collections. I had discovered that the history museum's experience resonated nationally, as many institutions suffered budget cuts, staff reductions, unambitious and celebratory exhibits, and intrusion into museum projects by donors.

Perhaps Brent Glass discussed historical scholarship, but I never heard any report of it. He seemed oblivious to serious discourse and was increasingly obsessed with museum renovation or achieving moments of fame. He provided unintentional humor as a clueless straight man when Stephen Colbert, not altogether jokingly, offered his portrait to the museum. It was embarrassing to witness the hapless director as Colbert trashed the museum's treasures. The portrait hung briefly in the Portrait Gallery, albeit near the toilets, appeared in the American Treasures Exhibit, and then Brent accepted the torn portrait (Colbert had petulantly stepped through the canvas) evidently without collections committee approval.[2]

Fresh from his abashment with Colbert, Brent traveled to Chicago to appear on the *Oprah Winfrey Show*, carrying with him some of the museum's highest value objects. The good news was that showing Dorothy's Ruby Slippers on national TV allowed millions of viewers to see them. The bad news was that Brent neglected to secure a signed loan agreement or any contract to remove the objects from the museum, and thus there was no insurance or security plan for objects valued at over $1 million. He stiffed the collections committee, which had unanimously recommended against removing the objects from the museum, and in addition the Ruby Slippers were quite fragile and needed conservation care. It was not amusing to conservation-minded museum staff that Oprah handled them without gloves and waved them around. Brent's judgment had been blinded by the glare of TV lights, and his several transgressions earned a harsh letter from the museum's Congress of Scholars.[3]

Occasionally Brent's attention wandered to exhibits. Expressing faith in chronology, he compiled a timeline of "Turning Points in American History (1765–2001)," perhaps his notion of a poor man's introductory exhibit. Such events, he postulated, "often represent a larger historical pattern or series of events," although it was not clear how such topics as "Yorktown," "Statue of Liberty," "Disneyland Opens," or "Elvis Presley on TV," all unexplained terms with no context, would substantially add to human knowledge. Why not just put in dates, I joked—1607, 1776, 1812, 1861, 1927? Who needs words?

The museum's Congress of Scholars questioned the value of a timeline and also observed that the never-to-be-completed "Introductory" exhibit, then in its fourth or fifth iteration, was floundering and mentioned a rumor that Kenneth Behring was intent on bringing in his own curator to oversee museum exhibit planning.[4]

As the museum neared its reopening date, Brent sought a "tagline or rather a 'slogan' that can be used in advertising and marketing." He consulted with several advertising agencies (no mention of how much this cost) and came up with the tag, "Real National Treasures," and what he called a secondary tagline, "Real Stories, Real Stuff," offered by a staff member. The three appearances of the word *real* in a total of seven words suggested an impoverished vocabulary. *Stuff* is not a particularly flattering term for national treasures, and Smithsonian collections are by definition valuable, although I must admit there are objects in the collections that make me scratch my head. Smithsonian secretary Wayne Clough reputedly paid about a million dollars to a "brand experience" firm to come up with "Seriously Amazing" as the Smithsonian tagline.[5]

The museum was scheduled to reopen on November 21, 2008, and Brent, overeager to compensate for this arid architectural vacuity lacking a new major exhibit, booked the president of the United States, paid for extravagant food and drink, and secured a copy of the Gettysburg Address for display. The huge artifact walls where barely identified objects resided were the only new exhibit offering in the museum. The central core of the renovated museum was a vast and empty space, uninhabited by museum objects except for the artifact walls. As expected, the skylight showered objects with dangerous levels of light and pushed foot-candle light measurements far beyond the allowable 8 to 10 to an alarming 1,300. Brent disregarded curatorial warnings of damage, arguing that lowering the light would sacrifice architectural integrity. The space resembled an airport (Skidmore designed airports), so along the deserted central core and corridors, I envisioned departure gates.

I continued to lobby for an agriculture exhibit, but both Jim Gardner and Peter Liebhold offered only susurrant remarks about including aspects of agriculture in a planned American Enterprise exhibit. Maybe Peter could have a section on great achievers of American agriculture. A major agriculture exhibit, Peter judged, "is not very attractive to me; it would just get tired and stale." American enterprise wouldn't get tired and stale? Peter became overenthusiastic about corn after reading Michael Pollan's treatment in *The*

Omnivore's Dilemma. His corn obsession brought to mind the John Deere representative who ignored my southern rural life project and suggested that I "do wheat." The exploration of either cornbread or whitebread did not interest me.[6]

On April 17, 2009, I gave a talk at Harvard University on an American environmental history panel. Helen Rozwadowski, a former fellow, had participated in an environmental conference there in October, and she came up from New London, Connecticut, for the session. I focused on environmental issues both in my book *Toxic Drift: Pesticides and Health in the Post-World War II South* and in the *Science in American Life* exhibit and discussed the widespread and reckless spray campaigns and the Agricultural Research Service's culpability. The next day, Helen drove me down to New London where she taught at the University of Connecticut's Avery Point campus. As we gazed at the river from campus, she observed a tug moving out to sea and suspected, correctly, that a submarine was coming into base. A few minutes later a conning tower rose near the tug. Her friend, later husband, Daniel, gave me a tour of a firehouse he was restoring, and that evening Helen invited friends over and served lobster. The next day, I trained home and met my German friends Max and Luise Preisler, who spent a few days with me.

During museum renovation and afterward, there were concerns because the museum was constructed before health hazards were recognized or taken seriously, and some pipes insulated with asbestos were disturbed during renovation, releasing asbestos dust. After the museum had reopened, asbestos readings were recorded in some storage rooms. Brent suggested at a staff meeting that as personnel worked in storage rooms, they should wear monitors to record any asbestos readings. This reminded me of dosimeters that soldiers wore during nuclear tests in the Nevada desert that offered no protection but only recorded exposure as they marched toward ground zero. Peter Liebhold, bless his heart, gasped and declared that he would not send his staff back to storage rooms until the asbestos was completely cleared. The staff vigorously nodded assent. Brent was unaccustomed to staff rebutting him and, according to witnesses, went up to Peter after the meeting and (mockingly?) put his hands around his neck as if to choke him. The staff mumbled itself out of the Carmichael Auditorium, grousing about how little Brent cared about toxic risks. This was the first staff meeting I had attended in the better part of a year, and I was appalled not only at Brent's ineptness and how poorly he ran the meeting but also how ill-prepared he was to deal with the asbestos

Roadside message between Jackson and Hattiesburg, Mississippi.
Author photo.

problem.[7] After serious health issues in the basement quarters of the photography unit, many of us were skeptical of the official report that there were no toxic agents loose in the museum.

I was extremely fortunate that SHA and OAH leadership opportunities came when they did, and since my museum obligations had dwindled alarmingly, I turned again to research and writing on my African American farmers project. In Starkville, Mississippi, in early May, I checked in at the mock antebellum University Inn, observing that the actual run-down motel unresembled its website of pillared majesty. When I asked about an internet connection, the aging clerk pointed across the parking lot toward a coffee shop and suggested that I might be able to log on there. I moved the next day. I spent a week among old friends at the Mississippi State University archives and on Sunday afternoon headed down to Hattiesburg on back roads.

In front of a church, I photographed a life-size yellow bucking bull emblazoned with "Jesus Saves" in bold letters but was unable to decode its symbolism. I also found Tatum Salt Dome Road after asking directions of some old-timers at a coffee shop. It was the site of the 1960s underground atomic tests

Region, Class, and Culture brochure.

mentioned above; I found no relevant signage. After dinner I went online to check the opening time of the University of Southern Mississippi archives, only to discover a recent posting announcing that the archives would be closed all week for duct cleaning. Dejected, I drove up to Memphis to visit friends and headed home.

In mid-June 2007, Grace Palladino, still a regular at the Irish Times, insisted that we have lunch, that there was something we needed to discuss away from the babble at the bar. At the White Tiger near Union Station, she confessed that Matt Wray, Nan Woodruff, and other former fellows had conspired with her to host a conference in my honor. Jim Lanier, a professor at Rhodes College in Memphis and an old friend, had arranged for seminar rooms and also dorm rooms for participants. The planning team had already contacted former fellows and established session topics based on my scholarly work. The conference, "Region, Class, and Culture: New Perspectives on the American South," was set for June 11–13, 2009.[8]

Grace, Nan, Matt, Jim Lanier, and David Less, among others, organized the conference and created a remarkable intellectual gathering. Over forty of the hundred invited former fellows and friends attended, and sixteen presented papers. The organizers put me up in Lauderdale Courts, in the apartment where a young Elvis Presley once lived with his family. Grace and Elvis enthusiast Bruce Hunt visited the apartment for a taste of bourbon, and I discovered that the ancient fridge's freezer compartment was a solid glob of ice. The excellent bourbon did not demand ice, so we toasted Elvis Presley neat. I complained to the management that the fridge had not been defrosted since the Presleys moved out. A wall in the bedroom where I slept was peppered with fantasy lip imprints from women admirers. The next morning, the water ran red with iron rust, so I showered in the dorm at Rhodes.

On the opening evening, June 11, people from the Memphis community joined fellows to hear Stephanie McCurry's address, "Antigone's Claims: Gender and Treason in the American Civil War." Her book *Confederate Reckoning: Power and Politics in the Civil War South* would appear in 2012. A reception followed, and then fellows and old friends convened for dinner and surprised me with tributes and roasts. Jim Lanier arranged for some of the forty-three photographs displayed in Seattle at the OAH convention to be hung in a Rhodes College gallery.

Sally Stein, a profound scholar of photography, approached me in the gallery and signaled me to follow her, and I trailed along with trepidation. She stood before a photograph of Emerson Fittipaldi cornering at the 1973 French Grand Prix at Clermont-Ferrand with track marshals and several people across the track clapping (it was actually the cool-down lap after Jackie Stewart's victory). She liked it very much, she said, and I later sent her a print with an annotation on Fittipaldi's remarkable career.

As Friday's last session in the library basement ended, at about 5:00, the lights went out followed by an announcement that there was a tornado warning for the area. The lights did not come back on, for a tree had smashed the Rhodes College power line, so college officials quickly rounded up flashlights for people in the dorm. There was enough hot water to shower the next morning.

David Less had called me some months before the conference and announced that there would be a music concert in my honor at the New Daisy Theatre on Beale Street and tossed out "Petefest" as the title. I winced, not

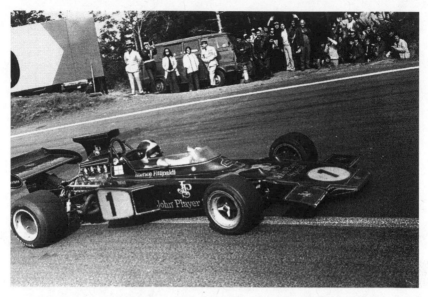

Emerson Fittipaldi, Clermont-Ferrand, France, 1973.
Author photo.

really wanting to call attention to myself, but David insisted. When I showed up that night, "Petefest" was on the marque. Billy Lee Riley had been seriously ill but after regaining his strength had played at the Memphis in May festival. When I arrived at the New Daisy, David Less told me that despite his ailments Billy Lee had a good sound check that afternoon and was determined to perform. I went to his dressing room and found him game to go on, although his wife, Joyce, was extremely wary. When he went onstage with Sonny Burgess, another Sun performer, and Luther Dickinson (of the North Mississippi Allstars and son of Jim Dickinson), he shook the rafters with "Red Hot" and "Flying Saucers Rock 'n' Roll." It was the fifties again, and the dance floor filled.

Sally Stein took a photograph of Billy Lee triumphantly leaning on his walker, his right arm raised and index finger pointing upward toward a blue light and a red light. It was a splendid photograph that captured Billy Lee's will and courage. He gave a powerful, even heroic, performance, knowing it could be his last. Later Joyce wrote that he had been teaching his five-

SCHEDULE

Thursday, June 11 – Blount Auditorium
5:00 pm: *Plenary Session* (Open to the Public)
- *Conference Welcome*--Jim Lanier, Rhodes College
- *Opening Remarks*--Nan Woodruff, Penn State
- *Antigone's Claim: Gender and Treason in the American Civil War.* Stephanie McCurry, Department of History, University of Pennsylvania.

6:30 pm: *Reception*

7:30 pm *Dinner* Lynx Lair, Bryan Campus Life Center (Registered Guests Only)

Friday, June 12 – Barret Library 51
9:00 - 11:00 am *Official Images.* Chair: Mary Panzer, Exhibition Art & Technology, New York.
- *The Same River Twice? The Stakes—and Mistakes?—in Rephotography.* Sally Stein, Associate Professor Emerita, Art History, University of California, Irvine.
- *Bureaucratizing Tradition: The Culture of New Deal Photography.* Jason Weems, History of Art Department, University of California, Riverside.
- *SNCC in the Rural South as Seen by Photographer Danny Lyon and Filmmaker Harvey Richards.* Scott Matthews, Department of History, Hollins University.

11:15 am –1:00 pm *Standing at the Crossroads.* Chair: Vernon Burton, Department of History, Coastal Carolina University
- *Black Blues and White Producers: The Racial Divide Between African-American Musicians and White Producers/Collectors.* Mark Allan Jackson, Department of English, Middle Tennessee State University.
- *Queer Cosmopolitanism; or, Southern Sex on the "Low Down."* Colin Johnson, Department of Gender Studies, Indiana University, Bloomington.
- *The Rural Roots of Low-Down Cultures: Implications for Health & Mortality Research.* Matt Wray, Department of Sociology, Temple University.

1:00- 2:45pm Lunch, Crain Reception Hall, Bryan Campus Life Center

3:00 - 4:45 pm *The Shadow of Slavery.* Chair: Joseph Reidy, Department of History, Howard University.
- *The Hidden History of the Southern Legal System.* Laura Edwards, Department of History, Duke University.
- *Race and the Pension Bureau.* Anthony Kaye, Department of History, Pennsylvania State University.

8:00 pm *Petefest: Rock 'n' Soul Traditions*–New Daisy Theater, Beale Street. Sponsored by the Curb Institute and Henry Turley Company.

Saturday, June 13 – Orgill Rm, Clough Hall
9:00 am: *Breaking the Land.* Chair: Lu Ann Jones, National Park Service.
- *The Jim Crow Section of Agricultural History.* Adrienne Petty, Department of History, City College of New York.
- *The Cost of Credit: Land Banks, Production Credit, and the Re-Shaping of the Southern Farm Economy.* Sara Gregg, Woodrow Wilson Presidential Library.
- *"Get Hard and Raise Hell": Financing the Cotton Crop on the Backs of Black Labor—and Its Consequences.* Jeannie Whayne, Department of History, University of Arkansas.

11:15 -1:00 *Lost Revolutions.* Chair: Leslie McLemore, Department of Political Science, Jackson State University.
- *From Free Labor to Displaced Persons: Black and White Workers in the Era of Neoliberal Globalization.* Greta de Jong, Department of History, University of Nevada, Reno.
- *Impoverished Democracy: North Carolina's War on Poverty.* Robert Korstad, Public Policy Studies and History, Duke University.
- *Martin Luther King's Unfinished Agenda in the Era of Obama.* Michael Honey, Interdisciplinary Arts & Sciences, University of Washington, Tacoma.

1:00 – 2:30: Memphis Barbecue Lunch followed by a tour of the Rock 'n' Soul Museum. Additional Cost.

Closing Reception: The Elvis Home on Audubon.
Closing Remarks: Jacquelyn Hall, Rhodes alum and Julia Cherry Spruill Professor of History & Director of the Southern Oral History Program, University of North Carolina.

"Region, Class, and Culture" conference schedule.

year-old granddaughter to play guitar and blow harp just before he died on August 2, 2009, at seventy-five years old. Jim Dickinson, Luther's dad and one of Memphis's illustrious and profound musicians, died on August 15.

After intermission, the Hi rhythm section, many of whom we had interviewed for *Rock 'n' Soul*, performed, and there was more dancing. I profusely thanked David Less for a wonderful evening, and it was made possible by the Curb Institute at Rhodes College and the Henry Turley Company.[9]

Luther Dickinson, Billy Lee Riley, center, Sonny Burgess, right.
Original in color. Sally Stein.

On Saturday morning, participants emerged from the dorm eager for more papers, and after two more sessions we adjourned to the Rendezvous for lunch, since many of the former fellows had never before enjoyed Memphis barbecue. I led a tour through the Rock 'n' Soul Museum before attending the final session at the Elvis Presley home, owned by Rhodes College, on Audubon. Jacquelyn Dowd Hall, a Rhodes alumna, old friend, and distinguished historian, gave the concluding talk. We explored the house, with its ample photographs of Presley during the years he lived there, and finally posed for a group photograph.

I could write endlessly about fellows and their research and writing and the stirring conversations we enjoyed at the Irish Times, in the cafeteria, and elsewhere. Fellows possessed a unique fondness for the Smithsonian Institution, for unlike most graduate or postgraduate history students stranded in academia, they observed collecting and exhibit preparation and mixed with museum professionals. They left to take teaching or public history positions

and, in many cases, maintained contact with fellows and museum staff. They published books, gave papers at history conferences, and assumed leadership positions in the historical community. They enriched both my social and intellectual life. The conference had brought together a remarkable group of scholars and friends, and nearly everyone there had shared Tuesday evening conversations during their Smithsonian fellowship.

I stayed in Memphis a few more days, and Calvin Turley, Henry's brother, invited me to stay in his guesthouse. He was a major backer of the Cotton Museum and was courting funding from some major agricultural corporations for a new exhibit. We talked extensively about content, but with Case International, Monsanto, and other major agribusiness players providing support, I warned Calvin that they would want a trade show, not historical treatment. Years later when I had a book signing at the Cotton Museum, I saw that it was indeed more trade show than historical exhibit. The power of corporate funding was insidious and national, and exposing museum visitors only to narratives of success denied them historical accuracy.

As Calvin was showing me the space for the planned exhibit, we passed a room clogged with boxes and binders that he offhandedly mentioned they were planning to get rid of. I asked what it was, and he said scrapbooks, photographs, and correspondence relating to the Cotton Festival. I asked if I could examine it and quickly concluded that it had historical value. I made notes on the content, and when I returned to Washington made a case for collecting the Cotton Festival material. Later, the Archives Center's Craig Orr visited Memphis and inventoried the material before having it shipped to NMAH. This was my final contribution to the museum's collections.

I drove across the river for an Agricultural History Society conference in Little Rock and then headed home. When I left Little Rock at dawn and aimed for Memphis, I drove into a rising sun and through a landscape thick with memories.

A few months later while at the beach at Nags Head, my friend Barbara Fields called and asked if I had heard that Jack Temple Kirby died, that she had heard the news in disbelief. We were especially upset because as president of the Southern Historical Association Jack would have given his presidential address in Louisville that fall.

Barbara accepted the task of preparing an address from Jack's manuscript and reading it at the convention. I made very short remarks in Jack's

Jack Temple Kirby.
*Courtesy of the Southern
Historical Association.*

Barbara Jeanne Fields.
*Courtesy of the Southern
Historical Association.*

memory at the convention. "Jack and I were born a month apart and a state apart (less than a hundred miles), and our careers had a remarkable convergence—writing books on agriculture in the 1980s and on environmental issues in this century." I also mentioned our late-night, alcohol-fueled discussions at SHA conventions. "Jack personified the values of the Southern Historical Association. He was a scholar and a gentleman, he was gifted and eccentric, he was fun and contentious, and he moved among us with intellect and wisdom."[10] He wrote books on the Progressive Era, on the South's treatment in media, and on agriculture in *Rural Worlds Lost: The American South, 1920–1960*, and finally his Bancroft Prize-winning *Mockingbird Song: Ecological Landscapes of the South*. Barbara Fields would become president of the Southern Historical Association in 2015.

In September 2009, I went back to South Africa for the fourth time and cleared my head. Midday in the bush is a time of relaxation between morning and afternoon game drives, and I read fiction, made notes in my journal, and thought about museum work, or the lack of it. From the perspective of the bush, the museum tasted unpalatable, and the distance magnified not only the museum's inept leadership but also the realization that I had been shoved aside. I was turning seventy-one in November, and by the time I left Africa I was determined to retire.

Back in the office, I turned on the computer and checked the backlog of email, and discovered an announcement of a buyout, that is, the Smithsonian would pay me to leave.

I had never taken time to analyze what retirement would entail. When I finally showed up at the personnel office, James Marshall discovered that I had begun work at the cusp of old and new retirement systems and had been put in the new but had the option of going either way. He prepared a side-by-side comparison, and I went with the old one. I left his office highly impressed with his professionalism and smiled, thinking that I would be able to buy good bourbon for the rest of my life.

I was not allowed to leave without two additional confrontations. Before I left for Africa, I had written a memo to the collections committee and left it with Peter Liebhold to sign and forward. The museum had been offered a mid-nineteenth-century hay press, and the collections committee had approved funds for me to travel to Connecticut to inspect it. It was a well-preserved wooden press, about the size of a large refrigerator. On its sides were chalked notations of how many bales had been compressed. When I returned from

Africa, I discovered that Peter had not forwarded my memo and immediately asked why. He insisted that I add to the memo a history of hay. I had been writing collections committee memos for twenty-seven years and told Peter that a history of hay was superfluous to collecting this object that dealt with process, not horticulture. As he stubbornly and pompously insisted, I could barely contain my disgust, and I belligerently told him, "No, I won't do it." I stalked next door to my office, seething that Peter, unlettered in agriculture, had again thwarted a collecting project.[11]

Just as I had given little thought to retirement, I had not investigated emeritus status and pestered Peter about it, not that I was keen on it any more than being called doctor or full professor. He put me off several times, but on December 15 made a rare appearance in my office (next door to his) and began denigrating emeritus status. I interrupted and asked why he was putting me off. After explaining that it was Brent's prerogative to grant or withhold emeritus, he claimed that Brent emotionally warned him not even to mention emeritus for me and threatened both Peter and the division with retribution. This scenario was way over the top, and given that Peter was Brent's acolyte I assumed that Peter's explanation was scripted, poorly scripted, for Brent could easily have refused me emeritus to my face or even in writing without threatening the division. This concoction was another of Brent's bizarre, evasive strategies to avoid confronting me directly. I theatrically railed for Peter's benefit, threatened to go to the Castle, and said disparaging things about Brent. After Peter left, I laughed to myself and thought, if Brent can give it, I don't want it.[12]

On December 17, the museum held a reception for the six of us who took the buyout, and I enjoyed seeing colleagues and reminiscing about museum work. As I moved about the reception suite and chatted, I reflected on my museum career. I had been involved in significant projects and worked with brilliant colleagues, and I had also witnessed wasted resources and lost opportunities. For a decade, I had suffered under a vengeful director and hapless supervisors. It saddened and aggravated me that I had never done an exhibit based on my scholarship. The staff at the reception was strikingly different from that in 1982, when I had arrived. Gone were nearly all of the historians of technology, curators who published articles and books, specialists, and many of the photographers.

On December 30, I went for my exit interview with Erica Mack, who told me all I needed to do was get a new ID with R for retired, turn in my keys,

hand in my parking permit, and unplug my office. I crossed the Mall and got my new ID with the R that I quickly learned would not access elevators to offices on the fourth and fifth floors, so after twenty-seven years I could no longer go to the library or visit friends without an escort. Erica had always been cheerful and competent in her dealings with me, as had Lolita Thomas, who smoothed my problems with GovTrip. I told her she kept me sane.

I shook the dust off my shoes as I left the building. I only returned for several fellows' colloquiums and Ken Slowik's chamber concerts.

It was a year and a half later, May 31, 2011, when on a Tuesday evening I got a call while having a pint with friends at the Irish Times. I walked outside to escape the noise and heard a remarkable story. President Barack Obama and his daughters arranged for an after-hours tour of an exhibit on Abraham Lincoln that Harry Rubenstein had curated. Earlier Harry had testified at a congressional hearing regarding Smithsonian collections and acquitted himself well, and Secretary Wayne Clough, impressed with Harry's competence, decided that Harry should lead the president and his daughters through the exhibit. The Castle sent Harry an email on Sunday afternoon telling him to arrive at the history museum by 6:00. Later in the afternoon he received a phone call from Brent Glass telling him that he would not be needed. When the president and his daughters arrived, Clough asked about Harry, and Brent said that he was unavailable. Later that evening the Castle called Harry to ask about his health. His health was fine, he said, but Brent had told him he was not needed. Lying to me was one thing, but lying to the Smithsonian secretary and to the president of the US was another order of magnitude. Several NMAH staff visited Secretary Clough to express their outrage. I was wrong when I suspected that Brent would escape with a tap on the wrist, for Clough fired him, giving him a face-saving retirement announcement so long as he was gone by July 10. It was altogether in character that Brent's hubris and lies led to his demise.

Dispossession: Discrimination against African American Farmers in the Age of Civil Rights came out in 2013, and then I started writing this memoir.

NOTES

Chapter 1: Historian/Curator

1. J. M. Spicer, *Beginnings of the Rice Industry in Arkansas* (Stuttgart, AR, 1964).
2. Author to Helen Boyd, October 26, November 10, 1982; Boyd to Author, December 2, 1982, in Author files. My correspondence, emails, and memos presently reside at my home and will be deposited in the Smithsonian Institution Archives. Hereafter cited as Author files.
3. Robert C. Post, *Who Owns America's Past? The Smithsonian and the Problem of History* (Baltimore: Johns Hopkins University Press, 2013), 10–15.
4. George Holt to Author, March 30, 1983, in Author files.
5. Author to Junior Johnson, April 26, 1983; Author to Rob Walker, May 4 1983, in Author files.
6. Author to Michael Kimberley, February 19, 1985; Author to Rob Walker, February 24, 1985, in Author files.
7. Author to Tony Rudd, November 20, 1985; "Ground Effect: Flying on the Earth" exhibit proposal, n.d., ca. November 1985, in Author files.
8. Author to Bill Withuhn, February 24, 1984, in Author files.
9. Bill Withuhn to Roger Kennedy, May 16, 1985, in Author files; Mike Christensen, "Curator Puts South's History in Its Place," *Atlanta Journal-Constitution*, February 11, 1990.

Chapter 2: Boundaries

1. Robert C. Post, *Who Owns America's Past? The Smithsonian and the Problem of History* (Baltimore: Johns Hopkins University Press, 2013), 174–77.
2. David F. Noble to Roger Kennedy, May 6, 1983, in Author files. Throughout *Who Owns America's Past?*, Robert Post alludes to the "dark side" of American history—that is, non-celebratory history—and how reluctant curators and administrators were to include it.
3. Bill Withuhn and Art Molella to David Noble, June 5, 1984; Noble to Withuhn and Molella, June 6, 11, 1984, in Author files.
4. Association of Curators, Bernard Finn, Chairman, to Roger Kennedy, September 10, 1984, in Author files.

5. Author to Bruce Hunt, August 12, 1985; Curators' Association Meeting, minutes, July 8, 1985, in Author files.

6. Louis Harlan to Author, February 1, 1985, in Author files.

7. "Gripes from the Third Floor," note to Author from fellows, n.d.; Author to Doug Evelyn, June 3, 1985, in Author files.

8. Bruce Hunt, Evaluation, July 31, 1985, in Author files.

9. Minutes of the Congress of Scholars, February 11, 2004, Paul Forman Papers, box 9, Congress of Scholars folder, acc. 10-165, Smithsonian Institution Archives; Sheila Burke, David Evans, and Tom Lentz to Smithsonian Research Staff, October 10, 2002, in Author files.

10. Author to Sally Stein, August 15, 1985, in Author files.

11. Author to Sally Stein, May 9, 1988; Author to Daniel Goodwin, May 23, 1988; Stein to Author, n.d., summer 1988; Stein to Author, August 19, 1988, in Author files.

12. Author to Nick Nicastro, October 14, 1988, in Author files.

13. Pete Daniel, "Debbie Fleming Caffery and Birney Imes: Images of the Working Class," February 18, 1993, talk in Birmingham, Alabama, in Author files.

14. Terry Sharrer to Roger Kennedy, February 10, 1984; Kennedy to Sharrer, March 13, 1984; Sharrer to Kennedy, March 14, 1984, in Author files.

15. Filmore Bender to Agricultural Experiment Station Directors, September 11, 1984, in Author files.

16. Terry Sharrer to Art Molella, July 1, 1985, in Author files.

17. Pete Daniel and Bill Withuhn, "Controversy and Fundraising in the Museum," paper prepared for a report on science and technology in NMAH, ca. 1990, in Author files.

18. NMAH Draft Policy on Donor Recognition, December 24, 1986, in Author files.

Chapter 3: An Exemplary Division

1. Art Molella to Author, February 19, 1985; Author to Molella, April 18, 1985, in Author files.

2. Lu Ann Jones to Author, February 23, 1984; Author to Jones, March 8, 1984, in Author files.

3. Author to Roger Kennedy, October 15, 1986; Author to Lonn Taylor, October 17, 1986, in Author files.

4. Author to Bruce Hunt, September 5, 1990, in Author files; "Documented," in "Talk of the Town," *New Yorker,* April 29, 1991, 28–29.

5. Barbara G. Tayor to Author, July 12, 1990, in Author files.

6. Toni Williams, "Black Group Irate at Cotton Gin Exhibit," *Jackson Clarion-Ledger,* n.d., clipping in Martha Swain to Author, October 1, 1993, in Author files.

Chapter 4: Lectures

1. Renate Semler to Author, April 15, 1986, in Author files.
2. Author to Leary Davis, November 27, 1991; Harold Woodman to Author, December 20, 1991; Author to Woodman, December 30, 1991, in Author files.
3. Notebook, November 27, 1997, in Author files.
4. Wang Siming to Author, April 8, 1992; Author to Siming, April 22, 1992, in Author files.
5. Author to Wang Siming, December 20, 1993; Author to Jean Ash, December 29, 1993, in Author files.

Chapter 5: Science and Conflict

1. The exhibit files from *Science in American Life* were transferred to the Smithsonian Institution Archives when I retired in 2009. John R. French to Robert McC. Adams, September 19, 1988; Author and Louis Hutchins, draft reply to John R. French, October 12, 1988, in Author files.
2. On the background and intention of the exhibit, see Arthur Molella and Tom D. Crouch, "Twentieth Century Limited: Attempts to Achieve an Integrated Presentation of Science, Technology, and Society in Exhibitions at the National Museum of American History," paper prepared for a report on science and technology in NMAH ca. 1990, in Author files.
3. Art Molella to Author, December 5, 2014, in Author files.
4. Author to Nancy Dean Eisenbarth, September 27, 1991, in Author files.
5. Author to Jim Kelly, June 3, 1991, in Author files. On the progress of the exhibit, see Author to William A. Neville, September 28, 1991, in Author files.
6. Author to Randy Finley, April 28, 1994, in Author files.
7. Pamela M. Henson, Oral history interview with I. Michael Heyman, April 20, 2001, 54–55, Smithsonian Institution Archives, Record Unit 9607.
8. Rowan Scarborough, "Smithsonian Chief Exhibits New View Toward Controlling Curators, Content," *Washington Times*, September 28, 1995, 1, 11.
9. Harry Crews, *A Childhood: The Biography of a Place* (New York: Harper & Row, 1978), 54–55.
10. Henson, Oral history interview with I. Michael Heyman, April 20, 2001, 79.
11. Joan E. Shields to Spencer Crew, August 16, 1995; Crew to Shields, September 1, 1995, in Author files.
12. Maurice M. Bursey to Author, July 18, 2006, in Author files. Bursey's letter was personal and did not reflect the American Chemical Society's position on the exhibit.

Chapter 6: Denying History

1. Pamela M. Henson, Oral history interview with I. Michael Heyman, October 15, 2004, 17–18, Smithsonian Institution Archives, Record Unit 9607.
2. Barney Finn to Spencer Crew, January 26, 1993, in Author files.
3. See Eric Foner and Jon Weiner, "Fighting for the West," *The Nation* (July 2/ August 5, 1991), 163–66.
4. See the articles in the *Journal of American History* 82 (December 1995), which provide a definitive discussion of the *Enola Gay* crisis. See also Robert C. Post, *Who Owns America's Past? The Smithsonian and the Problem of History* (Baltimore: Johns Hopkins University Press, 2013), 197–220.
5. See Stanley Goldberg, "Smithsonian Suffers Legionnaires' Disease," *Bulletin of the Atomic Scientists*, May/June 1995, 28–33; Michael Heyman to All Smithsonian Employees, January 30, 1995, in Author files.
6. Henson, Oral history interview with I. Michael Heyman, October 15, 2004, 27.
7. Henson, Oral history interview with I. Michael Heyman, October 15, 2004, 73.
8. "History and the Public: What Can We Handle? A Round Table about History after the *Enola Gay* Controversy," *Journal of American History* 82 (December 1995), 1029–1135; Post, *Who Owns America's Past?*, 197–209.
9. Harry R. Rubenstein, "Good History Is Not Enough," *Perspectives on History* (May 2000), (male bashing quote); Author to Karen Leathem, August 27, 1997, in Author files; Henson, Oral history interview with I. Michael Heyman, October 15, 2004, 27–28; Henson, Interview with Heyman, October 29, 2007, 71–77.
10. See Kai Bird, "Enola Gay: 'Patriotically Correct," *Washington Post*, July 7, 1995, A21.
11. Rubenstein, "Good History Is Not Enough."

Chapter 7: Research Road

1. Pete Daniel, *Lost Revolutions: The South in the 1950s* (Chapel Hill: University of North Carolina Press, 2000), 241–42.

Chapter 8: Rock 'n' Soul

1. For an in-depth account of Memphis music, see David A. Less, *Memphis Mayhem: A Story of the Music that Shook Up the World* (Toronto: ECW Press, 2020).
2. Notebook, October 5, 1998, in Author files.
3. Author to Smita Dutta, January 25, 1999, in Author files.
4. Notebook, July 22, 1999; Author to Smita Dutta, September 27, 1999; Author to Hank Grasso, September 30, 1999, in Author files.

Chapter 9: Defending Exhibit Standards

1. On Small's selection, see Robert C. Post, *Who Owns America's Past? The Smithsonian and the Problem of History* (Baltimore: Johns Hopkins University Press, 2013), 221–32.
2. Bob Thompson, "History for $ale," *Washington Post Magazine*, January 20, 2002, italics in original.
3. See Larry Van Dyne, "Money Man," *Washingtonian*, March 2002, 38–41, 131–39, copy in Author files; available online, https://www.washingtonian.com/2002/03/01/money-man/.
4. National Museum of American History Branch, Smithsonian Congress of Scholars to Smithsonian Institution Board of Regents, May 23, 2001; Bruce Craig, "NCC Washington Update," June 1, 2001, in Author files; Elaine Sciolino, "Smithsonian Group Criticizes Official Donor Contract," *New York Times*, May 26, 2001, A7.
5. Division of Cultural History to Robert D. Bailey (undersecretary), April 23, 2001, in Author files.
6. Barney Finn to Larry Small, June 8, 2001, in Author files.
7. Ellen Gamerman, "New Clashes with the Old at Smithsonian Institution," *Baltimore Sun*, July 5, 2001, in Author files.
8. Jacqueline Trescott, "Wildlife Agency Reinvestigates Smithsonian Secretary's Art," *Washington Post*, July 10, 2001, in Author files; Jacqueline Trescott, "Small Gets 2 Year's Probation," *Washington Post*, January 24, 2004, A1, 8, copy in Paul Forman Papers, box 9, Small/Burke folder, acc. 10-165, Smithsonian Institution Archives.
9. Congress of Scholars, minutes, October 10, 2001, in Paul Forman Papers, box 9, Congress of Scholars folder, acc. 10-165, Smithsonian Institution Archives; Jacqueline Trescott, "Ken Burns Gives Voice to Filmmakers' Concerns," *Washington Post*, April 19, 2006, C3; Norman D. Dicks and Charles Taylor to Lawrence Small, April 27, 2006; David Madland, "Television Deal Sets Bad Precedent for Charities," *Chronicle of Philanthropy*, May 19, 2006, in Author files.
10. Michael Killian, "Smithsonian Losing Another Leader," *Chicago Tribune*, April 4, 2002, 9; Teresa Wiltz, "Smithsonian Losing a Sixth Key Director," *Washington Post*, April 4, 2002, C1; Josette Chen, "Smithsonian Rocked by High-level Departure," *Nature*, April 11, 2002, 569.
11. Brian T. Huber to Lawrence M. Small, June 22, 2000; NMAH branch of Congress of Scholars to Sheila Burke, June 30, 2000, Paul Forman Papers, box 9, Small folder, acc. 10-165, Smithsonian Institution Archives.
12. Tim Golden, "Big-Game Hunter's Gift Roils the Smithsonian," *New York Times*, March 17, 1999, in Author files.
13. Larry Van Dyne, "Money Man," *Washingtonian*, March 2002, 38–41, 131–39.
14. David Montgomery, "Inspiration Investor," *Washington Post*, April 14, 2002;

Jessie-Lynne Kerr, "Jacksonville Native Cancels $38 million to Smithsonian," *Florida Times-Union*, February 6, 2002, A1, in Author files.

15. Elaine Sciolino, "Smithsonian Must Exhibit Ingenuity in the Face of Overlapping Gifts," *New York Times*, August 6, 2001; Georgie Anne Geyer, "Bored Rich Toy with Smithsonian Heritage," *Washington Times*, May 20, 2001, in Author files.

16. Elaine Sciolino, "Smithsonian is Promised $38 Million, With Strings," *New York Times,* May 10, 2001. See also Michael Killan, "Revolt at Smithsonian: Scientists Worry that Bottom Line is Sinking the Smithsonian, *Chicago Tribune*, May 6, 2001, in Author files.

17. Van Dyne, "Money Man."

18. Author to Barbara Clark Smith, n.d. (about May 11, 2001), in Author files.

19. Spencer Crew to NMAH Staff, July 3, 2001, update on recent events, Paul Forman Papers, box 9, Crew folder, acc. 10-165, Smithsonian Institution Archives; Spencer Crew to Helena Wright, May 25, 2001, in Author files.

20. Peter Liebhold to staff, February 7, 2002, in Author files; Post, *Who Owns America's Past?*, 239.

21. "Smithsonian and Philanthropy—Art and Politics," transcript of "To the Point," June 8, 2001, in Author files.

22. Victoria A. Harden, "Museum Exhibit Standards: Do Historians Really Want them?," *Public Historian* 21 (Summer 1999), 91–109; Museum Exhibit Standards Adopted by the Organization of American Historians Executive Board, April 2, 2000, in Author files; Paul Forman to Victoria Harden, August 27, 1999, Paul Forman Papers, box 9, acc. 10-165, Smithsonian Institution Archives.

23. Lee W. Formwalt, executive director, OAH, to Smithsonian Board of Regents, June 7, 2001, in Author files.

24. James H. Bruns to Lee W. Formwalt, June 11, 2001, in Author files.

25. Arnita A. Jones, executive director, AHA, to Smithsonian Board of Regents, transmitting Council resolution, June 18, 2001; John F. Stephens to Board of Regents, July 10, 2001; Bruce Craig, "Washington Update," July 12, 2001, in Author files; "Organizations That, Since April 2001, Have Expressed Concern or Protested Against One or More of the Actions or Policies of Smithsonian Secretary Lawrence M. Small," copy in Paul Forman Papers, box 8, compilation of articles criticizing Small folder, acc. 10-165, Smithsonian Institution Archives; Post, *Who Owns America's Past?*, 242–43.

26. Catherine Reynolds to Lawrence Small, February 4, 2002, copy in Paul Forman Papers, box 8, Reynolds/Behring folder, acc. 10-165, Smithsonian Institution Archives.

27. Jacqueline Trescott, "Smithsonian Benefactor Cancels $38 million Gift," *Washington Post*, February 5, 2002, A1; Michael Killian, "Donor Pulls Smithsonian Gift," *Chicago Tribune*, February 5, 2002; Jim Gardner to curatorial affairs staff, February 5, 2002, in Author files. Reynolds's withdrawal of the

bulk of her $38 million generated national press coverage; most was critical of her demands.

28. Author to Ray Smock, February 6, 2002, in Author files.

29. Adam Goodheart, "In the Capital: Smithsonian's Veteran Man-in-the-Middle Stands His Ground." *New York Times*, April 24, 2002, in Author files, italics in original. See also Patricia Nelson Limerick, "How Reporters Missed 'The Spirit of America,'" *Chronicle of Higher Education*, May 24, 2002.

30. Gil Klein, "Museums Want Gifts with No Strings Attached," *Tampa Tribune*, March 10, 2002, 1; Robert Cohen, "The Smithsonian, Brought to you By," *Newark Star-Ledger*, April 28, 2002, 1, in Author files.

31. "Report of the Blue-Ribbon Commission on the National Museum of American History," March 2002, copy in Paul Forman Papers, box 9, Blue Ribbon Report folder, acc. 10-165, Smithsonian Institution Archives.

32. Pete Daniel, *Toxic Drift: Pesticides and Health in the Post-World War II South* (Baton Rouge: LSU Press, 2005).

33. Author to Rebecca Lynch, November 7, 2001, in Author files.

Chapter 10: Entropy

1. Robin Morris to Author, December 17, 2002, in Author files.

2. Jim Gardner to Author, November 27, 2002, in Author files.

3. Larry Jones to Author, January 28, 2005, in Author files.

4. Jacqueline Trescott, "American Dreamer," *Washington Post*, January 3, 2003, C1, 5.

5. NMAH Congress of Scholars, Katherine Ott to Brent Glass, November 20, 2002, in Author files.

6. Larry Jones to Author, March 13, 2002, in Author files.

7. Notebook, August 19, 2003, in Author files.

8. Larry Jones to John R. Sellers, April 24, 2008, in Author files.

9. Sue Culver to Author, November 8, 2004; Author to Culver, November 12, 2004, in Author files.

10. Barney Finn to EPC, March 23, 2004, in Author files.

11. Announcement, March 20, 2007, "Smithsonian board of regents Announces Creation of Three-person Independent Review Committee," in Author files.

12. Roger W. Sant to Charles E. Grassley, April 16, 2007, copy in Paul Forman Papers, box 10, Small folder, acc. 10-165, Smithsonian Institution Archives.

13. Cristian Samper to Dear Colleagues, June 20, 2007, in Author files.

14. Editorial, *New York Times*, June 27, 2007, in Author files.

Chapter 11: The Wages of Mediocrity

1. Author to David Allison, July 30, 2004; Allison to Author, July 30, 2004, in Author files.

2. Carole Emberton, "The Price of Freedom: Americans at War," exhibition review, *Journal of American History*, 92 (June 2005), 163–65; Author to Carole Emberton, August 4, 2005, in Author files. See also Scott Boehm, "Privatizing Public Memory: The Price of Patriotic Philanthropy and the Post-9/11 Politics of Display," *American Quarterly* 58 (December 2006): 1147–1166.

3. Author to Carole Emberton, May 27, 2006, in Author files.

4. Sheet 1 of Survey, November 15, 2002, in Author files.

5. Author to Larry Jones, February 22, 2005, in Author files.

6. Lynn Chase and Dwight Bowers to America's Stories Team, December 20, 2004, in Author files.

7. NMAH Weekly Report to Sheila Burke for November 1, 2006; Author to Jim Gardner, November 3, 2002, in Author files.

8. Author to Larry Jones, March 12, 2005, in Author files.

9. Author to Larry Jones, n.d., (late April 2005); notebook, October 26, 2005, in Author files.

10. Jan Davidson to Author, November 14, 2005; Rick Shenkman, "Interview with Pete Daniel: The Great Flood of 1927," in Author files.

11. Author to Larry Jones, April 27, 2007; Author to Peter Liebhold, May 10, 2007, in Author files.

12. Author to Ellen Hughes, July 24, 2007, in Author files.

13. Harry Rand to Ellen Hughes, November 1, 2007; James Blackburn to Carol Ailes et al., August 5, 2008, in Author files.

Chapter 12: Dismissive Indifference

1. Author to Tom Summerhill, November 10, 2006; Notebook entry, October 6, 2005, in Author files.

2. Charles Joyner to Brent Glass, November 2, 2005, in Author files.

3. Brent Glass to Charles Joyner, November 28, 2005, in Author files.

4. Susan Dollar to Author, November 30, 2006; Author to Dollar, November 30, 2006; Dollar to Author, December 6, 2006; Author to Elizabeth Guin, December 30, 2006; Guin to Author, December 27, 2006, and other emails, in Author files.

5. Jack Kirby to Author, October 24, 2006; Author to Kirby, December 7, 2006, in Author files.

6. Author to Don Ritchie, January 25, 2007; Ritchie to Author, January 26, 2007, in Author files.

7. Author to Larry Jones, November 2, 2006; Ellen Roney Hughes to Brent Glass, November 27, 2007, in Author files.

8. Author to Jules Tygiel, December 19, 2007; Author to Jim Gardner and Peter Liebhold, December 9, 2007; Liebhold to Author, December 20, 2007; Author to Jim Gardner and Liebhold, December 29, 2007, in Author files.

9. Philip Kennicott, "Artifact or Artifice?", *Washington Post*, August 30, 2009, E1, 5.
10. Pete Daniel, "Remarks at the SHFG Meeting," March 13, 2008; Author to Laura Daniel Davis, March 13, 2008, in Author files.
11. Author to Shirley Wajda, August 8, 2008, in Author files.
12. Jody Rapport to Author, February 11, 2009, in Author files.
13. The presidential address, "Reasons to Talk about Tobacco," can be found in the *Journal of American History* 96 (December 2009): 663–77.

Chapter 13: Not Fade Away

1. Chart, "Federal Permanent Staff, 1992/2000/2008," in Author files.
2. Author to Larry Jones, January 21, 2008, in Author files.
3. Ellen Hughes to Brent Glass, January 31, 2008, in Author files.
4. Jim Gardner to Brent Glass, March 2, 2008; Ellen Hughes to members, Congress of Scholars, April 23, 2008, in Author files.
5. Brent Glass to NMAH staff, July 22, 2008; Philip Kennicott, "The Smithsonian: Wanted: Sun King, Apply at the Castle," *Washington Post*, December 15, E1, 5, in Author files.
6. Peter Liebhold to Author, March 13, 2009 (two emails); Author to Liebhold, March 13, 2009; Liebhold to Author, March 16, 2009, in Author files.
7. Michael Sofield to NMAH staff, May 1, 2009; Author to Larry Jones, May 7, 2009; Bent Glass to NMAH staff, May 8, 2009, in Author files.
8. Author to Matt Wray, June 21, 2007; Jim Lanier to Author, May 1, 2008, in Author files.
9. For Billy Lee Riley obituraries, see Bob Mehr, "Sun Records Legend Dies,' *Memphis Commercial Appeal*, August 3, 2009; Terence McArdle, "Sun Records Rockabilly Musician," *Washington Post*, August 4, 2009, clippings, in Author files.
10. Pete Daniel, remarks on Jack Temple Kirby, in Author files.
11. Author to Peter Liebhold, September 4, 2009, in Author files.
12. Author, memo for the file, December 16, 2009, in Author files.

INDEX

Small, Lawrence, 9, 41, 89, 134, 139–45, 147, 148, 149–50, 151; donor influence, 163; leadership controversies, 173; leadership issues, 178, 181, 185, 200; resignation, 172–73; rural life exhibit, 160–61

Smiley, David L., 3, 61–62

Smith, Augustus, 25, 28

Smith, Barbara Clark, 34, 148–49

Smith, Lillian, 106, 109

Smith, Louise, 153

Smithsonian American Art Museum, 41, 52, 89, 91

Smithsonian Business Ventures (SBV), 143

Smithsonian Institution Press, 43

Smithsonian Journal of History, 14

Smithsonian Magazine, 143

Smithsonian Productions, 50, 116–17, 142

Smithsonian Travel Office, 186

Smock, Ray, 5, 17–18, 36, 41, 43

Snapping Turtle lawn mower, 82, 164

Society for History in the Federal Government (SHFG), 7, 34, 149, 199

Society for the History of Technology, 7, 14

Soileau, Rouseb, 24

soul music, 22, 107, 115, 117, 133. See also Rock 'n' Soul exhibit

South Africa, 33–34, 217–18

South Carolina Council on Human Relations, 104

South Caroliniana Library, 104

Southern Historical Association: awards, 36; convention participation, 24, 40, 57, 60, 105, 108–9, 130, 163, 171, 197; and Jack Temple Kirby, 215, 217; and James Silver, 106; leadership opportunities, 189–90, 209; as

member, 7, 34; presidential reception sponsorship issue, 190–92

Southern Historical Collection, 96, 202

Southern Historical Convention, 57

Southern Oral History Project, 21, 104

Southern Writers Project, 201–2

Spearman, Alice, 104

Speed and Spirit exhibit, 152

Spicer, J. M., 12

Spirit of America Hall, 145, 150

Square Books, 134

staff morale, 177–78

Stampp, Kenneth M., 65

Standing at the Crossroads: Southern Life in the Twentieth Century (Daniel), 36, 46, 65

Stanford University Linear Accelerator, 87

Stange, Maren, 41

Staples, Bob, 152, 155, 183

Stark, Amy, 202

Starkville, Mississippi, 60, 209

STAX music studio, 115, 117, 119, 122, 125, 133

steam engine, portable, 161–62

steam-powered cotton gins, 28–29

Stein, Sally, 38, 41, 211, 212

Stembridge, Jane, 108–9

Stennis, John, 108

Stetten Museum, 149

Stevens, Carlene, 55

Stevens, Ted, 91

Stewart, Jackie, 211

Stewart, Jim, 117

Stipe, John Wesley, 57

StipeMaas, Skipper, 57

Stipe, Nancy, 57

St. John's College, 68

stock-car racing, 18–22, 105, 152–56, 163, 183

Stokes, Melvyn, 65